JEWELS OF THE
PHARAOHS

SPECIAL PHOTOGRAPHY
IN CAIRO BY
ALBERT SHOUCAIR

With 173 illustrations,
109 in color

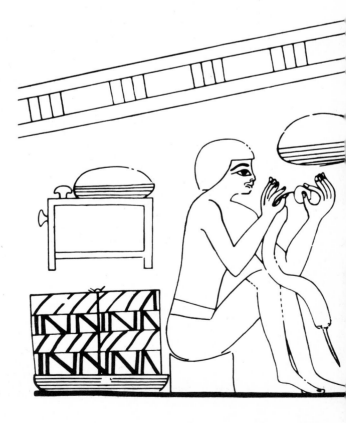

BALLANTINE BOOKS
NEW YORK

CYRIL ALDRED

JEWELS
OF THE PHARAOHS

Egyptian Jewelry of the Dynastic Period

ABRIDGED

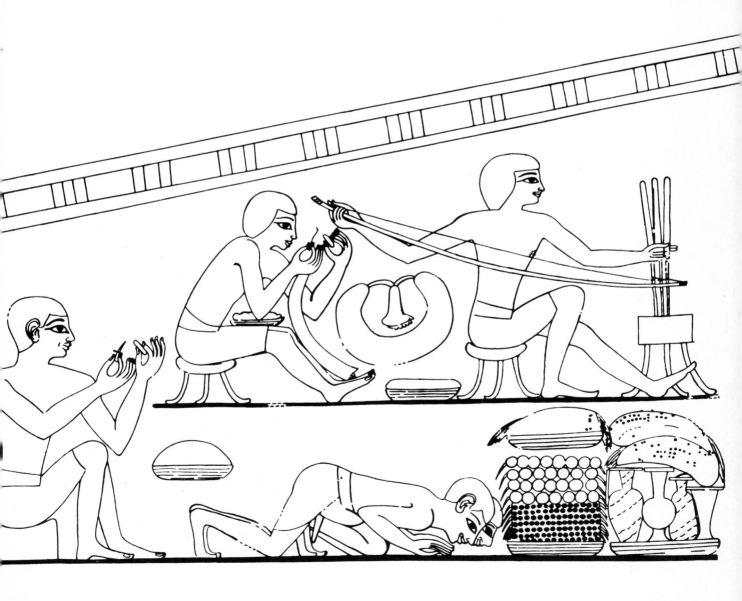

Contents

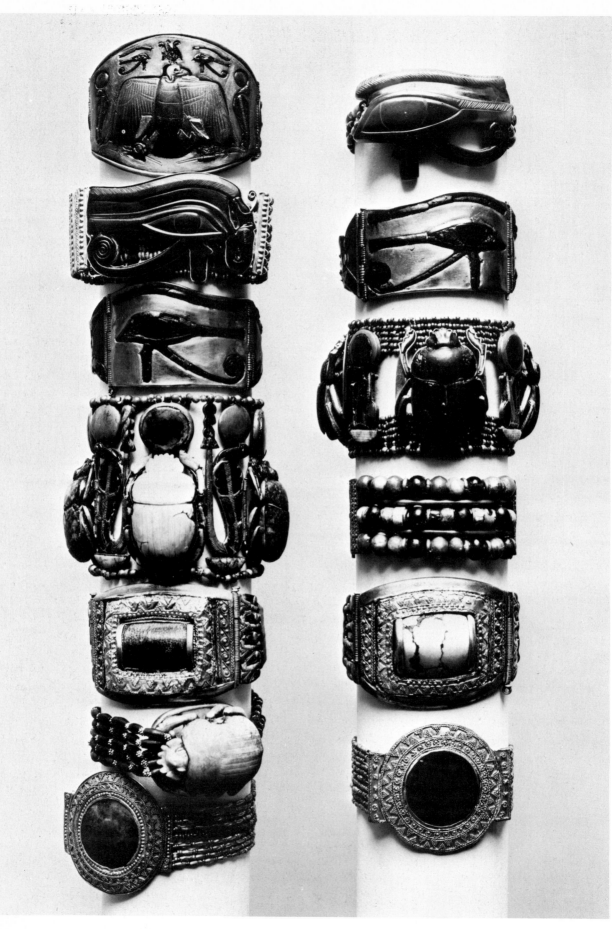

1 The Recovery of Ancient Egyptian Jewelry

On the 22nd day of the 3rd month of the Winter Season, in the 16th regnal year of the Pharaoh Ramesses IX (i.e. c. 1124 BC), a certain stonemason, Amun-pnufer, was taken in custody to the Treasury of the Temple of Mont, to the north of modern Karnak, and there brought before a tribunal of high officials, presided over by the Vizier, who was investigating allegations of wholesale robbery among the tombs at Western Thebes on the opposite bank of the Nile. After being beaten as a foretaste of what to expect if he withheld information, Amun-pnufer was made to take an oath to speak the truth and repeat evidence he had given three days before at a preliminary examination. While the secretary of the court took down his testimony, and incidentally preserved it for our eyes to read, Amun-pnufer described how he and seven other members of his gang had taken their mason's tools and forced their way into the tomb of King Sobek-em-saf of the Seventeenth Dynasty who had lived over four centuries earlier. They had eventually reached an inner place where the body of the king lay: and in an adjoining chamber they found the burial of his queen, Nub-kha-es.

'We found the noble mummy of the sacred king,' he went on, 'equipped with a scimitar. Numerous golden amulets and ornaments were upon his breast and a golden mask was over his face. The noble mummy of this king was entirely bedecked with gold and his coffins were embellished with gold and silver, both inside and out, and inlaid with precious stones. We collected the gold, together with the amulets and jewels that were about him and the metal that was on his coffins. We found the queen in the same state and retrieved all that we found upon her. Then we set fire to their coffins. We took the furnishings that we found with them comprising objects of gold, silver and bronze and divided the spoils amongst us . . . amounting to 160 deben [about 14½ kilos] of gold in all.'

Amun-pnufer concluded his confession by admitting that he and his gang had been robbing tombs at Western Thebes during the previous four years, but he sought to justify himself by asserting that a large number of other people did the same and were as good as partners in his crimes.

Bracelets from the left and right arms of Tut-ankh-amun, some of rigid half-cylinder design, the others of flexible bead-work, made of gold, electrum, hardstones and coloured glass. XVIIIth Dynasty. Cairo Museum

Near the end of July, AD 1916, Western Thebes was visited by one of the very rare but severe rainstorms that break over the desert and suddenly convert the empty water-courses of the region into roaring torrents even miles from the centre of the disturbance. The raging flood scours out new channels as well as old in its moments of fury and spills over in cascades, washing away detritus and shifting surface deposits as by the spade of the excavator. This phenomenon was well known to the natives of Qurna at Western Thebes who, when the storm had spent its force, roamed over the cliffs of the neighbourhood to see what the floods might have exposed. It was in this way that at the bottom of a cleft among the crags, not an hour's walk from where Amun-pnufer and his confederates had operated three thousand years earlier, one of the gangs found a tomb in which three queens of Tuthmosis III had been laid to rest c.1480 BC in all their funerary splendour and with a rich complement of toilet objects and vessels in gold and silver, in addition to their crowns and the other jewels they had worn in life. Their coffins had already rotted from damp and it did not take the gang long to rifle the burials and sell the loot to various dealers who soon dispersed it to Europe and America, where the bulk of it now forms one of the treasures of the Metropolitan Museum of Art (49–55).

These two accounts separated by three millennia of history will serve to show why it is in the nature of a miracle that any ancient Egyptian jewelry should have survived reasonably intact to modern times. The hunt for valuable grave goods in Egypt has gone on relentlessly since a little after the time of the first burial in that land and has entered into its folklore, and into such stories as those of Aladdin and Ali Baba. The wealth of treasure found in the tomb of Tut-ankh-amun (62–86) and in those of the later kings at Tanis (98–106), has revealed what compelling incentives there were for the impoverished and greedy to risk all in a search for sudden riches. The reason why the mummies of the great Pharaohs of the New Kingdom repose in a despoiled and shattered state in the Cairo Museum is that, by the time the rulers of Thebes in the tenth century BC had rescued their remains, they had suffered miserably from the axes of the more impious and rapacious of their subjects eager to strip them of the jewels with which they were smothered, the only traces of which are now occasional impressions left on their hardened skins. The sole difference between the thieves of Qurna in 1916 and their ancestors in 1124 BC was that in the case of the

7

former, more could be got for their plunder by selling it intact than by melting it down.

The special aura that attaches to finds of jewelry in modern Egypt is nowhere better sensed than in the account of the discovery of the jewelry of Queen Ah-hotpe of the early Eighteenth Dynasty (*obit. c.* 1550 BC). In 1859 one of the agents of Auguste Mariette, the Frenchman who had just been appointed Conservator of Monuments by Said Pasha, while excavating in the detritus of the Dra 'Abu l'Naga at Western Thebes, found the coffin of the queen which also contained a costly accompaniment of goldwork and jewelry (*37–46*). The story of this find, which lost nothing in the telling, soon reached the ears of the mudir of Qena who seized the coffin, had the mummy unwrapped in his harim and then took ship down the Nile to offer the treasure to Said as a personal gift. Mariette, learning of this act of piracy, and unwilling that the credit of his discoveries should be claimed by outsiders, set off in his official steam launch, intercepted the mudir's boat and succeeded by great effrontery and a show of force in recovering the treasure which he in turn presented to Said. Happily Said did not resent the manner in which his Conservator of Monuments had retaken possession of the jewelry, nor did he claim it all for himself; but his Oriental mind was at last awakened to the importance and value of the antiquities that were being uncovered, and he gave orders that a museum worthy of housing such valuable finds should be established.

The discovery of Ah-hotpe's jewels and trappings hardly ranks as serious archaeology since no reliable records were kept at the time of discovery, and some of the minor objects may have disappeared during the unwrapping in the mudir's harim. It is, for instance, impossible now to discover how the various elements in the unique Falcon Collar (*46*) were strung originally, though such information was doubtless available at the moment of unwrapping.

Actually no large deposit of jewelry has been found intact by scientific excavation in Egypt apart from that recovered from the tomb of Tut-ankh-amun, and even there the personal jewels, as distinct from the funerary amulets, had mostly been stolen. De Morgan, excavating in 1894 and 1895 in the precincts of the ruined pyramids of Ammenemes II (*obit. c.* 1895 BC) and Sesostris III (*obit. c.* 1843 BC) at Dahshur, had the good fortune to find the personal ornaments of six daughters of the royal house (*10–17, 19, 21, 28–33*). His methods of recovery, however, were defective and the crowns, pectorals, bracelets and necklaces were exhibited in their divorced parts for many years in the Cairo Museum until the study of the contemporary jewels from Lahun enabled them to be reassembled into something approaching their original appearance and magnificence.

In 1914, Flinders Petrie, excavating the pyramid complex of Sesostris II (*obit. c.* 1878 BC) at Lahun, lighted upon the pit-tomb of Sit-Hathor-Yunet, a daughter of the king, who had been buried within the enclosure of her father's monument. Her burial had been rifled in antiquity and her body broken up to retrieve the funerary jewelry which adorned and protected it so ineffectually. But the robbers, working in frantic haste and by the feeble light of guttering lamps, had overlooked an obscure recess which housed her jewelry caskets, wig-chest and toilet-boxes. These were subsequently covered with layers of mud washed into the chambers of the opened tomb by periodical floodings until the tomb-shaft was eventually choked with drifting sand. By the time Petrie's assistant, Guy Brunton, came to clear the recess, it resembled a large dried-out mud pie into which various bits and pieces of the objects had been stirred by swirls of storm-water and debris. The decayed wood was little more than a brown stain in the circumambient mud and the corroded copper and silver were reduced to virtual green and purple smears. Brunton spent days and nights in the cramped conditions of the tomb, picking away at the mass of mud with a penknife and a pin, until he had recovered without damage the thousands of pieces both large and minute. He also managed to make a plan showing the position of each item as he came upon it during his slow clearance of the recess and his notes and diagrams proved of inestimable value when the reconstruction of the jewelry and caskets was eventually undertaken.

As the Lahun hoard seemed to duplicate the contemporary treasure from Dahshur, Petrie was allowed to keep the jewelry with the exception of Sit-Hathor-Yunet's mirror, crown (*20*) and a pectoral (*26*), each of which was unique, and these remained in Cairo. Petrie subsequently sold the contents of the recess to the Metropolitan Museum of Art in New York where two of the caskets were reconstructed with great skill and ingenuity by A. C. Mace and the original appearance of the jewelry (*20, 22–26*) was recovered by Herbert Winlock in a brilliant study of the entire deposit based upon Brunton's invaluable fieldwork. Only in two minor particulars did Winlock go astray, and E. S. Eaton was subsequently able to show that the bird-claw necklace should be re-threaded to make two anklets (*23*). William Hayes has also pointed out that the gold tubes on the great wig of Sit-Hathor-Yunet should be rearranged in a chequer pattern (*20*).

A similar deposit covered with water-laid mud and debris was found by Edward Ayrton in a pit-tomb (No. 56) in the Valley of the Kings at Thebes in 1908. But it was excavated with far less skill and conscientiousness than Brunton had exercised at Lahun, and what was retrieved was for long regarded as part of the funerary equipment of

Queen Twosre (*obit. c.* 1200 BC) hidden away by a robber or guardian in the pit in which it was found when her tomb (No. 14) was usurped by her successor Set-nakhte, and her burial evicted. There is little doubt, however, that what Ayrton found was the burial of an infant daughter of Twosre by her first husband, King Sethos II, and the child's meagre personal jewels had been supplemented with pieces from the queen's trinket boxes, including heirlooms (*93, 94*).

The discovery by Pierre Montet in 1939 of royal tombs of the Twenty-first and Twenty-second Dynasties at Tanis has brought to light jewelry of the Late Period, mostly of a funerary character and maintaining the traditional design of such amuletic pectorals, collars and bracelets (*98–106*). But it would appear that the burials of the Pharaohs in question had been disturbed and rearranged in antiquity, and it is probable that their personal ornaments had long been filched by the time Montet came to uncover them. While in the mass the goldwork and jewels found at Tanis make an impressive show, it is clear that each king took to the tomb a far less opulent store of treasure than was buried with Tut-ankh-amun.

In Egypt, as elsewhere, spectacular discoveries of such riches have more often been made by accident than as a result of deliberate search. Thus in 1906, while a railway embankment was being constructed at Zagazig in the Delta, near Tell Basta, the site of the ancient city of Bubastis, a hoard of gold and silver, mostly in the form of vessels but including bracelets of Ramesses II (*87, 88*), was uncovered. This was probably a cache hidden by a thief or temple official in troubled times and never reclaimed. The Antiquities Department had difficulty in establishing its right to all this treasure-trove against the claims of a local dealer, and as a result some of the hoard is now in the Berlin and Metropolitan Museums. Such chance finds as that of the treasure of the queens of Tuthmosis III have usually been made by private persons who are only too willing to dispose of the objects to middlemen under a vow of secrecy; and it is seldom that such discoveries come to the ears of authority. In this way jewels have entered collections abroad with no details of the circumstances in which they were found, or at the best

accompanied by a garbled and often deliberately misleading account. It is rare that the Cairo Museum has been able to take possession of such fortunate finds, a notable exception being the Tukh el-Qaramus hoard which was found by accident in 1905 when an ass, straying from the path, put its hoof through a large pot buried near the surface of the ground and revealed to its overjoyed rider the glitter of gold and silver that lay hidden within. Unfortunately for the finder, he was seen to remove his prize to his home and nearly all its contents were recovered by the Antiquities Service before they could be dispersed. They proved to be mostly of Hellenistic date and thus outside the scope of our survey.

Such treasure that has escaped the melting-pot during the last century and a half, whether it has been carefully uncovered by the archaeologist or by the hands of less scrupulous looters, now lies scattered among a hundred collections in Egypt, Europe and America. This fortuitous sampling of ancient jewelry, however, is unfortunately rather uneven. While we have representative examples from the Middle and New Kingdoms and are thus in a position to assess the achievement of these periods, the actual specimens of Old Kingdom date are very rare indeed and reflect mostly a funerary art. The Saite period, which was characterized by a return to the classic styles of earlier ages, expressed by meticulous and unfaltering techniques, is unrepresented except by a few battered funerary amulets. In the latest periods of Pharaonic history, the native jewelry is replaced by Persian and Hellenistic designs favoured by those of the ruling classes who could afford such an expensive luxury.

Despite the incomplete nature of this conspectus, Egyptian jewelry in the mass forms a most impressive testimony to the skill and taste of the ancient craftsman, making its appeal by its effective design and the glowing colours of each jewel considered as a whole. In this it bears a closer resemblance to medieval stained glass than it does to modern jewelry. Precious gemstones employed in the making of modern expensive jewels were unknown to the ancient Egyptians who selected their materials for their colour and polish rather than their refractive powers, brilliance and rarity.

2 The Uses of Ancient Egyptian Jewelry

It should be obvious from the foregoing chapter that what has survived today is but an infinitesimal proportion of the jewelry that was produced in Egypt during the three millennia of its history under the Pharaohs. In the first place, personal adornments were worn in life by men as well as women and these were not restricted to finger-rings but could include bracelets, anklets, collars, necklaces and, at some periods, even earrings and fillets. Everyone who could afford a burial, however modest, expected to be tricked out in his finery after death and even the poorest inhumations do not lack a string or two of beads around the neck or arm of the deceased. The sands of the necropolis at Saqqara are so rich with the 'mummy beads' of disturbed burials that the stringing of them as necklaces for sale to tourists is a venerable local industry.

The gods, too, had their jewelry. Every shrine sheltered the statue or statues of gods which had to have a change of raiment, including jewelry and especially collars, as part of the daily ritual of service. The temple magazines held impressive quantities of jewels, as we can read from their inventories, though of course all have long since been looted and only a miserable huddle of discarded treasure found hidden in the precincts of the temple of Dendera bears any witness to the wealth that was once stored in temple repositories. The pictures of the furnishings provided by Tuthmosis III for the temple of Amun at Karnak, and shown sculptured on the south wall of a chamber adjacent to the sanctuary, include a catalogue of the various gold necklaces, collars and bracelets which he supplied for the service of the god. With such widespread patronage it is clear that the occupation of jeweller must have been one of the most flourishing in ancient Egypt throughout its long history.

Jewels, by which we mean any ornament designed to adorn the person, may be worn for various reasons, but probably their fundamental and most compelling purpose in ancient Egypt was as amulets for the protection of the wearer from mysterious hostile forces. These might manifest themselves in tangible forms such as noxious animals, crocodiles, snakes, scorpions and the like; or they might take a less visible shape and appear as disease, accidents and such natural calamities as flood, storm and drought. To protect himself against such inimical powers, the ancient primitive, like his modern counterpart, tied charms to his wrists, ankles, neck, waist and other vulnerable points. Such talismans might consist of various stones, such as the carnelian, turquoise and lapis lazuli, that preserved within themselves the colour of life-blood, the fresh green of springing vegetation or the blue of water and the holy sky-realms. The pebbles had to be perforated before they could be attached by linen cords or leather thongs; thus the stone pendant was introduced and later supplemented by various shaped beads in such artificial materials as pottery, green or blue glazed steatite, glazed quartz frit ('faience') and glass.

Among such magic substances must also be included gold, which was probably first found as shining granules in river sands. Gold could be worked by comparatively simple means and fashioned into gleaming beads and objects that never lost their lustre but seemed to retain within themselves all the fire and glory of the sun. No wonder, therefore, that the flesh of the very gods was believed to be made of this eternally shining material.

The claws of birds of prey and other ferocious creatures, or the horns and tusks of wild animals, were also thought to contain magic virtues that could be turned to the advantages of the possessor of such *disjecta membra*; and prehistoric amulets often take these forms though only the bird claws survived as the amulets of historic times (*12, 23*) and even they are not found after the Middle Kingdom.

Another natural product that aroused primitive wonder was the shell of fresh- and sea-water animals (*2, 15, 31*). Bracelets could be ground out of the conus shell. The cowrie shell with its indented lip has the appearance of a half-closed but ever-watching eye (*19*) and was therefore thought to be, by sympathetic means, a prophylactic against the evil eye, a belief in the blasting powers of which is still widespread around the shores of the Mediterranean and in East Africa. Even in recent times Nilotic women have worn aprons sewn with cowrie shells to protect the pelvic organs from the aborting and sterilizing effect of a malevolent gaze. The cowrie shell and the cowroid design were used in ancient Egypt for the same purpose though in time they were supplemented and replaced by the *wedjet* eye of the sky-god Horus (*80, 81*) which, with the scarab, is probably the commonest amulet found in ancient Egypt.

The 'Eye of Horus' was but one of a whole host of symbols that came into existence with the invention of hieroglyphic writing and could have significance as protective devices. Thus an object fashioned as the *sa*-sign, a rolled-up papyrus shelter with the meaning 'protection', could be used as a general defence against any hostile force (*12*). Moreover, other symbols could play a more positive role, and the *ankh* (a sandal strap) or the *tyet*

(a girdle tie) or the *djed* (a column of trimmed papyrus stalks) could promise their bearer 'life', 'welfare', 'endurance' and the like (16). Small images of the gods, or their familiar animals, could place the wearer under the direct protection of the deity. Lastly amulets in the form of glyphs could be combined into brief mottoes or expressions of good wishes (17, 28), or the names of kings regarded as protective deities. Such compositions are particularly characteristic of the Middle Kingdom jewels from Dahshur and Lahun; but many of the jewels from the tomb of Tut-ankh-amun are also designed upon elements forming the name of the king (75–77, 79).

The amuletic character of Egyptian jewelry underlies most of its forms and purposes, particularly in the case of that made to be placed upon the peculiarly vulnerable mummy of the deceased (7–9). Such funerary charms are often of a flimsy construction, consisting of thin layers of metal foil upon a plaster filling and having cheap substitutes for hard stone inlays or beads, since they were not called upon to suffer the abrasive wear of everyday life. Funerary jewelry, in fact, follows traditional designs which vary little from one age to the next, and which have been tabulated and often captioned in the pictures painted on the insides of wooden coffins in the First Intermediate Period and Middle Kingdom, as substitutes for the real things or as supplements of them.

Jewels could also be used as an extension of their magic powers to enhance the sexual attractiveness of the wearer, in the same way as dress and cosmetics were employed. It is when the adornment of the person becomes paramount that the artistic aspects of the jewel become as important as its amuletic significance. Thus fillets and circlets were devised more to keep the hair in a pleasing shape than to protect the head. The artificial cowrie shells in the girdle around the waist (22) could be filled with rattling pellets to give forth a seductive tinkle as the wearer swayed her hips in walking. Cunningly designed anklets and bracelets could enhance a slender limb or disguise a thickened joint.

For such aids to beauty, wreaths, chaplets and collars of fresh flowers were an inevitable choice; and the industry of the florist must have been among the earliest and longest-lived in Egypt. A lotus bud was usually tucked in the hair of guests at feasts (56). Collars made by sewing flower-petals, leaves, fruits and seeds onto semicircular or penannular sheets of papyrus or strips of palm leaf were supplied as ephemeral decorations. Even the boatmen in the marshlands would take a handful of dripping water-weed with all its twined flowers and weave it into a chaplet to keep the hair in place against the gusts of the strong north wind. On gala days they might stick lotus blooms into such fillets and hang wreaths of the freshly picked flowers from their necks.

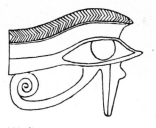

Wedjet eye

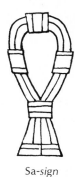

Sa-*sign*

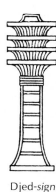

Ankh-*sign*

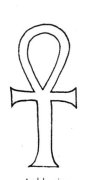

Djed-*sign*

Tyet-*sign*

Herdsman from a painting in the tomb of Itet at Meydum

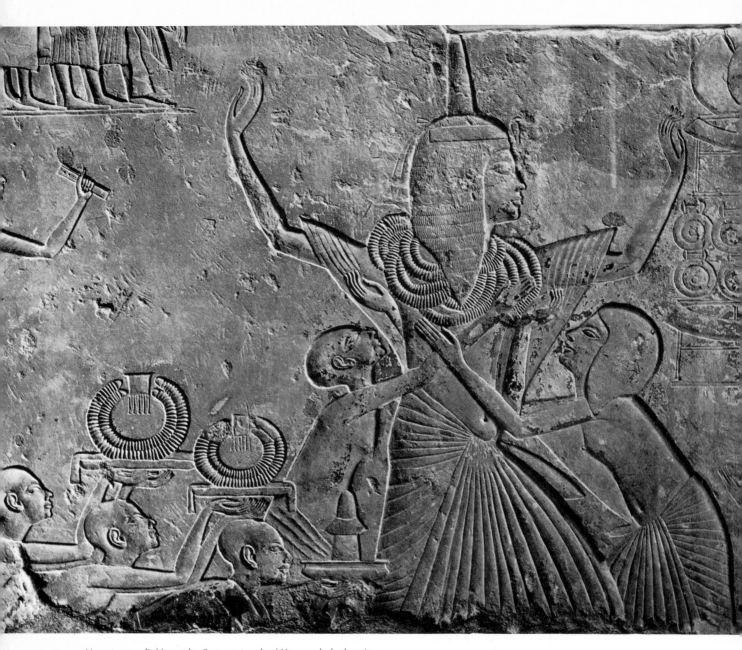

Limestone relief from the Saqqara tomb of Har-em-hab showing him receiving many gold collars of honour from the King. XVIIIth Dynasty. Rijksmuseum, Leyden

The jewellers early contrived to translate into less transitory materials the colour and design of such natural forms, and their creations underwent a constant development. Perhaps the two crowns from Dahshur (*13, 14*), one a naturalistic transformation and the other a more stylized interpretation of the floral archetype, are among their outstanding triumphs in this field. It is perhaps not without significance that the generic Egyptian word for 'jewelry' appears to refer to imitation plants and flowers.

As elsewhere, jewels could also be used to exhibit the status and wealth, and therefore the power and prestige, of the owner. In *The Lamentations of Ipuwer*, the sage, in describing the effects of political decay and social revolution during the twilight of the Middle Kingdom which have turned his world topsy-turvy, bewails that 'gold and lapis lazuli, silver and turquoise, carnelian (?) and amethyst are hung around the necks of slave girls while noble ladies walk through the land and house-mistresses are forced to beg.' Rich jewels in ancient Egypt could not be displayed on any scale of magnificence except as the rewards of the king: and it is clear that, as in modern Europe, one of the responsibilities of the Court jewellers was the making of valuable orders and decorations for bestowal by the Pharaoh upon favoured officials.

The Order of the Golden Collar was perhaps the oldest of such honours, and one of the treasure chambers of Sahu-re's funerary temple has provided us with an early record (c. 2475 BC) of the investiture by the king of his courtiers with collars, diadems and seals under the general description of 'The Award of Gold'. Sabni, one of the border barons of Elephantine, boasts how he was summoned to the Residence in Memphis and there decorated with 'the gold of favour' by Phiops II for leading successful missions into Nubia and the Sudan (c. 2200 BC). It also seems to have been the practice for the great feudal lords during the Old Kingdom to ape their king in rewarding followers with gold ornaments. Thus Neb-em-akhet, a son of King Mykerinos of the Fourth Dynasty, presents gold necklaces to dancers who entertain him on a relief in his tomb. In the New Kingdom, the 'gold of honour' had taken a different form and strings of gold disk beads (*shebyu*; 36) were hung around the necks of the persons whom the king wished to honour on special state occasions. In some representations the recipient is shown bowed down under a number of such necklaces. Even in the fourth century BC a so-called Neo-Memphite relief in Cairo shows the award of gold collars of the earlier type; and it would be rash to claim that this is a purely fictitious scene harking back, in the archaistic manner of such reliefs, to an event which existed only in the past.

Another mark of rank was the Order of the Golden Fly, which first makes its appearance during the early New Kingdom under increased influence from Asia. This award, which appears to be of military significance, was given particularly for valour, and the soldier Ah-mose-pen-Nekheb, who fought under the early kings of the Eighteenth Dynasty, boasts that he received no less than six flies from Tuthmosis I. The order could apparently also be given to women, for Queen Ah-hotpe, who rallied the Theban forces at a critical moment in the struggle against the Hyksos hegemony, had three large boldly designed flies among her treasure (41). One at least of the queens of Tuthmosis III was buried with a necklace of small flies also in gold. Gold lions and bracelets were included in such rewards, which together with other valuable objects in precious metals, such as parade weapons, took the place of money in an age when coinage did not exist.

Such jewels were the work of craftsmen attached to the Court and were generally distributed by the king, particularly on such ceremonial occasions as his coronation and jubilees. In the tomb of Kheruef at Thebes, for instance, there is a scene showing Amenophis III presiding at the distribution to his officials of decorations or rewards in the form of gold fishes, birds and plants during his First Jubilee. The king, as the wealthiest and most active of patrons, would give constant employment to his gold-

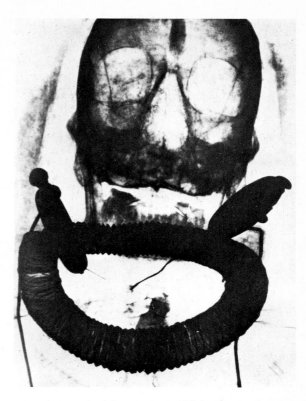

X-ray photograph of the upper part of the unwrapped mummy of Kha, showing him wearing jewelry beneath his bandages, including earrings and a shebyu *necklace of heavy metal beads probably of gold. XVIIIth Dynasty. Turin Museum*

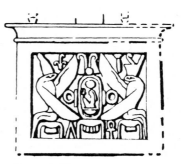

Pectoral of Surero

Pectorals of Kheruef

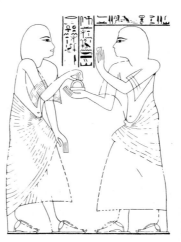

Huy receiving Tut-ankh-amun's signet

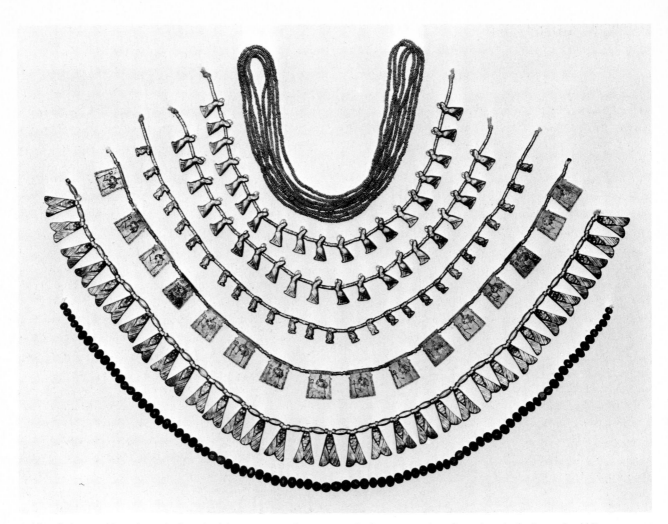

Gold and silver necklaces from the burials of three queens of Tuthmosis III. The top string is of beads each made of five gold grains soldered around a central hole. The second string from the bottom consists of pendants in the form of gold flies. XVIIIth Dynasty. Metropolitan Museum of Art, New York

smiths and jewellers. They had to prepare complete parures not only for himself on his accession but also for his wives on their marriage to him, unless they were the daughters of foreign potentates, in which case their personal ornaments were evidently supplied by their fathers as part of their dowry. Nevertheless the three Syrian wives of Tuthmosis III had only one or two items of un-Egyptian design and nearly all their jewels bear the name of their husband who must have provided them. Gifts in the form of jewels, particularly of gold, were sent with despatches to foreign potentates who sometimes commissioned work from Egyptian craftsmen.

The funerary jewels of the king and his relations would also have to be prepared as part of his burial equipment from the first years of his reign, and these would be of a more traditional and less individual design than the ornaments worn in everyday life. At the king's jubilees it would appear that new jewels were made; and both Surero and Kheruef are shown presenting pectorals to Amenophis III on the occasion of that monarch's jubilee.

We are also fortunate in having several of the carved gems made for insertion in gold bracelets for this same celebration. One specimen shows the diminutive figure of the donor, a high official, holding his fan of office behind Queen Tiye, and gives evidence that on such great occasions valuable gifts were offered to the Royal Family by their courtiers, either from their bounty or by virtue of the duties of their office.

Lastly, jewels could be made for purely utilitarian reasons. Massive cylinder seals of gold or hardstone mounted in gold and bearing the king's name were conferred on those high officials who were to act in the name of the Pharaoh during the Old and Middle Kingdoms. In the New Kingdom the seal was replaced by a heavy signet ring, the bezel of which bore the king's cartouche. Probably also to be included in this category of objects of utility are the *menyet* necklaces and counter-poises that were carried by great ladies or priestesses as symbols of their devotion to the cult of the goddess Hathor or her avatars.

3 The Materials

Gold was the ineluctable material from which Egyptian jewelry came to be fashioned. Modern precious metals such as platinum, rhodium and palladium were virtually unknown to the ancient world, but their shining white appearance could be achieved by various alloys of silver and gold occurring in the natural state. The qualities that made gold so desirable have already been enumerated. It could be won and worked with comparative ease: it did not decay or tarnish in use but was indestructible, and its warm colour seemed to reflect the fire and brilliance of the sun. Egypt was fortunate in having within its boundaries immense deposits of gold, the richest by far of the ancient world. Modern experts, investigating the skill and diligence with which the ancient gold-fields were exploited, have reported that the Egyptians were very thorough prospectors and miners. No workable deposits have yet been discovered that they overlooked. It seems clear that by the Nineteenth Dynasty they had exhausted the more accessible supplies, for both Sethos I and Ramesses II had to open up mines deeper in the Eastern Desert, where wells supplying subterranean water required for the washing of the crushed ore and the sustenance of the workers could not easily be found. A map on a damaged sheet of papyrus from this period shows some mines, probably in the Wady Hammamat.

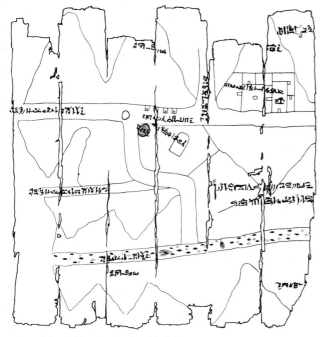

Map of the gold mines in the Wady Hammamat

Much of the gold, and certainly that which was won in earliest times, was found in metallic form as shining granules among sands and gravels. Its collection and melting into larger rings or ingots were not difficult processes and well within the ability of primitive peoples. It is possible that much of the gold levied in the New Kingdom as an annual tax upon Nubia and the Lower Sudan, as well as upon certain towns in Upper Egypt such as Koptos, Edfu, Esna and Hierakonpolis which had connections with the Eastern Desert, was collected in this way. It is shown in tribute scenes either as ring-shaped ingots or as gold dust contained in red leather bags. Minimum amounts appear to have been fixed every year and such metal entered into the state magazines, whether of the king or of the larger temples. It is also probable that a certain amount of gold won by the same processes found its way by private trading into the free market to be used for the jewels of those citizens who could afford such luxuries.

Later and more advanced methods of mining involved the extraction of gold from veins in quartz rock, which had to be fractured by quenching areas previously heated by fire, pounding and grinding the broken portions, and panning the powder to separate the heavier metal particles. Such work was very laborious and performed, at least in Ptolemaic and Roman times, by criminals. Earlier the army, which was often used as a labour force, may have been employed on such work as well as captives.

Egyptian gold contains impurities mostly in the form of silver, which, when it amounts to as much as a fifth of the whole, becomes the pale amber-coloured alloy, electrum (Greek: *electron*). A higher proportion of silver produces a white metal indistinguishable in appearance from silver. Egyptian gold also contains varying percentages of other metals, chiefly copper, iron and sometimes platinum. It is clear that in remote antiquity goldsmiths must have relied upon colour and surface appearance for their assays, since they speak in one place of 'green gold' by which they presumably mean gold containing a fair proportion of silver. The Amarna Letters show that gold was tested by casting it into a furnace whence it did not always emerge weighing as much as it did before. This would suggest that, by the New Kingdom at the latest, the refining of gold was understood and carried out presumably by the cupellation process. Since at this period the smelting of bronze from copper and tin ores was widely practised, it is probable that improved metallurgical skills led to the discovery that

alloys of gold such as electrum could be artificially produced. By the end of the Eighteenth Dynasty the Egyptians had certainly learnt to make an alloy of copper and gold which would hardly appear in nature (60), and it is reasonable to suggest that similar experiments were conducted with other metals. As a result of the passage of time much ancient goldwork has acquired a grey, reddish brown or plum-purple patina due to the tarnishing of the copper, iron and silver components. It is evident, for instance, that in some of the jewels of Tut-ankh-amun (64, 65) gold was selected which has radically changed its colour over the centuries, very probably as the result of the deliberate introduction of other metals to alloy with it. This explains why the Babylonian rulers were not averse to casting into the furnace the gold they received from Egypt to see whether it was as pure as it pretended to be.

Some goldwork during the New Kingdom from the Amarna Period until the end of the Ramessids (i.e. from 1370 to 1080 BC) has a shining rose-purple patination, which so far from being the result of slow chemical change over the centuries is an intentional effect apparently achieved by introducing iron salts into the metal at some stage of manufacture (84, 94, 97). It has been plausibly suggested that the addition of 'fool's gold' (iron pyrites) to the metal while it was being melted may very well have achieved this distinctive coloration which is due to a very fine film of iron oxide on the surface of the gold. Such coloured goldwork or the secrets of its manufacture evidently came from Asia, for one of the Amarna Letters from the King of Mitanni, listing the gifts that he was sending to Amenophis III, speaks of ornaments of gold 'through which blood shines'. The Egyptian name for this coloured gold is unknown. Some specimens, such as the openwork ornaments of Tut-ankh-amun, show both the pink colour of the treated metal and the yellow gleam of the natural gold, but this could easily have been achieved by scraping away the extremely fine film of oxide in selected areas.

Electrum was a naturally occurring alloy of gold and silver imported from the Eastern Desert and from the land of Punt, believed to have lain somewhere on the Somali coast. The evidence suggests that in earliest times its relationship to gold was not properly understood and it was classified as a separate metal. By the New Kingdom, however, it is almost certain that it was being produced artificially.

Silver to the ancient Egyptian was another form of gold, for he called it 'white gold', which should not be confused with its modern counterpart made from gold alloyed with nickel or platinum. In this, the ancient Egyptian seems to have spoken truer than he knew, for nearly all the silver found in the Old and Middle Kingdoms has a high proportion of gold in its composition varying from as much as 38 per cent down to 9 per cent. The name given to the metal by the Egyptians suggests that it was found in association with gold and it is in fact a low grade of gold containing so much silver as to be grey-white in colour. The metallurgical techniques required to smelt silver from its ores were probably not within the knowledge of the Egyptians at this period, and most Egyptian silver shows specks of gold unevenly distributed over its surface. The discovery that silver could be obtained from smelting argentiferous lead ores appears to have been made in Western Asia whence it began to be imported, particularly from the time of the New Kingdom onwards, though the Treasure of Tod, a deposit mostly of silver objects and ingots contained in four boxes bearing the names of Ammenemes II (obit. c. 1895 BC) and buried under the foundations of a Middle Kingdom temple, bears strong evidence that it derives from an as yet unknown Asiatic source.

Silver was rarer than gold in Egypt and was probably for that reason more highly prized until the Middle Kingdom, when imports from Asia began to arrive. The bracelets of Queen Hetep-her-es of the Fourth Dynasty (3), though massive in appearance, are actually thin shells of silver, whereas the gold on her furniture was lavishly applied. Even at the time of Tut-ankh-amun little silver was used in his funerary equipment, the only sizable pieces being one of the trumpets and a vessel in the form of a pomegranate, though at least three silver jugs and a seal on a chain had been stolen from it, according to a label listing the contents of a broken box. The amount of silver buried on ancient Egyptian sites, however, was originally far greater than what has been recovered because, apart from losses due to plundering, silver unlike gold corrodes in contact with salt-impregnated soils, and cannot be restored if mineralization is complete.

Gold, electrum and to a lesser extent silver were the noble metals used for setting the gemstones which we would now classify as no more than semi-precious. The Egyptian chose them for their rich colours, not their refractive powers, and the classic trio that formed the basis of his colour schemes for jewelry were the blood-red carnelian, the vivid blue-green of turquoise and the deep cerulean blue lapis lazuli. The lust to possess such stones sent Egyptian prospectors into the Eastern Desert, where carnelian pebbles could be picked up without much difficulty, and into Sinai where turquoise had to be mined laboriously from veins in sandstone outcrops. Lapis lazuli, however, was not found within the borders of Egypt and had to be imported from the Euphrates area whither it had been traded from Badakhshan in Afghanistan. It has been suggested that the Egyptian name for the stone, *khesbed*,

is a variant of this toponym. These hardstones were not only used for inlays but also for beads, in which form they are known from the predynastic period, an indication of the extreme antiquity of trade routes.

A list of craftsmen in a papyrus in the British Museum mentions a *mes'at* or 'purveyor of precious stones', who may have been a sort of prospector roving the desert and collecting its produce, whether animal or vegetable as well as mineral. In addition to carnelian, other red stones capable of taking a high polish were sought out, such as red jasper and garnets which often occur in nature in the form of dodecahedral crystals; it requires very little working to turn them into beads. Often the garnets are shed from their matrix by weathering and form beaches of spheroidal stones which need only to be perforated to become beads. Egyptian garnets which are found at Aswan tend to be too small for use, but larger specimens came from Western Sinai. The popularity of garnets in the Middle Kingdom may have been due to the intensive exploitation of minerals in Sinai during that period.

An alternative stone used in place of turquoise is green felspar (27), the Amazon Stone, of an opaque rich green tint, which is sometimes distinctly blue, and is easily broken along its two dominant planes of cleavage. A broad seam of the stone with evidences of ancient working has been found in the Eastern Desert. It was used for beads, particularly during the Middle Kingdom, and was still being employed for amulets and inlays during the time of Tut-ankh-amun.

Amethyst, which occurs in cavities in granite rocks, was used exclusively for beads and pendants, and occasionally for scarabs, even as late as the reign of Tut-ankh-amun (69). Though its popularity was greatest at the time of the Middle Kingdom, it appears as early as the First Dynasty in one of the bracelets of King Djer (c. 3000 BC) (1). It is, however, a stone of a colour that has to be used with discretion and it says much for the restraint of the Egyptian jeweller that he refrained from employing it as an inlay. Ancient amethyst workings have been found in the Aswan district, the Eastern Desert, and in the region of Abu Simbel. The rhomboidal crystals of the stone can be weathered or ground into ovoid or spheroid shapes, which were most commonly worked into beads.

Other stones used sporadically in Pharaonic times were yellow, green and brown jaspers, rock crystal, obsidian, banded chalcedony and calcite. The beryl is found only in jewelry of Hellenistic date.

From earliest times the Egyptians tried to find natural and artificial substitutes for their classical gemstones. By the time of Tut-ankh-amun they were using Iceland spar, a pure and transparent form of calcite, and rock-crystal, both backed by coloured cements as inlays (64, 66, 70, 71).

But their greatest need was for a dark blue substance which imitated the expensive imported lapis lazuli, and their search for such a substitute was pursued with all the diligence that European chemists in the eighteenth century AD exercised in their endeavours to imitate Chinese porcelain. In predynastic times they had discovered not only how to coat soapstone with an alkaline blue or green glaze but also how to fire powdered quartz into a compact substance covered with a gleaming vitreous glaze coloured green and blue from copper compounds. Later they developed black, red, white, yellow, and lilac glazes on the same body. Such materials could be easily carved or moulded into beads of various shapes and sizes.

In certain circumstances, with a greater proportion of alkali and rather higher temperatures, small quantities of the ingredients used in faience-making will fuse into a bright blue or green frit which, when ground up, can be used as a glazing substance or as a pigment. By the Fourth Dynasty at the latest, the Egyptians had succeeded in making a crystalline lapis blue material which owes its colour to the presence of copper calcium tetrasilicate. This substance, generally known as 'Egyptian blue', the *coeruleum* of Pliny, was exported to Rome in Imperial times where it was used as the standard blue pigment for wall-paintings, and only disappeared finally from the artist's palette in the seventh century AD. It is probable that the blue inlays used in some of the jewelry from Lahun and Western Thebes were of this substance (25, 26, 51), though they had changed to a whitish powder in the damp mud that eventually buried them.

Frit is a form of glass, and isolated examples of glass as beads are found from the Fifth Dynasty to the beginning of the New Kingdom, the most notable example perhaps being the string containing small bright blue glass specimens together with silver, carnelian and green felspar found on the neck of an infant of the family of King Mentu-hotpe II (c. 2050 BC). The introduction of glass on an ambitious scale as an intentionally made material occurs only in the New Kingdom, the earliest datable pieces bearing the name of Tuthmosis III. The royal patronage of the new craft is seen in the proximity of glass factories to the palaces at Thebes, Amarna and Ghurab. It is probable that the making of glass in any quantity had to await the invention of the bellows-operated blast furnace, and increased interest and experimentation in the fusion of different ores which must have marked the introduction of bronze on a wide scale in Egypt during the New Kingdom, when copper was displaced as the metal in general use. From the fact that the blue colour of Egyptian glass often comes from cobalt compounds which are not found in Egypt, it has been deduced that glass was not an Egyptian

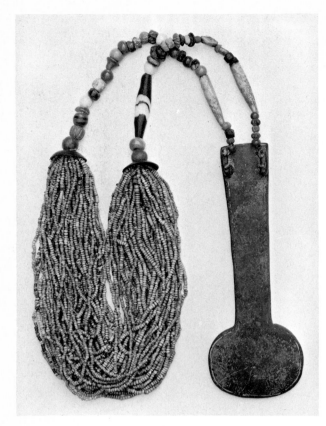

Menyet consisting of a thick necklace of faience beads connected by two strings of glass and stone beads to a bronze counterpoise. XVIIIth Dynasty. Metropolitan Museum of Art, New York

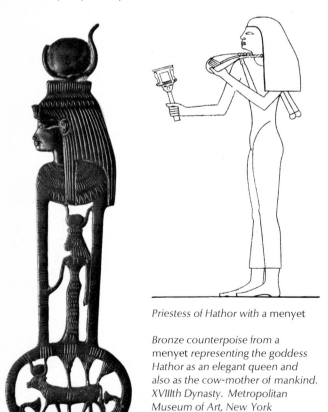

Priestess of Hathor with a menyet

Bronze counterpoise from a menyet *representing the goddess Hathor as an elegant queen and also as the cow-mother of mankind. XVIIIth Dynasty. Metropolitan Museum of Art, New York*

invention despite its occasional and accidental emergence as a by-product of the making of faience.

Ancient Egyptian glass is a soda-lime silicate, not dissimilar in composition to modern glass, but containing a lower proportion of silica and lime. It was, however, usually opaque, though it is sometimes translucent and even occasionally transparent. Its main quality, when it is found in a good state of preservation, is the brilliance and intensity of its colours, yellow, white, black, red, green, dark blue, light blue and greenish blue. The Egyptian found that in glass he could produce a number of close imitations of his classic gemstones, and he used them in his jewelry with enthusiasm, as so many of the furnishings from the tomb of Tut-ankh-amun bear witness. That the Egyptian was deliberately trying to imitate stones as much as creating a new substance is seen in his description of glass as 'melted stones'. Lest it be thought that 'glass' with its modern connotation suggests a rather cheap and inferior product, it must be emphasized that Egyptian glass, despite its brilliant colours, lacks a sparkling surface, and the minute bubbles of captive air give a texture to the substance which often makes it difficult to distinguish from that of the stone it is trying to imitate. Some of the objects from the tomb of Tut-ankh-amun have, for instance, been catalogued as inlaid with lapis lazuli, carnelian and felspar, when glass simulating those stones would have been a more accurate description (78).

It is evident that the materials for Egyptian jewelry came almost exclusively from minerals mined or picked up in the Eastern Desert or Sinai. The early prospectors had no scientific means of distinguishing between various substances except by colour and hardness, and for this reason they included gold and silver in the same category as their precious stones, though they gave precedence to the former. On the other hand, naturally occurring gemstones are followed in the offering lists by the base metals, and they in turn by the artificial stones, suggesting that the Egyptians realized that the last two classes of substance could both be made by smelting various ingredients which were very different from the resulting products.

It also suggests that the Egyptians regarded man-made products as inferior to those that the gods had provided. The chief deity of the deserts, from which all the beautiful materials of jewelry came, was Hathor, the goddess of love and beauty. She was particularly associated with jewelry and it is perhaps significant that her priestesses carried an elaborate *menyet* necklace as a symbol of her cult. She was also the patron of miners and prospectors who roved over the region and exploited its minerals.

4 The Craftsmen and their Tools

In the so-called *Satire on the Trades*, which the Egyptian schoolboy was expected to copy as part of his onerous training, and in order to encourage his flagging resolution, the privileged lot of the scribe is contrasted with that of less favoured workers. 'I have never seen a goldsmith sent [on an important mission]', declares the author, 'but I have seen the metalworker at the mouth of his brazier. His fingers were dried and wrinkled like the skin of a crocodile, and he stank worse than the roe of fishes.' Such lampoons tend to obscure the esteem that was felt for the craftsmen who produced jewels in such abundance for their wealthy clients. Apuia, one of the chief goldsmiths of Amenophis III, was influential enough to build a handsome tomb for himself in the necropolis of Memphis; and his son, Pa-ren-nefer, who held a like office under Akhenaten, not only had a large sculptured tomb at Thebes, but an equally important one at Amarna. Pa-ren-nefer, in fact, was sufficiently intimate with the king to be appointed his cup-bearer.

It may well be that the apprentices and journeymen who actually sat over the heat of their charcoal braziers manipulating their blowpipes and tongs were inferior in the social scale to the artists who designed the jewels and supervised their manufacture, but they were certainly not unprivileged. The favoured position and modest affluence enjoyed by the mortuary craftsmen of Deir el-Medina suggest that all similar adepts at highly regarded trades could command the respect and purses of their patrons.

The gold deposits in the deserts bordering Egypt and Nubia were the most considerable of the ancient world and it is probable that the techniques of extracting the metal and its alloys and working it were largely Egyptian

discoveries. Such knowledge would have been handed down over the centuries from father to son as a closely guarded mystique; and while there is no evidence for the existence of guilds of goldsmiths it is probable that the craft of the jeweller remained in the hands of a limited number of families working in one or two favoured localities. It is to be suspected, for instance, that the ancient northern capital Memphis, with the artificer Ptah as its patron deity, housed the most important goldsmiths' quarter, a tradition which persisted in medieval times and survived until recently in the metalworkers of the Cairo bazaars. It is also not improbable that accomplished workmen from other areas of the Mediterranean may have been attracted to this centre, drawn by the demand for jewelry, and the opportunities for patronage at a period of high culture and prosperity. As gold was a precious material, and its control and use the chief interest of kings, goldsmiths were a privileged community who worked mostly in royal workshops, or those attached to cults under royal protection. If their patrons withdrew their support for any reason, such as anarchy, conquest or impoverishment, the goldsmiths could migrate to where-ever their luxurious trade was welcome. By the New Kingdom it would seem that the goldsmith's techniques were practically universal over the Near East, and it is sometimes difficult to claim certain goldwork found in Egypt as exclusively native in design and manufacture (46, 48).

Besides the king, such wealthy patrons as the gods of the larger cities, particularly Amun of Thebes, employed goldsmiths in their workshops. Three overseers of goldsmiths were rich enough to have tombs in the Theban necropolis, while the exact location of five others has been lost. In addition it is known that two other goldsmiths, perhaps connected with the Court, had tombs at Thebes. A number of relatively expensive monuments made for goldworkers are scattered among the world's collections. Such men were doubtless highly skilled craftsmen, but they were not necessarily the designers of the jewels that they were called upon to make, apart from those of traditional pattern which varied little from one generation to the next. The designs of Court jewels would have to be changed, in some particulars at least, with each reign; and original artists might very well have added striking novelties to the old stock of patterns. The Dahshur and Lahun jewels show how changes could be rung on familiar themes. All the pectorals differ in their designs with the

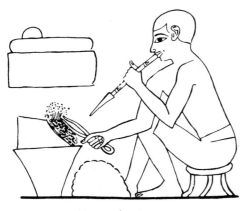

Man at a brazier

exception of one belonging to the Princess Sit-Hathor-Yunet, which appears to be a copy of an earlier model, and made by an uninspired workman (24, 26).

The chief jewellers were doubtless literate men who had had the general training of a scribe but had specialized in the decorative arts. They probably knew all the techniques used by the goldsmiths and lapidaries though they may not necessarily have been proficient in them. The chief sculptor Neb-Amun, who lived under Amenophis III and was evidently a designer who could produce the drawings and cartoons for all objects of applied art besides sculpture, is shown in the paintings in his tomb examining the products of metalworkers, joiners and other craftsmen, which are brought to him for his inspection and approval. The Second Prophets of Amun at Thebes during the New Kingdom seem to have had special responsibilities for supervising various constructions and commissions on behalf of their king as well as their god. Thus paintings in the tombs of some of these officials show them examining the work of several craftsmen in the workshops attached to the temple of Amun, including the goldsmiths' ateliers where the weighing-out of the gold and silver to be allocated to the various jobs is done under the eye of one of their officers. The rich funerary equipment, embellished with gold and silver inlaid with semi-precious stones and coloured glass, which Amenophis III provided for his parents-in-law, was made under the supervision of their son, the Second Prophet of Amun, though unfortunately

the valuable jewels that must have been supplied as part of the gift had been stolen by the time the tomb was discovered in 1905. There is even some evidence that Tuthmosis III may not have disdained to design a set of vessels for the treasure he dedicated to the temple at Karnak. Certainly the chief sculptor of Akhenaten confesses that the king himself instructed him. This probably means that Akhenaten also stipulated the design of the jewels which he presented so lavishly to his family and friends.

In the Old Kingdom, it would appear that the chief priests of the artificer god Ptah of Memphis, who bore the title 'Greatest of Craftsmen', were responsible for the designing of works of art both great and small, including jewelry. In reliefs of this period, dwarves are frequently shown handling the finished ornaments. In view of the fact that Ptah can appear in the form of the dwarf Patek, such dwarves may have had some connection with the making of jewelry; but it is more likely that, as they were chiefly employed as valets and personal attendants upon the Royal Family and high Court officials, they were more concerned with assembling and storing such adjuncts of clothing in their masters' wardrobes.

The jewellers *par excellence* were, of course, the gold- and silversmiths, as is the case even today, but a list of craftsmen in the Hood Papyrus already referred to, shows that there were minor specialists among this group of workers. Thus the *nuby*, or goldsmith, is immediately

A workman of the Chief Sculptor Neb-amun weighing out gold rings (against a bronze ox-head weight) which are to be made into such objects as the vessel and collar seen in the basket behind him. Tomb No. 181 at Thebes. XVIIIth Dynasty

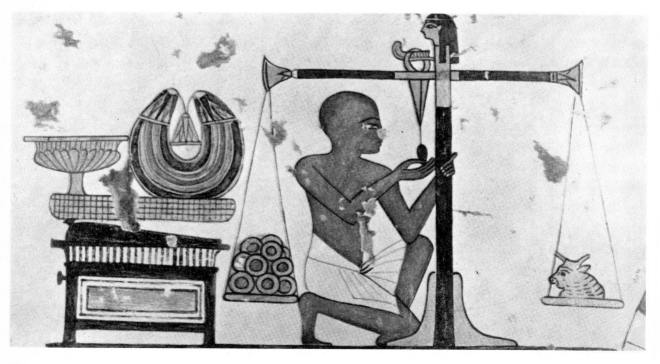

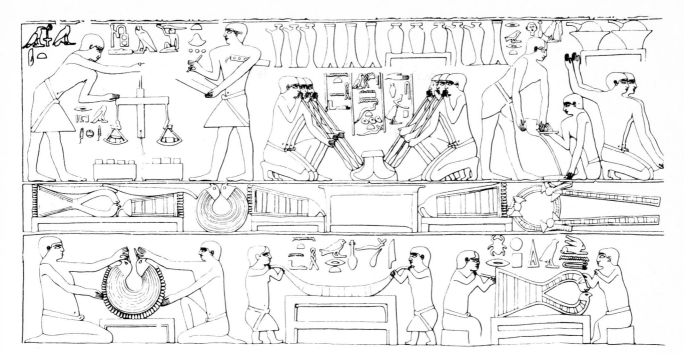

Goldsmiths at work

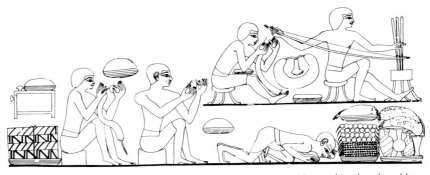

Men making bead necklaces

followed by the *neshdy*, or worker in precious stones, whom today we would call a lapidary since his products were suitable for inlaying in wooden and stone furniture besides metal settings. There was also a *baba*, or faience-maker, a firer of glaze, who practised the art of firing a quartz paste into moulded shapes generally with a brilliant blue or green glassy surface, but later in other colours as well, or combinations of two or more colours in the same piece. In the New Kingdom he doubtless added the new-fangled art of making glass to his repertoire of skills. Another member of the jewellers' fraternity was the *setro* who appears to have been a maker of necklaces, a skilled occupation as anyone will know who has attempted to reconstruct an Egyptian 'broad collar' from its component parts. He made use of the products of the *iru weshbet*, or bead-maker; but whether this particular workman was restricted to making beads in glass and faience, in which case he would have been a specialist kind of *baba*, or whether he worked and drilled the precious stones of the *neshdy* is unknown, although the latter is sometimes

Man threading beads

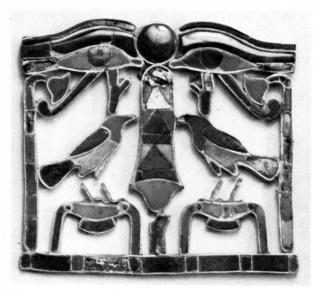

Jewelry excavated from a private tomb at Rikka: gold inlaid with carnelian, turquoise and lapis lazuli. The bivalve shell is entirely of gold with the name of Sesostris III supported by uraei formed in wire and soldered to its face. The pectoral shown back and front is based upon a royal design with crows (?) taking the place of the king's falcons. XIIth Dynasty. Manchester Museum

found drilling beads. The enormous number of beads that were produced in Egypt from all kinds of materials and which give its jewelry so much of its characteristic form and appearance, suggest that the *iru weshbet* were many and industrious.

In reliefs and paintings the jewellers are shown working side by side with metalsmiths and joiners, apparently in the same ateliers. This was probably because close supervision was exercised over all those workers who had to use gold, silver and to a lesser extent bronze, in the objects they made. The gold and silver are shown being carefully weighed out and recorded for issue to the craftsmen, and doubtless they were strictly accounted for. We know that when the Pharaohs sent jewels and other valuable gifts to their brother monarchs in Asia, they took care to mention the amount of gold and silver that had gone into their making.

Supplies of gold and silver appear to have been reserved for the king or the temples of the gods, such as Amun, to whom the Pharaoh had allocated gold-bearing tracts in the Eastern Desert and in Nubia. Nevertheless a certain amount of gold must have been allowed to reach private hands, for even the modest burials that have been found unrifled often yield up articles of gold in the form of amulets, beads or jewels. Gold could also be worn as gifts of the king, such as orders, decorations and parade weapons; and the bullion with which he rewarded meritorious henchmen could be made into jewels. It is clear that private persons besides the Court and the gods could legitimately own articles of gold, because otherwise the robbing of tombs would have been rapidly detected, and the culprits instantly identified. It is probable, therefore, that in addition to working in the studios attached to palaces and temples, the jewellers also did a certain amount of private work in their homes, in very much the same way as the workmen of Deir el-Medina made tombs and monuments for themselves and similar clients when they were resting from their labours on the royal commissions which were their *raison d'être*.

The tools used by the jewellers were of the simplest and most primitive kind. Their furnace was a pottery bowl upon a stand filled with glowing charcoal. Their blowpipe was a reed tipped with a clay nozzle which would need to be renewed frequently. Yet even with such a crude instrument it would have been possible to raise the temperature of a metal object heated on the brazier to a critical point in selected areas sufficiently high to make hard solders melt and run, and even to fuse the metal being worked if insufficient skill was exercised. It is clear that the craftsman could have had only a very imperfect control of the heat, and it is astonishing that he achieved so much with such primitive implements. Nevertheless he

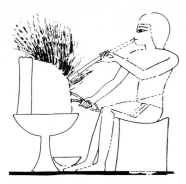

Man at a brazier

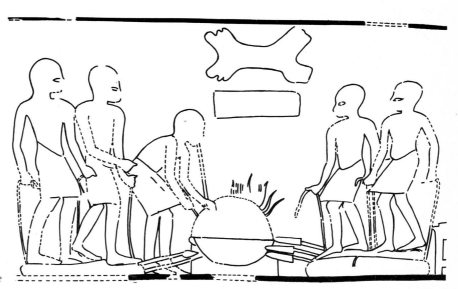

Blast furnace

was well aware of the different melting points of various solders and selected them with the size and nature of the job in view. When a larger mass of metal had to be melted, a squad of men would bring their several pipes to bear upon the fire beneath a clay crucible; by the time of the New Kingdom, however, a blast furnace had been introduced worked by leather bellows actuated by the feet and cords similar to that used by native smiths in Africa in recent times. Metal had to be melted in such large crucibles either in order to convert gold dust, ingots or scrap into larger masses that could be subsequently beaten into sheets, or to provide a pour for casting into moulds of clay. The crucibles were lifted off the fire by two springy rods, presumably green sticks, clamped at both ends.

Gold and silver were hammered by polished pebbles held in the hand; and simple as this tool may appear, it would have been entirely effective, the domed head of the stone having the same expanding impact as the collet head of a modern raising hammer, while the flat faces could be used for planishing. The stakes on which vessels are shown in the process of shaping must have been of wood; so are the blocks on which gold and silver are being beaten into leaf. Perhaps such blocks were covered with skin to deaden the jarring effect of beating with a stone held in the hollow of the hand on an unresilient surface.

Such simple tools are the only ones shown in the hands of metalworkers in the reliefs and paintings. Nevertheless in New York there are two hammer heads of identical shape, one in bronze and the other in limestone, similar to a modern blacksmith's hammer with a flat surface at the proximal end and a tapered wedge-shaped cutting edge at the distal. It is most likely that the limestone specimen, at least, was used for working soft metals such as gold.

The place of the modern file was taken by abrasive stones of various degrees of fineness, made from sandstone and quartzite. Such implements used with fine quartz sand strained through the mesh of cloths of varying degrees of coarseness could also be used for polishing stones chipped into shape for inlays.

The ancient craftsman must have been considerably handicapped by the lack of an effective cutting device such as shears for trimming and shaping metal, which had to be punched with a bronze or copper chisel. Holes were usually made by pressing an awl into gold or silver sheet, though a bow-drill was used for drilling stones. The tongs shown in the hands of workmen seated before their braziers were almost certainly of bronze or copper. Despite such crude and imprecise tools, the Egyptian jeweller achieved results which are very seldom less than commendable; such marvels of craftsmanship as the Dahshur and Lahun treasures are truly astonishing.

5 Techniques

METALS

It is evident that with the crude tools at their command, only techniques of the simplest kind could have been employed by the Egyptian jewellers. The standards they achieved in their craftsmanship were dependent more upon skill of hand, the qualities of their raw materials and the time taken to complete a job than the precision and effectiveness of their implements. The settings of their jewels were normally made in precious metals, gold, electrum and, to a lesser extent, silver; and the processes employed by the jeweller are inseparable from those used by contemporary metalworkers.

As we have emphasized in the previous chapter the methods of Egyptian metalworkers appear to have been those in common use throughout the Near East. While the large deposits of gold in the deserts of Egypt and Nubia must first have been exploited by the natives of the region, there was probably always some opportunity for foreign techniques and styles to be introduced, particularly during the upheavals of the Hyksos invasions of the eighteenth century BC, when ancient states were modelled on new lines and new principalities appeared with fresh demands for the old luxury of jewelry and the trappings of sovereignty. In the New Kingdom, foreign princesses with their retinues of experts entered the harims of the Pharaohs as part of the diplomacy of the time. Such influences are probably responsible for inducing some scholars to see Helladic and Syrian influences in the metalwork of the period, particularly in that found in Lower Egypt (35, 36, 46, 48, 58). The explanations may well be that the metalwork of the entire area shows a generic similarity in its techniques and styles, though it appears to be more of Egyptian inspiration than any other.

The difference between the techniques of the jewellers and the metalsmiths is one of degree rather than kind. Raising and sinking metal plates upon stakes so as to hammer out beaker or dish shapes would indeed seldom have to be practised by the jeweller, but casting, repoussé, chasing and soldering would be among the skills he would daily be called upon to exercise. Here to some extent his burdens were lightened by his use of gold that was generally of a high carat, ranging from 17 to 22. Such metal is soft and malleable and has a higher melting point than gold alloyed with greater amounts of silver and copper. It allows solders to be used for joining various components of the gold setting without incurring too great a risk of fusing the metal being worked; and this was important where primitive blowpipes and braziers were used which could not control temperatures to any critical extent.

Gold received in the form of rings or bags of assorted granules had first to be made into sheets for most jewelry and this would be done by fusing the dust or ingots into larger masses in the blast furnace, pouring the melt onto a flat surface and hammering it out to a sheet of the required thickness. The gold beating would have the effect of making the metal hard and brittle, particularly if it were of a lower carat, and unless this springy effect was required it would have to be reheated from time to time in order to anneal it. In the absence of any tool resembling shears, the gold sheets would have had to be cut by scoring several times with a sharp implement such as a flint or hardened copper chisel, and, if the metal was thick, by bending it to and fro until it fractured along the score-marks. In the case of less extensive cuts or more complicated forms, the plate was trimmed to the required shape by means of a copper or bronze chisel, tapped with a wooden mallet.

Gold of a high carat is sufficiently malleable to be worked with tools of bone or even hardwood, and these may very well have been used for repoussé and chasing. For these processes, the plate with the design drawn upon it was mounted upon a bed of some firm yet yielding substance such as wax, or a mixture of wax, resin and mud, upon a board. What appears to be the remains of such a 'pitch-block', with a cast of the metal sheet that was once worked upon it, was found by the Germans in a sculptor's studio at Amarna in 1913–14. The outlines and interior linear detail could be pressed into the mounted metal with a tool of bronze or bone by the repoussé method. Such lines would appear on the reverse side of the plate as raised contours. Hollows hammered into the metal by means of a hardwood, bone or metal punch with a polished end that could be slid over the surface between each hammer blow, would appear on the reverse as raised domes. Repoussé is virtually the complementary process to chasing, being worked on the back of the plate instead of its face. By alternating the two processes the metal can be pressed and hammered into relief which, if necessary, may be more than half-round. At the same time fine detail can be indicated and sharpness and precision achieved in the drawing. The gold reverses of the pectorals from Dahshur and Lahun were worked by these processes.

Engraving, another technique of the goldsmith, involves the ploughing-out of a furrow in the metal with sharp

24

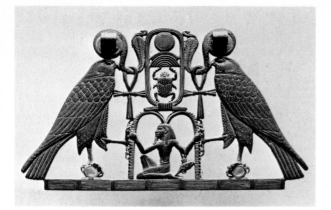

Pectoral of Sit-Hathor-Yunet, reverse, gold with details in delicate chasing. XIIth Dynasty. Metropolitan Museum of Art, New York

point. In view of the absence of iron or steel tools in Egypt until the Late Period, there has been some speculation about the nature of the burin used, and flakes of chert, obsidian and other hard and brittle stones capable of being chipped to a sharp point have been suggested. Stone tools of this type may have been used for carving and engraving hard substances such as ivory; but engraving weakens metal by scooping out trenches in its surface and is impossible on material which is thin in section. It would appear, therefore, that the Egyptians engraved metal only when iron became common. Until then, fine detail was added by delicate chasing.

Besides working flat sheet into raised relief by repoussé and chasing, it was also possible to press, hammer or burnish thin metal into dies cut in lead, stone, wood or pottery. Such a method was employed where a great number of simple standard shapes were required, as for instance in metal beads or elements used in the stringing of collars or girdles. It would seem that hollow metal beads were made by working sheet into a die cut with a bowl-like depression, perforating the hemispheres so formed with their thread holes, trimming their edges and soldering them together along their adjacent large circles. Where a solid result was required, the two halves of such shells were filled with a fine compact clay before soldering could take place.

As the complementary process, sheet gold could be worked over a pottery, wood, stone or metal positive formed as a core that could be withdrawn, provided there were no undercuts, to leave a shell of metal reproducing the likeness of the original, but larger by the thickness of the metal sheet. Such a process was used where the shape was more complex and difficult to cut into intaglio in a die (*31, 32*). It is probable that the heads of the goddess Bat on the mirrors and caskets of the Lahun and Dahshur jewels were made by this method. The Egyptians as early as the

Archaic Period were able to make copper statues by hammering sheets of metal over a wooden core retained within and such work must have made them familiar with the moulding effects they could obtain by this means. In the case of gold shells made by the same method, additional detail and depth could be added by chasing and repoussé.

The Egyptians were also familiar with the modelling effects of stamping moulds into wet clay sealings, and must have tried to secure a similar effect by interposing a thin sheet of gold between the stamp and a soft impressionable substance such as clay, and exerting additional pressure by striking the stamp with a hammer. The uniform results so achieved by the operation of the same stamp could also, of course, have been enhanced by chasing the metal impression. It would seem that the gold amulets used for funerary purposes, and generally of a rather simple and flimsy construction, were made by this method.

Strips could be cut from metal sheet by scoring or by cutting with the chisel, and if they were made sufficiently thin would assume the form of a wire triangular or square in section. This raises one of the problems of ancient technology, whether the Egyptians knew how to draw such strips into wires of circular cross-section, or whether they employed a technique, familiar in Hellenistic times, of winding a thin strip of gold upon a mandrel, such as a length of thread, subsequently withdrawn, in the same way as paper drinking-straws are made. The tube so formed could be made smaller in diameter by tighter coiling. Another and easier method more generally employed in the Hellenistic age is 'block-twisting', by which a strip of metal of square or rectangular cross-section was twisted about its major axis, resulting in a solid wire with a screw thread of variable pitch. The preparation of such wire would require frequent annealing. A finish was imparted by rolling it between flat surfaces which, if sufficiently vigorous, could almost eliminate the spiralling. The wire could be made thinner by tighter twisting and stretching.

Chisel cutting plate into wires

25

There is no evidence that in early Pharaonic times the Egyptians made wires by these methods, though not enough examples have survived and been studied to give a proper conspectus. It has been claimed that the square-sectioned wires were made round by hammering, a process which would have been virtually impossible except in the case of thick wires. It would have been feasible to roll wire of square or triangular section between two hard flat surfaces, so as to round off the corners by pressure or abrasion, only for short lengths at a time. Unfortunately, in his pictures of metalworkers in action, the ancient Egyptian did not represent the process of wire-making. While the use of the drawplate made of a hard stone, such as glazed steatite, has been postulated by several investigators such as Möller and Vernier, the suggestion has been generally scouted. The Egyptian was able to drill hardstone beads for threading upon wires as well as linen fibres (40), and it does not seem improbable that he would have noticed in time the effect of forcing a bead drilled with a circular hole over a wire of square or triangular section, especially as the Egyptian drill would have made a hole of conical shape. Arthur H. Kopp, the ill-fated chemist of the Metropolitan Museum of Art, noted in the case of the gold wire circlet of Seneb-tisi (6) that 'microscopic examination showed . . . plain evidence that this wire had been cut from sheet and then drawn – square edges are seen here and there, and even shear marks at right angles to the wire axis, while longitudinal streaks plainly show evidence of drawing.'

The pulling of square- or triangular-sectioned wire through a bead would have been more of a smoothing action than a drawing one, and it may well be that the bead was rubbed up and down the wire and not the wire pulled through the bead. If the hole was not exactly circular at its egress, but had been broken through by drilling from one side only, an irregularity could have caused the striations that are sometimes seen in these wires. In the New Kingdom, however, when new processes may have been introduced, the block-twisting method appears on the scene to supplement the rolling and smoothing processes of making wires. The first evidence can be seen on an ear-plug of Amarna date (58) which reveals that both techniques were in use on the same object; the braided wires having apparently been made by block-twisting, the plain ones by rolling or possibly smoothing.

Long lengths of wire were seldom required for Egyptian jewels, the circlet of Seneb-tisi being a notable exception. When a continuous length of wire was required, it was made by soldering shorter lengths together. The imperfect joins of such a length might be the 'shear marks' observed by Arthur Kopp. For most of his work the Egyptian jeweller required only short lengths of wire, the main need for which was in the manufacture of chains. For these, wire was coiled upon a rod of suitable diameter and cut longitudinally to produce a number of penannular rings which could then be interlinked before soldering the ends of each ring together. The resulting chain was, of course, very simple. A more complicated and stronger chain (96) was made by soldering each penannular ring into a continuous circle, pressing it into an elongated figure-8 shape and bending it up into a stirrup which could be looped through another. Such chains tend to have a square cross-section and are sometimes known as square or loop-in-loop chains (45, 106). The loops may be doubled, quadrupled or even sextupled by threading each link through the ends of the two or more preceding links. The resulting chain is columnar in shape with a woven herringbone effect that has frequently encouraged the erroneous belief that they have been plaited.

Another method of making wires was by soldering granules into given lengths and straightening the wire so formed by rolling it between two flat surfaces. The ear-plug from Amarna (58) shows examples of such wire, as does some of the goldwork from the tomb of Tut-ankh-amun. Beaded wires made by this method are best treated under granular work below.

For constructing the metal settings of his various jewels, the Egyptian had to join pieces together with hard solders, and several pictures of the goldsmith sitting at his brazier with blowpipe in mouth and tongs in hand show him at this exacting task. That the Egyptians knew how to join metal with hard solder by the Fourth Dynasty at the latest is clear from the bed canopy which belonged to Queen Hetep-her-es (c. 2600 BC), since its copper sockets were formed by bending sheet copper into a cylinder and soldering the overlapping joints with a silver alloy.

A group of five gold fishes found in the coffin of an infant in a Middle Kingdom grave at Haraga clearly reveals that the Egyptian goldsmith was familiar with solders of different melting points and chose them carefully according to the size and nature of the job. These fish pendants are graduated in length from 4 cm. for the largest to 1·5 cm. for the smallest. They have survived in various states of preservation, the largest being in perfect condition and the smallest in a state of total disintegration. It is clear that each was made of two shells formed either in a mould, or more probably over a wood or steatite positive. The half of each fish was filled with a finely levigated clay, the fins and tail inserted along the medial line, and solder run around the join. In the case of the largest fish there were sufficient heat-losses from its more extensive surface area to ensure that the ancient craftsman with his crude blowpipe could only just reach the temperature necessary

Gold fish pendant, largest of a set of five, from the grave of an infant at Haraga. XIIth Dynasty. Royal Scottish Museum, Edinburgh

to melt the gold solder used; but in the case of the smaller fishes, no such control was possible and he was in danger of fusing the thin shells almost at the same time as the solder itself. For the second largest fish, therefore, he chose a silver solder with a melting point well below that of the gold shells. At the time of discovery the solder which had flashed along the seam and over part of the fins and tail had changed to an easily visible purple 'horn-silver'. The other fishes in the group had been soldered with alloys of even lower melting points, containing copper, judging from the green deposits left on the goldwork. In the case of the two smallest fishes this poorer solder had decayed completely and the shells had fallen apart revealing the method of construction.

Whether the goldsmith made solders artificially or used less rich metals, which he distinguished by colour, to join nobler metals is problematical. Presumably he began in earliest times by empirical means to discover that some types of naturally occurring gold would fuse at a lower temperature than others; but it is almost certain that the making of bronze would have familiarized him with the ability to lower the fusing point of a metal by adding other metals or substances to the melt. Certainly by the Amarna Period he was producing a copper-gold alloy that could hardly have occurred in nature (60), and some of the goldwork from the tomb of Tut-ankh-amun suggests that he was deliberately debasing gold by adding copper or silver, since the objects show patchy tarnishing and corrosion (64, 65).

The hard soldering of metals, whether with natural or artificial alloys, would have required the use of an oxide-removing flux to achieve success. In modern times borax is generally used for such purposes but there is no evidence that this mineral was used in ancient times. Deposits of borax have not been recorded in modern Egypt. The nearest plentiful supplies are found in Turkey and Tuscany, but it is doubtful whether borax was traded from such remote sites to Egypt in antiquity. No name for the mineral has been identified in ancient Egyptian lexicography; nor has the element boron been traced in analyses of ancient

Egyptian materials. If borax had been used as a flux, it seems strange that no traces of it have been found in Egyptian glass or faience, in which, however, natron plays an important chemical role as a flux and binder. Natron, a mixture of sodium carbonate and bi-carbonate, with other sodium salts, occurs abundantly in Egypt and had such a multitude of uses that it was regarded as a magic substance. It is improbable that the fluxing and de-oxidizing qualities of natron in soldering would not have been discovered in antiquity. In point of fact, the writer has found no difficulty in joining pieces of silver with silver solder using a mixture of sodium carbonate and bi-carbonate in place of the usual borax. It has the advantage that it does not sputter like borax. Such a flux must have been used to silver-solder the second largest of the Haraga fishes, since solder had run onto the fins and tail following the course of surplus flux and had not subsequently been cleaned off, perhaps because it was less visible when new than when it had been converted into purple-brown horn-silver.

While it is clear, therefore, that the ancient Egyptians could solder metal with alloys of copper and silver, using natron as a flux, some doubt exists about the means they employed for soldering their goldwork with gold-rich solders. In ancient gold jewelry, the joins between the various components are usually undetectable. In the group of gold fishes from Haraga, for instance, while the silver/copper soldered joints are visible in the smaller specimens, the two halves of the largest fish are joined by a gold solder that cannot be distinguished from the gold of the shells and fins. If the join had been made by a gold alloy with a lower melting-point than the component parts, the solder would have been visible by its different colour, however slight, and however carefully any surplus might have been cleaned away, since after the lapse of nearly four millennia a distinct patina would have had a chance to develop.

This lack of any distinction in colour between the gold of ancient objects and their soldered joints has been ascribed by some authorities to the welding together of the various parts, a technique which would have been quite impossible with the crude tools in use at the time. Other writers have suggested 'surface enrichment' to account for the uniformity in colour. When gold alloys have been buried for any length of time, electrolytic action with salts in damp soils results in the disappearance of the baser metals in favour of the nobler. It has also been postulated that the ancients employed mild acids such as vinegar to achieve surface enrichment quickly by artificial means. Such treatment would have resulted in the pitting of the areas containing the displaced metals, whereas no such effects are discernible, even under strong magnification. Moreover, goldwork which has survived in dry conditions,

without contact with damp soils, reveals the same qualities.

There seems little doubt to the writer that the ancients soldered their goldwork by the process known as colloidal hard soldering, which was rediscovered in recent times by H. A. P. Littledale in seeking a means of reproducing the effects of Etruscan granular and filigree work without flooding the grains and wires with solder. Mrs P. F. Davidson, Research Associate of the Brooklyn Museum, has shown that a simplified version of Littledale's process results in a bond between various gold parts which 'if properly done has no peer in strength'. In colloidal hard soldering, ground copper carbonate, probably in ancient Egypt in the form of powdered malachite so commonly used as an eye-cosmetic, is mixed with gum or glue and this adhesive is employed to stick the grains or wire into place, or to coat the adjacent edges of the parts to be joined. The work is then heated on the charcoal brazier with the assistance of the blowpipe on those areas which have to be raised to the highest temperatures. At 100°C the carbonate changes to copper oxide, by 600°C the adhesive has become completely carbonized and at 850°C the carbon combines with the oxygen in the copper oxide and vaporizes as carbon dioxide, leaving the merest traces of copper adhering to the gold parts. At about 880°C a curious phenomenon occurs: the gold in contact with the copper melts to form a welded joint, whereas both gold and copper melt at nearly the same temperature well above this point, viz. 1083°C and 1063°C respectively. The process had great advantages for the ancient craftsmen. There was no decrepitation of flux to throw pallets of solder off the job, and the various parts were already stuck together by the dried adhesive before heat was applied. All that required to be done, once the mixture had been correctly prepared and applied, was careful heating over the bed of glowing charcoal. The work could subsequently be heated up a number of times to affix other elements, without the risk of unfastening joints that had previously been made. Mrs Davidson has used the technique to 'fasten granules to granules, granules to sheet gold, sheet gold to sheet gold, wire to sheet gold and every other possible combination of grains, sheet and filigree.' She has further found that it is possible to exclude the copper carbonate from the adhesive if the gold to be joined already has a sufficiently high percentage of copper.

The process is particularly suitable for gold, though claims have been made that it will also work for silver. For copper itself hard solder with fluxes must have been used. Although the ancient Egyptians knew of tin by the New Kingdom at least, and had smelted lead in small amounts from predynastic times, soft solder was not developed in antiquity for jewelry or fine work in metal.

Colloidal hard soldering was used to join granules together to form beaded wires and these were subsequently rolled between flat surfaces to straighten them. Increasing the pressure during rolling has the effect of squeezing the grains into cylindrical or spool shapes. Ancient Egyptian beaded wires, which were introduced in the Amarna Period, do not show the elaboration of shapes which are so characteristic of later Hellenistic work, and evidently rolling was limited to straightening a crooked row of granules soldered together. Nevertheless, in the ear-plug from Amarna (58) the effect of unequal pressure on the plates rolling over the wires has resulted in the distortion of the granules into near spool shapes in places, and it is interesting to see the emergence at this time of an accidental effect that was later intentionally exploited.

Granules of uniform size are made today by such processes as snipping strips of metal into equal squares, or winding wire over a mandrel and cutting the coil so as to produce rings of equal size. These particles are then heated until they fuse into globules. Similar methods have been postulated for antiquity; but such processes, which are simple with modern tools, would have been found difficult by the ancient craftsman. He had, however, plentiful supplies of ready-made granules to hand in the bags of gold dust in which much of the gold tribute reached him. All he needed to do to obtain grains of uniform size was to sift the contents of such bags through screens of different mesh. Two or more such granules could be fused together to obtain larger globules.

During the New Kingdom the Egyptians made a bead by soldering five or more grains into a ring around a central hole. When these were threaded together, they intermeshed to produce what looks like a flexible reticulated tube of solid gold. Examples have been found in the tombs of three queens of Tuthmosis III and of Tut-ankh-amun (83, 84). Hollow ball beads were also found there decorated with granular work. The earliest appearance of such techniques in Egypt, however, is found in the treasure of the Princess Khnumet from Dahshur (15) and has a decided Asiatic look with its star-shaped medallions. The butterfly motif, with its somewhat Aegean echo, had appeared much earlier in the jewelry of Queen Hetep-her-es (3); and in the absence of all personal jewelry of the Old Kingdom, it would be rash to assert that granular work was not introduced until the Middle Kingdom. Nevertheless there are good grounds for believing it to be of Asiatic origin, since the goldwork found by Woolley in the royal cemetery of Ur and dated to c. 2550 BC already shows familiar designs in granules. It may well be that, with the more intimate contacts between Egypt and Asia in the Twelfth Dynasty, new techniques were introduced by immigrants and adopted by native goldsmiths.

There is less doubt about the origins of the most characteristic feature of Egyptian jewelry, its cloisonné-work, in which strips of metal were bent to shape, placed on edge and soldered to base plates so as to form cells or cloisons. The cells were then set with coloured inlays cut to shape and cemented in position, the entire surface being subsequently polished. This technique was known from the early Old Kingdom at the latest, for fragmentary dummy vessels have been excavated from the ruins of the mortuary temple of King Nefer-ir-ka-re (*obit. c.* 2460 BC) which imitate originals made of gold inlaid with coloured stones. Scraps of jewelry found in the tomb of Queen Iput of the early Sixth Dynasty (*obit. c.* 2340 BC) include two drop beads made in cloisonné-work. The technique reached its greatest perfection in the Middle Kingdom, but it is still very much in evidence in the tomb of Tut-ankh-amun where, however, short cuts were being taken in the fitting of the inlays.

Related to cloisonné-work is niello, in which an alloy of copper and silver blackened by sulphur compounds is used as a foil to raised designs in gold. Examples of this technique are more characteristic of the Aegean area; and almost the only example from Egypt is the blade of the dagger of Amosis, found in the treasure of Queen Ah-hotpe, which has an inscription and animal designs inlaid in gold against a black composition centre-rib on each side of the blade.

The remaining technique of metalworking which the Egyptians had fully mastered was casting. This was not often employed in jewelry-making since stampings and mouldings in sheet metal gave adequate and more economical results. Nevertheless, there was no alternative to casting in the case of certain parts of objects or of entire jewels. The head of the vulture pectoral of Tut-ankh-amun, for instance (78), must have been cast, since carving and filing it out of the mass would have been very wasteful of precious gold.

Such pieces were doubtless cast by the *cire perdue* method, the model being worked in beeswax, fitted with a sprue and the whole invested with fine clay. When this had been carefully dried and heated to a high temperature the wax would burn off, allowing gold melted in a crucible to be poured into the cavity. Statuettes and similar small articles would be cast solid, but the Egyptian in the New Kingdom, at least, could also cast larger objects by the *cire perdue* method on a core retained within by chaplets of copper.

NON-METALS

Egyptian jewelry has conveniently been classified into hoop jewelry, which consists essentially of metal hoops such as finger-rings, anklets, bracelets, circlets and the like; and bead jewelry, which comprises necklaces, girdles, collars, headdresses, bracelets and anklets. Pectorals, amulets and pendants may be regarded for the purposes of this classification as more elaborate beads. The special contribution of Egypt to the jeweller's art was its bead jewelry. No other nation of antiquity produced such an enormous wealth of beads in so many different shapes and substances, and used them not only in single and multiple strings but threaded to form patterned textiles, or sewed them on linen or papyrus backing to make such articles of dress as belts, aprons and sandals.

Beads, which are found in Egypt as early as the Neolithic period, were first made of natural objects such as pebbles, seeds, shells, teeth, horns and bones which had some amuletic significance. But aesthetics reinforced magic when objects were fashioned out of materials chosen for their appearance as much as for their numinous power. The earliest of these were pebbles and crystals that could be shaped, drilled and polished to thread upon a string. A factory for making stone beads found at Kerma above the Third Cataract of the Nile, though dating to the Twelfth Dynasty, doubtless shows techniques which had long been traditional. The first stage of the process was to select pebbles (e.g. of carnelian or jasper) or crystals (e.g. of amethyst or garnet) of an appropriate size and shape, or to break up larger stones to obtain such pieces roughly chipped to shape. They were then drilled, sometimes from one point only, but often from opposite poles when the hole began to wander from its proper axis. Some doubt exists as to the type of drill used. In prehistoric times it may have been a stalk fed with an abrasive powder and rotated between the palms of the hands. The 'wobbly drill' with its flint borer used for hollowing out stone vases does not appear to have been used for beads. An enigmatic scene in a relief dated to the Late Old Kingdom shows large blocks of carnelian being worked by an instrument, apparently of wood, perhaps a development of the hand-rotated stalk.

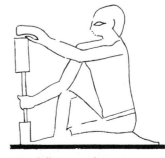

Man drilling carnelian

For the most part, however, the drill in common use was the bow-drill. Its point was usually of copper fed with an abrasive powder such as crushed flint, chert, stone-dust from the beads themselves, or fine quartz sand; but there seems some evidence that the borers could also be of flint or chert, perhaps reflecting a traditional practice dating back to prehistoric times. Scenes in New Kingdom tombs show lapidaries operating three drill-stocks at once with the same bow, but though it has been claimed that the feat is possible it seems more likely that the operation represented is polishing rather than accurate boring.

The rough perforated beads were then ground to a better finish by rolling them between flat rubbers of an abrasive stone such as quartzite; or, in the case of cylindrical beads or several disk beads threaded on to an axle, by rubbing them in grooves ploughed out of gritty stone blocks. They may also have been finally polished by jamming them on the points of a bow-drill and rotating them in suitable recesses in a wooden block fed with an abrasive mixture of fine quartz sand and oil or water.

The art of the bead-maker reached a high point of achievement in the Middle Kingdom (34). From this period stone beads have survived of minute size and extraordinary fineness in which perforations of great length occur. How such beads were made is unknown but it is to be suspected that the hole must have been drilled first and the body afterwards rubbed away till the desired degree of thinness had been obtained.

The constant search for a convenient substance from which hard blue and green beads could be easily made was partly successful when the Egyptians discovered how to coat steatite (soapstone) with a green or blue vitreous alkaline glaze as early as the Badarian period of the prehistoric age (c. 4000 BC). Steatite, which occurs in several places in Egypt, can easily be worked since it is very fine-grained and soft enough to be marked by the finger nail. It is eminently suitable for carving into such objects as statuettes, vases, amulets and beads. On being heated in the glazing oven it does not change or fracture but becomes dehydrated, in which state it is hard enough to scratch glass. The working of steatite into glazed beads, while not difficult, is tedious and time-consuming, and except for the more complicated shapes steatite was replaced by mass-produced faience beads.

White disk beads were made from shells, particularly that of the ostrich egg, which were broken into pieces of convenient size and trimmed roughly circular, then drilled, threaded on a stiff core and rubbed to shape in the same way as stone disk beads were made. Such shell disks exist from the Neolithic period and never completely lost favour, though they were replaced in the Eighteenth Dynasty by similarly shaped beads made of white faience.

The greater proportion of ancient Egyptian beads, however, are made of faience which was introduced in the predynastic period. According to Petrie and Reisner, such beads were made on an axis, perhaps of thread, which would be burnt out in the firing, leaving a hole. Disk beads, ring beads and tubular beads were made by coating the axis with the body-paste, rolling the long cylinder so formed on a flat surface and scoring it with a knife into sections of different lengths, depending upon what kind of bead was required. Other shapes, such as ball beads, were rolled between the hands and perforated while still soft with a stiff point such as a needle-like wire. The beads were then dried, coated with glaze, if indeed glaze had not been mixed with the paste, and fired, the smaller specimens often being fused to the condition of translucent frit.

The vast majority of faience beads are blue or green in colour; but black, red, yellow and white beads were also produced, especially in the New Kingdom. In addition to making beads of simple geometrical forms, the Egyptians could press faience into moulds to make beads of more complex shape, such as pear-shaped drop beads, hieroglyphs, figurines, leaf and flower forms. Ring beads were attached to one or more points of the larger beads at the final glazing and are the means of stringing them into collars and bracelets. In the Amarna Period, when faience and glass manufacture reached a high degree of perfection, leaf, flower-petal and fruit forms were cast in polychrome faience as elements in the elaborate floral collars (91) and fillets that replaced the more ephemeral archetype worn on festal occasions.

The latest material from which beads were made was glass, introduced in quantity during the New Kingdom. Petrie, who had an excellent opportunity of studying the manufacture of glass from the remains of the factory he found at Tell el-Amarna, reports that the usual method of making beads was by winding drawn-out threads of molten glass upon a copper wire which contracted on cooling and could be withdrawn. Threads of different colours could evidently be used in the same bead; and drop shapes, as well as spherical, cylindrical and barrel beads, were produced by this method. Glass, too, could be pressed into moulds and treated very much as a more brilliant kind of faience. Some modest jewelry was also produced at this time entirely in glass, such as ear-studs, and earrings made of two differently coloured glass canes twisted together to form diagonally striped rods (58).

A decline of skill in the manufacture and manipulation of glass is evident in Egypt after the end of the Eighteenth Dynasty, and as a material it virtually disappears after the fall of the New Kingdom with the destruction of the Late Bronze Age civilization of the Near East. Glass-making in Egypt was not revived until Ptolemaic times, after

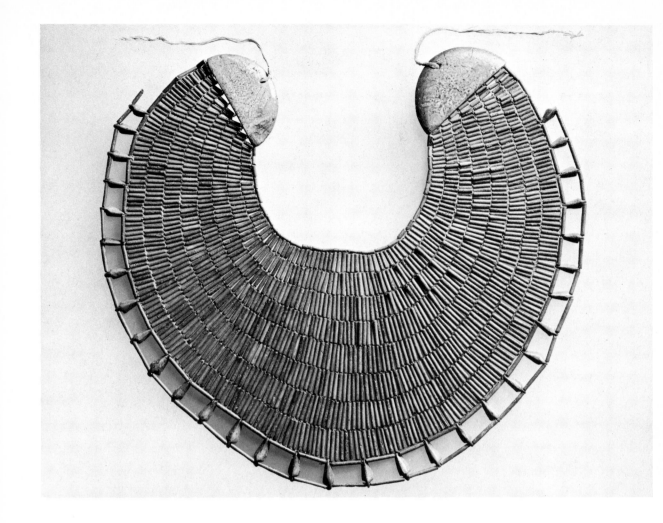

Alexander the Great had founded Alexandria with its cosmopolitan population and trades in the fourth century B C.

The Egyptians learnt very early to combine strings of beads into chokers, bracelets and anklets by means of spacer beads. These were in effect perforated bars of bone or ivory or wood, often covered with gold leaf, or of faience or metal interspersed along the threads at intervals to keep the beads in position as flexible bands of ornament instead of a sagging tangle of strings. Bead-work, so threaded, could be made into the pattern of the block-border so dear to the sensibility of the Egyptian artist as a decorative motif.

A special kind of spacer was the collar terminal, usually in the form of a flat faience or stone lunette with diagonal holes on its straight edge through which the various strings of beads could be anchored (8, 10, 55). Other holes at the opposite point of the terminal took the tie-strings by which the collar was secured. In the funerary Broad Collars the end-pieces are often in the form of a falcon's head (7, 11, 46, 54); and the most elaborate examples are of gold inlaid with stone or substitutes.

Broad Collar of the Steward Wah strung from bright blue-green faience beads, almost circular in shape and deepest in the middle. XIth Dynasty. Metropolitan Museum of Art, New York

Chokers

The making of stone beads was a routine if exacting task: the more expert lapidaries must have specialized in the cutting, fitting and polishing of the inlays that went into the making of the cloisonné jewelry which is the chief glory of Egyptian decorative art. It is probable that a fragment of jasper, carnelian, turquoise, felspar or lapis lazuli, left over from bead-making, was selected as near to the required shape as possible and chipped and rubbed so as to fit the appropriate cell exactly. It was cemented into position with resin mixed with a calcareous filler, such as powdered limestone or gypsum, presumably applied in a molten state, since an oleo-resin would have taken a long time to dry out and harden. The cements were often tinted to match the colour of the inlays, but in the Dahshur and Lahun jewels the filler now appears as a white plaster which may have lost its pigments and organic adhesives. When the inlays had all been fitted carefully, the entire face of the jewel almost certainly would have received a final polish.

Inlay work must have been a highly skilled occupation and it is very probable that the craftsman would have sought ways of securing the desired result by less laborious means. The substitution of green and blue frit for the rare and costly turquoise, felspar, and lapis lazuli must have eased their tasks somewhat, since this material could have been cast near to the required shapes and sizes. The introduction of niello suggests that the jeweller was striving to find a plastic material that could be easily and quickly inserted in the cloisons and fill them exactly without incurring long and tedious labour in the process. The substitution of glass for natural stones in the New Kingdom gave the craftsman a means of casting his inlays direct in the cloisons, since all he would need to do was to pack powdered glass into the cells and heat it up until it fused into a compact mass. This is virtually the process of enamelling, in which the glass at its melting point penetrates the surface of the metal and adheres closely to it.

That the ancient Egyptians knew the arts of enamelling is generally denied, despite the fact that it would have been perfectly feasible for powdered glass to be fused in the separate cells of gold cloisonné-work, since the melting point of ancient soda-lime glass is below that of gold. The presence of lead in some glass from Amarna would also assist in a proper bond between the glass and metal. While it is apparent that, in most of the jewels of Tut-ankh-amun, glass inlays have been used like precious stones, each piece being cut, shaped to fit its cell and cemented in position, there is at least one object which displays a different technique. This is the pectoral in the form of a vulture (78) which may have been worn by the king in life. It is made of gold, the cloisons being inlaid with blue, green and red glass. The inlays fit their cells more tightly and accurately than is the case with the majority of jewels from the same deposit; and this and the absence of any traces of cement give them the appearance of having been fired *in situ*. The proof that this is indeed the case is to be seen in the small crater made by an air-bubble visible in most of the red glass inlays forming the lesser coverts of the wing. Blow-holes can also be seen under the microscope in one or two places in the blue glass inlays, while the outlines of the gold ribs have a burred effect, as though the entire surface has subsequently been ground down, the inlays having shrunk in their beds on firing.

This pectoral at least shows an example of cloisonné enamelling and a closer examination of other of the Tut-ankh-amun jewels might reveal that it is not unique; some of the finger-rings, for instance, look as though the backgrounds of their bezels are enamelled in blue glass.

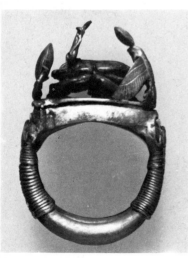 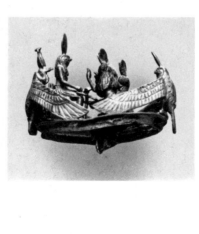

Finger-rings of Tut-ankh-amun, gold and lapis lazuli. They are developed from signet rings, with elaborate bezels showing (left) a scarab carrying a crown protected by a moon-bark and falcon; (centre, bezel only) worship of the sun-god Re; (right) scarab carrying moon disk and crescent, flanked by scarabs with sun disks. XVIIIth Dynasty. Cairo Museum

6 The Forms

ORNAMENTS OF THE HEAD AND TORSO

The jewel worn on the head by both men and women, royalty and commoners, was the circlet, known from the captions to the coffin pictures of the Middle Kingdom as the 'boatman's circlet'. In its most rudimentary form this appears to have been a chaplet, woven of water-weed plucked from the river verges, that was placed on the brow to confine the hair. The strong north wind that so often prevails over the waterway in the Nile Valley is very apt to blow the boatman's hair into his eyes, and the meaning of the phrase is obvious. In time this vegetable prototype was translated into a more permanent metal version and the gold wire circlet of the House Mistress Seneb-tisi from Lisht (6) is a Twelfth Dynasty simplified version of such a chaplet. The almost contemporary crown of the Princess Khnumet from Dahshur (14) is a much more sophisticated example, in which the strands of weed have been intertwined with flowers and buds made of blue, red and green stones in gold settings.

A further development from this circlet was the diadem, originally a band of linen tied around the brow with a bow at the back, the loose ends falling on the neck. Lotus flowers and buds could be tucked into this band, especially on festal occasions. In the reliefs of the Old Kingdom there frequently appears a scene of boatmen wearing such flower-bedecked fillets and engaging in real or sham fights in their papyrus skiffs. Probably these contests have a religious significance and the circlets themselves have a primary or incidental meaning, like the Crown of Justification of Hellenistic times. Certainly, the boatmen's circlet became a royal crown when mounted with a uraeus or vulture, and was worn by both kings and queens (20, 85).

As a costume adjunct worn by commoners, the natural flowers were soon replaced by stylized versions in beads; while the band, its knot, and the loose ends falling as streamers, also lent themselves to interpretation as beadwork held together by spacers. Such fillets appear to be worn by the daughters of Djehuti-hopte in a painted relief from his tomb dating to the Middle Kingdom (18). That the flower-bedecked chaplet had already been the inspiration for a metalwork version by at least the early Old Kingdom is shown in the painted statue of Nofret at Cairo. Here on a white band are set red and green rosettes, each with eight radiating lines from a central boss flanked by the calyx of a flower or perhaps the spathe of a flowering rush with two buds emerging. This is evidently a painted representation

of an original in silver, like some of the surviving fillets, with cloisonné appliqués inlaid with green, red and blue stones. A similar design appears in the tomb of the later queen Mer-es-ankh III, where the spathes emerge vertically from the diadem: the bow-tie at the back has also been transformed into a pair of papyrus umbels, while the knot has become a circular boss set between them, as almost invariably was the pattern for all practical jewels.

A more stylized version of such a design appears in the second crown of the Princess Khnumet (13), where the diadem has become a continuous linkage of the appliqués seen on the fillet of Nofret with the upright spathe-elements in the example worn by Mer-es-ankh III. The rosettes in all examples are probably greatly simplified versions of a roundel, consisting of a central boss with four so-called lily flowers radiating to the four points and a 'lily'-bud set between. A princess of the Fourth Dynasty had a gold fillet set with one such roundel (4), alternating with two papyrus-umbel bow-knots having a pair of ibises resting on them. Similar motifs appear on gilded copper head-bands at Boston and Leipzig.

Painted limestone statue of Nofret wearing a cloisonné silver circlet and a Broad Collar of hardstone beads. IIIrd–IVth Dynasty. Cairo Museum

33

Roundel from furniture of Queen Hetep-her-es

The crown of the Princess Sit-Hathor-Yunet from Lahun (20) shows a restrained interpretation of the same theme. The fillet is a perfectly plain gold band to which fifteen inlaid roundels have been riveted. The double papyrus-umbel bow-knot at the rear has become a single umbel, but made in the round as a support for a flickering sheet-gold plume. The tapes at the rear have also become a pair of sheet-gold streamers hinged to one of the roundels, and are supplemented by a pair of such streamers hanging from each side. The addition of an inlaid uraeus worked à *jour* exalts this essentially plebeian headgear into a royal crown.

Other examples of the circlet designed as a crown have survived from subsequent periods. The tomb of the three queens of Tuthmosis III has yielded to date one such specimen in which the uraeus or vulture of heiress consorts has been replaced by the gazelle-head insignia of secondary queens (49 cf. 47). The circlet, which was the only crown placed over the head of Tut-ankh-amun within his coffin, has carried stylization a stage further (85) with the narrow band bearing roundels reduced to mere carnelian bosses, and uraei attached to the side-streamers. The last variation on this design of jewel to have survived is the chaplet belonging to an infant daughter of Queen Twosre in which the fillet has been attenuated to a narrow ribbon carrying six large composite flowers in purple gold instead of simple roundels (94). From this it is but a short step to the crown of roses so characteristic of the Isis cult in Roman times.

In the New Kingdom the boatman's circlet fell from favour as the head ornament of private persons and was replaced by the fillet, apparently a band of linen, papyrus or palm-leaf secured by tapes at the rear and sewn with leaves and flower petals. These are shown, in the contemporary tomb paintings, being handed to guests together with the floral collars. Doubtless more permanent versions were made in bead-work, faience or metalwork; but if so, none has survived. The only proof of their existence is the cast left in the hardened resin-soaked bandages still adhering to the despoiled mummy of Queen Meryt-amun of the early Eighteenth Dynasty, who evidently was buried wearing one or more of these fillets in bead-work instead of the boatman's circlet, or perhaps in addition to it.

Another means of decorating the hair was provided by the wig ornaments that are shown on the monuments in the Early Middle Kingdom, and actual examples of which were found in the burials of Seneb-tisi (6) and the Princess Sit-Hathor-Yunet (20). The first of these had ninety-eight rosettes of beaten sheet-gold interspersed at regular intervals with the tresses of her hair or wig. The princess had a great quantity of short gold tubes of two sizes which could be threaded on her braided locks in a chequer pattern so as to give the appearance of a complete gold reticulation covering the wig. Similar hair tubes were found in the treasure of Dahshur.

A more elaborate and opulent development of these wig ornaments is found in the Eighteenth Dynasty, where the treasure of the queens of Tuthmosis III (53) yielded the elements of at least two headcovers consisting of inlaid gold rosettes, graduated in size, strung between vertical ribs of small gold tubular beads. The complete example has a chased golden crown-plate at its summit from which falls this scintillating cascade of inlaid gold elements.

Among the hair ornaments are perhaps to be included the *nekhau*, or amuletic pendant in the form of a fish, which was evidently attached to the side-lock of children, perhaps as a protection against drowning. The *nekhau* was usually made of green stone; and a famous Egyptian tale tells of the consternation that was caused when the turquoise fish pendant of one of the young maidens who were rowing King Sneferu on his pleasure-lake fell into the water. Several such hair ornaments have survived in turquoise and gold besides other materials.

Girl with fish pendant

Another hair jewel used only by children was a hair-ring or clasp for keeping the youthful side-lock in order. These must have been in fashion from the earliest times but it is only in the New Kingdom that they are represented in detail, and become increasingly elaborate as the age wears on. The sons of Ramesses III, for instance, are shown in their tomb paintings as wearing one or more decorative slides to their side-locks. No hair-rings have been positively identified and a dispute exists as to whether certain penannular gold ornaments are rings for the hair or ears (see below). It seems to the writer that the Ramessid hair-clasps take the form of small bracelets (95), which would provide the most convenient way of confining a thick and braided lock of hair.

The earring was unknown in Egypt during the Old and Middle Kingdoms; but it comes into general use at the end of the Second Intermediate Period, probably as a result of a general dissemination of foreign ideas stimulated by the Hyksos domination, since earrings had been known in Asia for at least a thousand years earlier, as jewelry from the royal cemetery at Ur reveals. The first notable example found in Egypt is a pair, each made of four penannular ribbed tubes soldered together, which comes from a woman's burial at Western Thebes that may be dated to the last years of the Seventeenth Dynasty (36). Such rings were worn through holes of large diameter perforated in the ear-lobes, judging by the size of that portion of the jewel which was to be inserted. So unlikely has it seemed to some Egyptologists that these rings could be worn in the ear, that examples have been described as hair-rings; and it has been assumed that the tresses they were designed to keep in place were introduced into the gap in the ring almost hair by hair until the ring was packed tight. Experiment by the writer, however, has shown that the springy nature of living hair prevents penannular rings from staying in place; and no such ornaments can be seen in representations of women's coiffures on the monuments, however detailed they may be. An even larger, semicircular, hole must have been made for the penannular rings made in red jasper that have been retrieved in such quantity from burial-grounds (58). A number of these stone earrings have perforations on their periphery to take pendants. Heavy rings in thick gold or bronze have a similar exceptionally narrow gap in which to insert the ear-lobe (94); and the problem remains of how they were fitted to the ears. Perhaps, like their stone counterparts, they were clipped on to the ear in infancy. The metal specimens may have been pinched together once they had been inserted, but no such method of closure could have been employed on the stone rings.

The most popular earring during the Eighteenth Dynasty was made of a number of hollow triangular gold hoops soldered together; these were evidently worn by women, a pair in each ear-lobe, if we are to judge by four examples still in situ on the mummy of a woman at Turin, and the double perforations in the ears of Tuyu at Cairo. The fashion for wearing a ring in the ear was less popular with men and was slow to be adopted. Yuya, the husband of Tuyu, has unpierced ear-lobes, though large earrings for men had been in use for at least two generations. The ear-lobes of Tuthmosis III are apparently unpierced, whereas those of his son Amenophis II have small perforations. Mai-her-pra, Tuthmosis IV, and Tut-ankh-amun, however, had a large hole in each ear that would have taken the thick tubes from which their ear-ornaments were suspended (83, 84). It has been assumed that such earrings were worn by boys only until the age of puberty, when they were laid aside. Tomb paintings and reliefs exist, however, showing that on occasion adult men wore earrings.

Parallel with the development of the earring goes the evolution of the ear-stud which was introduced at the Amarna Period. Mushroom-shaped specimens in stone, glass, metal or faience have been found (58) in which the shank could be inserted in the hole in the ear-lobe, leaving the circular boss, either plain or decorated, on the outside and in the plane of the ear, not at rightangles to it, as is the case with the earrings. A relief of Queen Tiye shows her wearing a stud in the form of a flower, the long stem of which has been threaded through the hole in her ear-lobe. Sculptures of Nefert-iti and Tiye depict them wearing large plugs or studs in their ears. It is in fact at this period that the stud developed into the plug, a disk of metal or faience with a grooved edge that could be inserted into large holes in the ear-lobes. The earliest known example is the specimen believed to come from the Royal Tomb at Amarna (58), and now in Edinburgh, which has a heavy ornamental disk with a wide flange in place of a shank. The granular and filigree work on this specimen has a somewhat un-Egyptian appearance and the fashion for such barbaric jewels may have spread from Asia. From this time, however, the practice of wearing ever heavier and larger ear-plugs (97) developed steadily in Egypt until by the Twenty-first Dynasty the women of the ruling house were wearing, in addition to earrings, plugs of such a size that their ear-lobes were distended to mere stringy loops of flesh, as their mummies plainly reveal. Subsequent dynasties, however, show a less extreme form of fashionable mutilation, though it is true that we lack the mummies of the royal women from which to draw a proper comparison.

In contrast to such barbarities, the Egyptians did not perforate the septum or wings of the nose for the insertion of a ring, though such an ornament was in use in Asia and Nubia. A statuette, formerly in the Amherst Collection,

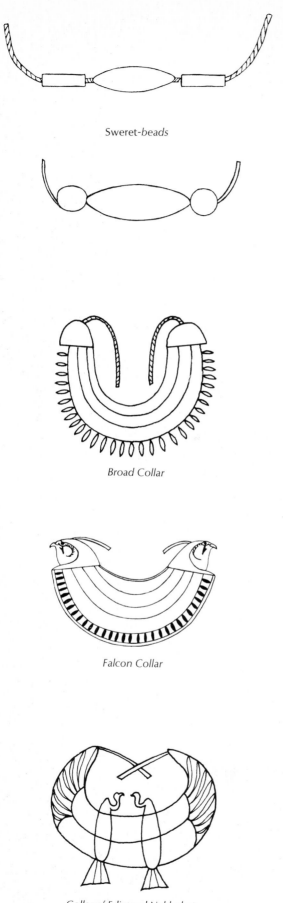

Sweret-beads

Broad Collar

Falcon Collar

Collar of Edjo and Nekhebet

shows a Nubian woman or godling, with her brood of children represented as apes, all wearing silver nose-rings. A burial of the tenth century BC, excavated at Abydos, yielded a nose-ring in position on the body of a woman; but this is an isolated case and she may well have been a foreigner.

The ornaments for the neck are developments of the charm strung upon a cord. At one extreme they become pectorals, at the other, collars. The pebble polished, perforated, and threaded on a string of leather or linen is one of the commonest amulets of prehistoric times; and this primitive jewel survived in the barrel-shaped carnelian *sweret*-bead, usually flanked by a green cylindrical or ball bead which the texts specify should be hung around the neck or on the breast of the deceased. Sometimes a large number of such beads are mentioned, so that the pendant has in effect become a necklace. A string of shell, stone or faience beads is found in even the poorest of burials; and a number of such necklaces connected by spacer elements becomes the collar.

The collar in ancient Egypt is so universal that it is virtually an item of dress. The most popular version is the Broad Collar, composed of cylindrical beads or tubes strung vertically in rows in a semicircular or penannular shape and terminating in two lunate end-pieces, and a lowermost row of drop beads. Such collars are found painted on statues and reliefs from the Early Old Kingdom, but have rarely been recovered intact, though a notable gold and faience example of Sixth Dynasty date is at Boston. A version of the Broad Collar known as the 'Collar of the Falcon', with terminals in the form of falcon heads, is often found painted on coffins and in funerary contexts. A number of actual examples have survived in various materials: faience, metal and stone. More elaborate versions substitute beads fashioned as hieroglyphs for the simple tubes of the main body of the collar.

The coffin pictures of the Middle Kingdom also acquaint us with the 'Collar of Green Stone', the 'Collar of Lapis Lazuli' and the 'Collar of Gold', the 'Collar of Silver' and the 'Collar of Electrum', referring to the kinds of beads used in their composition. But there are also other funerary collars, apparently cut out of sheet-gold and chased in the form of birds with wings outspread and curving up into a semi-circular shape. Such collars are described as of the god Horus, in the form of a falcon; of the goddess Nekhebet, in the form of a vulture; of the goddess Edjo, in the form of a vulture, but with a cobra's head; and of the goddesses Edjo and Nekhebet with two bodies or heads. Actual examples are very rare, probably because they were proper only to royal burials. The few that do survive have been found on the bodies of Pharaohs. Tut-ankh-amun, for instance, was covered with sets of such collars not only in sheet-gold but also in flexible cloisonné-work of great elaboration.

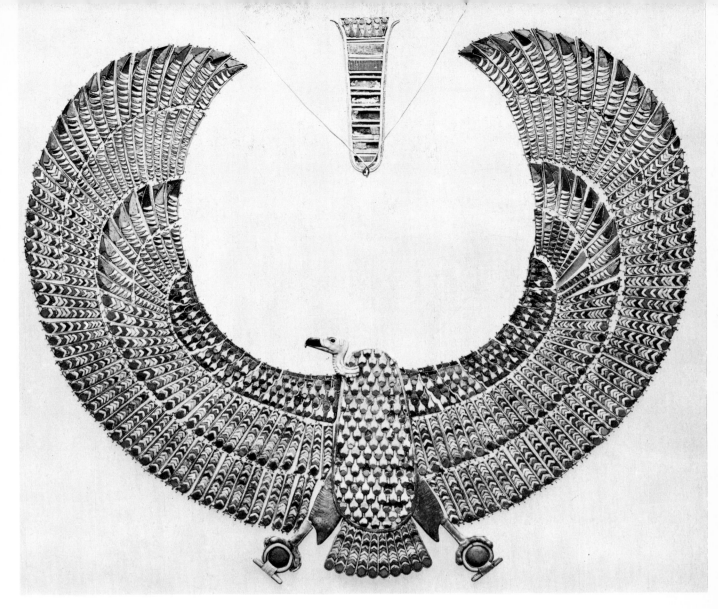

Flexible Vulture Collar and counterpoise made of 250 separate gold elements inlaid with coloured glass and strung together: from the mummy of Tut-ankh-amun. XVIIIth Dynasty. Cairo Museum

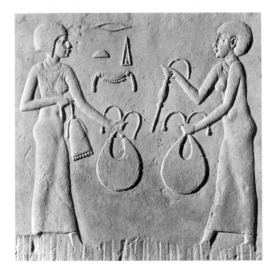

Limestone relief in archaizing style showing women carrying collars, a counterpoise and a sweret-bead necklace. 4th Cent. BC. Cairo Museum

Miniature Broad Collar, gold inlaid with carnelian, felspar and lapis lazuli, made for adorning a cult-statue. Ptolemaic Period. Metropolitan Museum of Art, New York

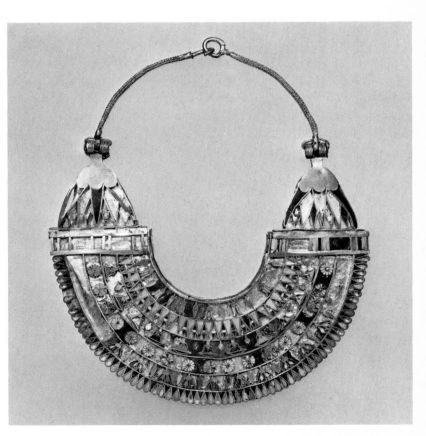

Wife of Mereruka wearing a menkhet

Pendants

Pendant with Bat insignia, tomb of Khufu-khaf

All such collars were designed to be worn with a *menkhet*, a counterpoise which hung down the back of the neck and balanced some of the weight of the collar in front. Such counterpoises are pictured on the monuments, but few examples worn in life with a Broad Collar appear to have survived, although funerary versions do exist, notably those in both plain sheet-gold and cloisonné-work which were inserted in the wrappings of Tut-ankh-amun.

With the Eighteenth Dynasty a new type of collar, a bead version of a garland of flowers and leaves, makes its appearance. In such collars the terminals are usually in the form of lotus flowers and buds. The natural garlands were made by sewing rows of leaves, flower-petals, berries and fruits, interspersed with faience beads, onto several sheets of papyrus and securing the ends by tapes. This type of floral collar persisted even as a funerary adjunct, sometimes appearing with falcon-head terminals on the coffins of all subsequent periods.

A special kind of necklace is the choker, closely hugging the column of the neck just below the chin; this is a narrow band of bead-work, with spacers at intervals, worn by women during the Old Kingdom. It was evidently secured at the back with tie strings, if we are to judge from the coffin pictures of the Middle Kingdom; by then it had ceased to be fashionable, though it is still represented in the Late Period on figures of goddesses wearing archaic dress.

The simple jewel in the form of a single pendant or amulet, such as the *sweret*-bead hanging from a cord around the neck, developed on different lines from the necklaces into the pectoral. In the Old Kingdom such pendants occur sporadically, being attached to a cord strung at intervals with supplementary beads, and have the appearance of shells, or shell-forms made in other materials. A common pendant, shown on the monuments of the Old Kingdom as the regalia of palace officials, is the fetish of the goddess Bat, which later was transformed into the sistrum of the cognate deity Hathor. This jewel is in the form of the cow-eared face of a woman wearing in-curving horns on her head and a trapezoidal panel of beads falling below her chin. The pendant is frequently combined with a girdle knot. The figure of Bat sometimes appears as a decorative element in the pectoral ornaments of the jewelry of the Old and Middle Kingdoms, after which she loses her identity to the great goddess Hathor.

Some representations of the Broad Collar during the Old Kingdom show a bead panel hanging from the centre of the lower edge as a pectoral. This panel can also be attached to the collar by straps; or can be independent of it, hanging from the neck by straps that pass over or under the Broad Collar. Sometimes it takes a trapezoidal shape,

probably inspired by a lotus-flower which is occasionally worn hanging down from the neck. The lower border of such pectorals is finished as a row of drop beads, and its straps end in falcon-head terminals.

During the Middle Kingdom, both types of pectoral underwent a rapid development. Large trimmed pearl-shells were worn as pendants, particularly in Nubia where they were popular until very recently. They were frequently inscribed with the protective name of the reigning Pharaoh. More sophisticated versions made in precious metals or cloisonné-work have survived from the period (31) and each of the princesses buried at Dahshur appear to have had at least one pendant of this type in her parure. The trapezoidal pectoral is also inscribed with the prophylactic name of the Pharaoh, and in the royal jewels is transformed into the kiosk-shaped primeval shrine which acts as a frame for the king's cartouche supported by heraldic devices, whether in the form of plants or animals. If the name is absent, the royal attributes are represented in symbolic form. Such pectorals were worn in life on simple bead necklaces, though other contemporary examples have straps of bead-work. Later specimens, such as those belonging to Tut-ankh-amun (68, 70, 71), are very elaborate with intricate straps and counterpoises.

The importance of the pectoral ornament increases with the rise in popularity of the scarab amulet. By the beginning of the New Kingdom a large image of this beetle carved in a green stone had replaced other stone pendants worn on the breast of the deceased. Such 'heart-scarabs' (45), inscribed with magical texts which insured the wearer against self-condemnation at the Last Judgment, are common thereafter and are incorporated as a central element in the design of the shrine-shaped pectorals (63, 66, 82, 106). But all such scarab pectorals are restricted to funerary use.

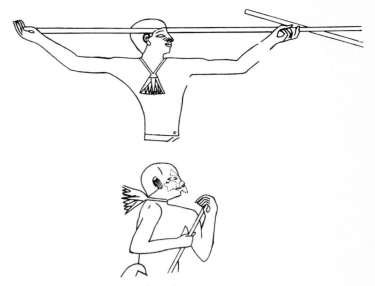

Boatmen with lotus flower pectorals

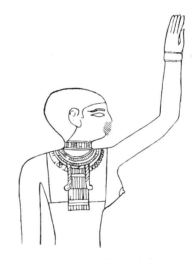

Daughter of Khufu-khaf

Pectoral of electrum, the hardstone inlays missing: the reverse chased with heraldic figures of the gods of Upper and Lower

Egypt confronting the emblem of Bat below the protective eyes of the sun-god. XIIth Dynasty. Eton College, Windsor

The jewel worn over the hips by women was the girdle, the chief function of which was amuletic. Girdles are not represented in the Old Kingdom when women, even servant-girls as distinct from children, are not represented in the nude. In the Middle Kingdom, concubine figures in faience, wood, clay and other materials are sometimes shown as wearing cowrie-shell girdles. In the New Kingdom there are many pictures of nude handmaidens and young girls clearly wearing the girdle about their hips: sometimes it is shown as though worn outside the gown (56).

One of the earliest complete examples has been retrieved from the deposit of Sit-Hathor-Yunet (22). The large beads are in the form of hollow gold cowrie-shells strung on two cords with acacia-seed beads of gold, green felspar and carnelian spaced between. The princesses buried at Dahshur also had cowrie-shell girdles, one of slightly different pattern (31); and similar girdles in gold and silver have been found in other burial-grounds of the Middle Kingdom. Towards the end of her life, Sit-Hathor-Yunet acquired another girdle of different design (23) with the large beads in the form of double leopard heads, and the spacer-beads of identical shape but on a smaller scale. The two strings were threaded with amethyst ball beads. Another of the Dahshur girdles was of a similar design which, however, had a very brief fashion, being replaced before the New Kingdom by girdles of less massive appearance (35) with modest spacer-beads of semicircular shape separated by small ring or barrel beads. In one example belonging to a queen of Tuthmosis III (50), the spacers are in the form of the fish amulet.

Belts as distinct from girdles were worn by men to support their kilts around the waist (95); but a development of the woman's girdle is the belt worn by one or more of the queens of Tuthmosis III (52). This was composed of seven rows of acacia-seed beads, similar to the specimens in Sit-Hathor-Yunet's earlier girdle, in gold, carnelian, turquoise, and probably blue faience or glass. The gold beads are soldered together to make spacer-bars and two plain bars form the clasp. Elements of three belts of different lengths have survived, but only enough beads have been secured by the Metropolitan Museum of Art to make one complete example. Such pieces of women's costume jewelry are unknown from any other source and are not represented on the monuments: they probably reflect a foreign fashion adapted by an Egyptian jeweller.

ORNAMENTS OF THE LIMBS

The ornaments of the arm, which were worn by both sexes, comprise armlets for the upper arm and bracelets for the wrists. They could be either flexible or rigid,

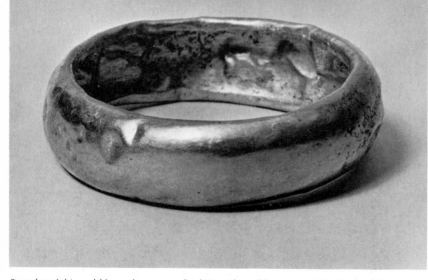

Bracelet of thin gold from the cenotaph of King Kha-sekhem-wy at Abydos. IInd Dynasty. Metropolitan Museum of Art, New York

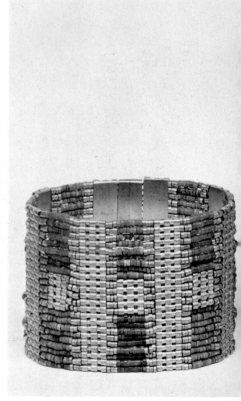

Bracelets of Sit-Hathor-Yunet shown clasped, made of carnelian and turquoise beads separated by gold spacer-bars and slides inlaid with the prenomen of Ammenemes III. Metropolitan Museum of Art, New York

depending upon whether their prototype was a string of beads or a section of elephant tusk, a type of bangle which is still in fashion today in various parts of Africa. In the Old and Middle Kingdoms, only bracelets were worn: armlets do not make their appearance on the monuments until the beginning of the New Kingdom. Nevertheless, it is clear that single strings of beads were sometimes worn above the elbow, as was found to be the case when the mummy of Princess Ashyet of the Eleventh Dynasty came to be unwrapped.

The rigid armlets are copies of shell or ivory prototypes. The earliest known example in gold dates to the Archaic Period, but the silver bracelets of Queen Hetep-her-es are of the same design, though inlaid with coloured stones (3). Such bracelets in graduated sets were worn only by women on the forearms. They went out of fashion during the later Fourth Dynasty. The simple ring bangle, square in cross-section, was originally of ivory, but in time, versions in metal and faience were also made. During the Eighteenth Dynasty they appear to have been worn in pairs on the upper arm, particularly during the period from Amenophis II to Amenophis III. A metal version of what looks like an ivory bracelet is found in the reign of the latter king worn on the wrist of one arm only (42), whereas in the reign of his son Akhenaten an example is worn on each wrist.

The jewelry from the tomb of King Djer at Abydos shows that flexible bead bracelets were in use by the First Dynasty, and the future development lay only in the use of spacer beads and an increase in the number of strings of beads that could be incorporated into such jewels by lengthening the spacer-bars. Methods of fastening the ends of the band together were also devised as an improvement on the mere knotting of tie-strings which was apparently the original means if we are to trust the coffin pictures of the Middle Kingdom. The Dahshur and Lahun bracelets had a detachable inlaid member which was part of the decorative pattern and could be slid into position on grooved bars forming the terminal spacers of the bead-work (21, 25, 33).

Anklet fastening

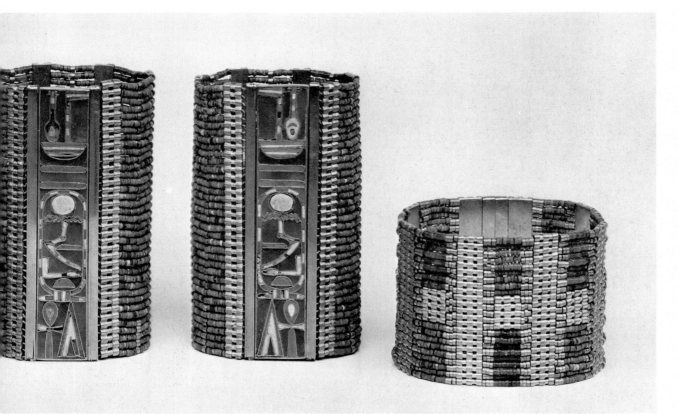

An elaboration of the simple string of beads worn on the upper arm, as for instance by Princess Ashyet, is the so-called motto-clasp favoured by the royal women of the next dynasty. These are inlaid jewels composed of glyphs and symbols forming a name, motto, or good wish; and were fastened to the upper arm with a cord or string of small gold beads. Associated with them are other single strings of beads incorporating figures of recumbent lions, which were apparently worn by the princesses as bracelets (21, 28). By the time of King Ka-mose of the Seventeenth Dynasty such jewels had become armlets. He had a pair of lions flanking the name of his brother Amosis; they had originally been tied by a stout cord around his right arm, though they were found loose in the debris in his coffin. The motto-clasp had thus become combined with the lion figurines, and the integration of the two types of bracelet is found in the complete gold armlet belonging to Ka-mose's

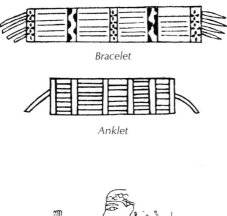

Bracelet

Anklet

Dancer from Qau

mother, Queen Ah-hotpe, who in life certainly wore it above her elbow (37, 38). Similar feline animals, such as cats and sphinxes made in gold or hardstones, are incorporated in the jewelry dated to the centuries following the fall of the Twelfth Dynasty and are still to be seen in the armlets of the queens of Tuthmosis III.

The flexible wristlets and the rigid bangles combine their functions in the hinged bracelets which also appear at the beginning of the New Kingdom, when two half-cylinders of metal are hinged together at both edges, one hinge having a retractable pin to allow the encircling band to be opened (44). Simple plain bracelets of gold in this design were supplied for the queens of Tuthmosis III; but other bracelets in the parure were more elaborate, with inlays of ribbed carnelian, felspar and glass cemented in position, being in fact rigid versions of the bead-and-spacer bracelets of the Middle Kingdom (51).

As the New Kingdom progressed, even more opulent arm ornaments were made in this design; and the carnelian and sard plaques of Amenophis III, the massive bracelets and armlets found on the limbs of Tut-ankh-amun (74), and the gold bracelets of Ramesses II from the Tell Basta hoard (87, 88) are all in the same tradition. So are the silver pair found in the burial of Queen Twosre's daughter, though their flimsy construction may owe much to the probability that they were destined only for funerary use.

The ornaments of the legs, the anklets, are indistinguishable in design and manufacture from those of the arms. In the coffin pictures they are identical; and both in actuality and on the monuments they were made *en suite*. Generally, however, the anklets are rather less deep than the bracelets, though not, for instance, in the case of the jewelry worn by a daughter of Djehuti-hotpe at Deir el-Bersha. They are shown as worn by women only until the early Ramessid period. As it is physically impossible to pass a rigid ring over the instep so as to make it fit snugly around the lower leg, anklets were at first of flexible bead-work secured with ties or clasps. Later, they too were made solid and hinged in two halves, so that it is difficult to distinguish them from bracelets (100, 101). One such specimen, found on the body of Tut-ankh-amun, has been identified as a bracelet, though it was found in the region of the King's legs. It is probable that all such leg ornaments were worn just above the ankle.

A peculiarity of women's anklets in the Middle Kingdom is the bird-claw pendant worn on a string or double string of beads (12, 23). Some of these pendants are very elaborate; the specimens belonging to the Princess Khnumet found at Dahshur were of goldwork, with an imbricated pattern in cloisonné-work. Usually one claw only was worn over the outer ankle-bone, but anklets exist

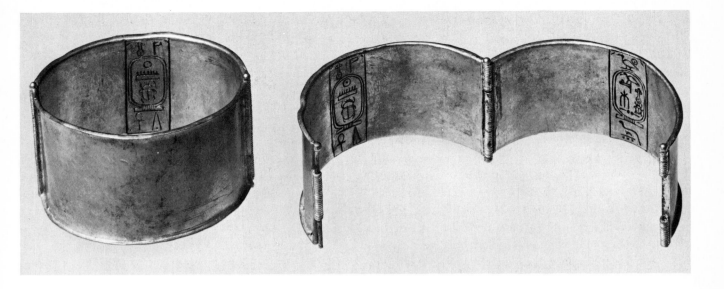

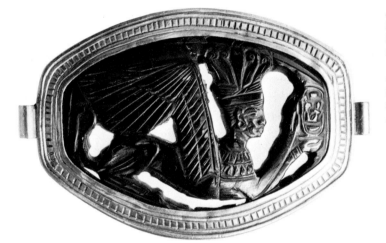

Anklet, gold inscribed with the name of Tuthmosis III, belonging to one of his queens, made of two half-cylinders hinged together with retractable pin fastener. XVIIIth Dynasty. Metropolitan Museum of Art, New York

Dark sard plaque in a modern gold mount, one of several from bracelets of Amenophis III, showing a winged female sphinx supporting his name. XVIIIth Dynasty. Metropolitan Museum of Art, New York

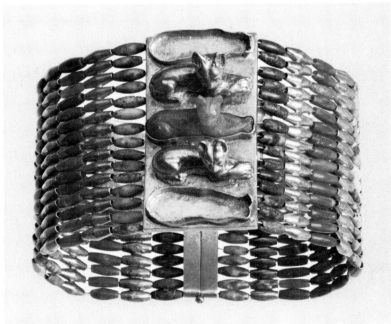

Armlet of carnelian, green felspar and blue paste (restored) beads with a gold spacer decorated with recumbent cats, belonging to a queen of Tuthmosis III. XVIIIth Dynasty. Metropolitan Museum of Art, New York

where several claws are spaced at intervals on the same string of beads.

Towards the end of the Old Kingdom there came into fashion a novel type of seal, to which archaeologists have given the description 'button seal' from the appearance of the majority of such objects. They are usually made of glazed steatite, but may be carved from other substances. They were soon ousted from favour by the scarab, however, which was partly an amulet and partly a signet. Many thousands of scarabs were thenceforward to be made in Egypt, mostly in glazed steatite but also in other materials, and have become the characteristic product of ancient Egypt and of modern forgers.

Essentially they are objects of cabochon shape, pierced through their greater diameter by a thread-hole, the convexity being carved more or less realistically as a scarab beetle, and the base usually incised with an inscription. The first scarabs may have been worn like a bead on a string; but the custom soon arose of tying them on the fingers by a thread. In more permanent examples, the thread was replaced by gold wire; and at that point the signet ring had been invented. The finds at Dahshur (32) and Lahun yielded nearly three dozen scarabs in cloisonné-work and precious stones inscribed with the names of the princesses or contemporary Pharaohs, as well as decorative devices. About a third of them are strung on gold wire rings with their ends coiled to imitate linen thread.

During the Second Intermediate Period the finger-ring underwent a full mechanical development, the wire being thickened into a rod of hoop shape with knopped ends, around which the thinner suspensory wire could be wrapped. The next stage was to flatten the knops and perforate them, in order to take a thick wire rivet on which the scarab could turn. Another method was to draw out the ends of a length of thick wire bent into a ring and to insert them from opposite ends of the hole in the scarab, coiling the emergent lengths onto the body of the ring (60). At the same time the scarab itself was mounted in a gold or silver funda with tubes to take the rivet or wires (103). The last stage in the development was to cast the ring and a non-swivelling scarab-shaped bezel in one piece (59, 60), and such massive metal signet rings are characteristic of the Amarna Period, when lighter versions in faience were also made, probably for distribution as favours on the occasion of festivals and Court functions. Different ways of making metal finger-rings, however, were employed at the same time; but the only change that the finger-ring underwent in post-Amarna times was a tendency for the bezel to be isolated from the mass of the ring and to assume more the appearance of an inscribed plate attached to a hoop.

Other amulets, such as the *wedjet*-eye, in hard stones may take the place of the scarab in finger-rings worn for decorative or protective purposes (60, 103). The ring with an inscribed bezel acting as a signet appears to be an Egyptian invention, the development of which can be traced. It is worthy of note, however, that decorative types of finger-rings, fully evolved, appear in the Dahshur treasure, and since their bezels are ornamented with granular designs, it is probable that the finger-ring, as distinct from the signet, was in origin an Asiatic import.

There are several jewels which, although represented on the monuments, have not been found in actuality. Thus queen-mothers and principal queens are shown on state occasions wearing an elaborate ornament on their hair or wigs in the form of the feathered skin of a vulture (90), its head thrust forward over the brow, the body fitting the skull like a cap, its tail descending over the occiput, and each wing and leg falling on each side of the head behind the ear. The wig-cover in New York, however (53), gives us more than a hint of how such jewels were made in reality. They must have been composed of plates of gold cloisonné-work, threaded together to form a flexible headgear of great magnificence and no little weight.

There are also stoles in bead-work, of which only one possible example has survived from the tomb of Tut-ankh-amun (72). Certain garments peculiar to the king, such as the imbricated corselets and the apron hanging from the belt (95), though made in gold cloisonné-work, are to be regarded more as items of dress than as jewels. Again, the only specimens known belong to Tut-ankh-amun. In the same category of clothing are to be placed the belts made of bead-work, sometimes in the funerary versions having an apron of long bead pendants (9). An exception, however, is perhaps to be made of the belt of Prince Ptah-Shepses of the Fifth Dynasty, which is more the work of the jeweller than the tailor.

The thin ribbons, presumably of gold in the wealthiest examples, which bound the bouffant coiffures or wigs of women in the Middle Kingdom and Early New Kingdom, have not been found intact; and the bobbins with carnelian bosses, around which the ends of the two large pendant wings of these same wigs were wound (18), have not been identified. Conversely, a curious amuletic pendant in the form of a tubular case, usually decorated in various ways, and generally hollow though sometimes solid (33), has never satisfactorily been explained, though it is often found in the graves of women during the Middle Kingdom, and even as late as the reign of Tuthmosis III.

Epilogue

For reasons which we have already emphasized, the mass of Pharaonic jewelry that has eluded the depredations of time and man is relatively small and hardly representative of the craft throughout its long history in ancient Egypt. But although the small extent of this random sampling has allowed it to be studied fairly intensively, a great number of questions still await answers, particularly in regard to ancient techniques and designs. The technical examination of Egyptian jewelry by modern craftsmen has suffered from too ready an assumption that the ancient jewellers used most of the materials, tools and processes available today, when it is clear that such is not the case. Before any further progress can be made along this line of research, museum authorities will have to sanction the use of more scientific means of examining ancient jewelry; and the microscope, X-rays and the spectroscope will have to be pressed into service much more than they have been used in the past. At the moment, no accurate analyses of many ancient materials, and particularly of their trace elements, have been recorded. Without fuller and more accurate data it is idle to speculate on the nature of ancient technical processes, the trade routes by which they were disseminated and the cultural contacts that they show.

Studies by Winlock and others have indicated what a valuable contribution stylistic analysis can make to the recovery of the forms and appearance of ancient jewelry: but more remains to be done in this field of design. Lastly, in an age of increased awareness of the importance of 'conservation', it should not need to be stressed that when they were first displayed in all their splendour, the jewels of the Pharaohs did not exhibit that tarnish and damage which are all too often their portion today.

Pendant in the form of a bulti-fish: gold inlaid with carnelian, turquoise and lapis lazuli. XIIth Dynasty. Walters Art Gallery, Baltimore

Chronological Table

Archaic Period *c.* 3100–2686

Dynasty I *c.* 3100 . Djer *c.* 3045–3020
Dynasty II *c.* 2890 Kha-sekhem-wy *c.* 2704–2686

Old Kingdom *c.* 2686–2160

Dynasty III *c.* 2686 Sekhem-khet *c.* 2642–2638
Dynasty IV *c.* 2613 Queen Hetep-her-es *fl. c.* 2600
Dynasty V *c.* 2494 . Sahu-re *c.* 2483–2469
. Nefer-ir-ka-re *c.* 2469–2460
Dynasty VI *c.* 2345 .
Dynasties VII–VIII *c.* 2181–2160 .

First Intermediate Period *c.* 2160–2040

Dynasties IX–X .
Dynasty XI (part) .

Middle Kingdom *c.* 2040–1633

Dynasty XI (part) *c.* 2040 Mentu-hotpe II *fl. c.* 2050
Dynasty XII 1991 . Ammenemes II 1929–1895
. Sesostris II 1897–1878
. Sesostris III 1878–1843
. Ammenemes III 1842–1797
Dynasty XIII 1786–1633 .

Second Intermediate Period *c.* 1633–1559

Dynasty XIV *c.* 1786–1600 .
Dynasties XV, XVI *c.* 1674–1559 .
(Hyksos Kings) .
Dynasty XVII *c.* 1650–1559 .
(Theban Kings) . Sobek-em-saf II *fl. c.* 1630
. Nub-kheper-re Intef *fl. c.* 1600
. Ka-mose *c.* 1562–1559
. Queen Ah-hotpe *c.* 1580–1540

New Kingdom 1559–1085

Dynasty XVIII 1559 . Amosis 1559–1531
. Tuthmosis III 1490–1436
. Amenophis III 1405–1367
. Akhenaten 1378–1362
. Tut-ankh-amun 1362–1353
Dynasty XIX 1320 . Ramesses II 1304–1237
. Sethos II *c.* 1223–1218
. Queen Twosre *c.* 1223–1200
Dynasty XX 1200 . Ramesses III 1198–1166
. Ramesses IX 1140–1121

Tanites 1085–945

Dynasty XXI . Psusennes I *c.* 1070–1052
. Amenophthis *c.* 1052–1003

Libyans 945–751

Dynasties XXII–XXIV . Osorkon II *c.* 860–832

Late Period 751–332

Dynasties XXV–XXXI .
(Kushites, Saites, Persians) .

Ptolemies 332–30

Note: All dates are B C. Only the names of the kings or queens mentioned in the text are given their place in this table.

THE COLOUR PLATES

Sources of the Illustrations

COLOUR PLATES (*by plate number*)

Albert Shoucair 1, 2, 4, 5, 10–19, 21, 26–33, 37–46, 57, 61–77, 79–84, 87, 88, 93, 94, 96–106; Peter Clayton 3, 6, 7–9, 20, 22–5, 47–55, 59, 85, 86, 89–92, 95, 107–9; Tom Scott, Edinburgh 34–6, 58, 60; courtesy of the Trustees of the British Museum 56; F. L. Kenet, copyright George Rainbird Ltd, 1963, 78.

MONOCHROME PLATES (*by page number*)
(Where not acknowledged in the captions)

Courtesy of Dr A. Klasens, National Museum of Antiquities, Leyden 12; Ross, Turin, courtesy of Dr Silvio Curto 13; courtesy of the Griffith Institute, Ashmolean Museum, Oxford 6, 32, 37 (top); Tom Scott, Edinburgh 27; Professor Max Hirmer 33; Costa, Cairo 37 (below left).

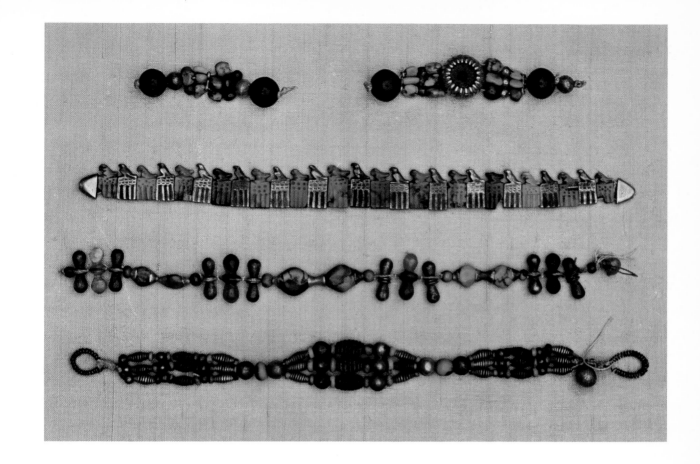

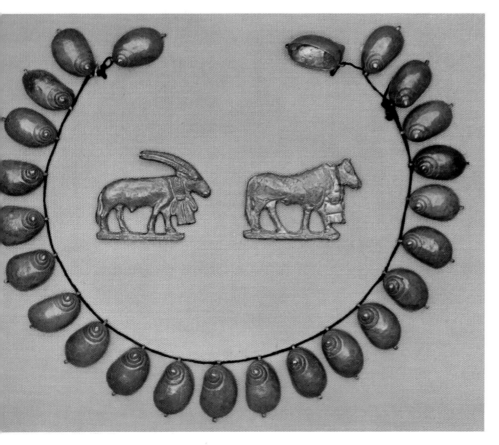

1 Bracelets from the tomb of King Djer, from Abydos

2 Gold ornaments of the Archaic Period, from Nag-ed-Der

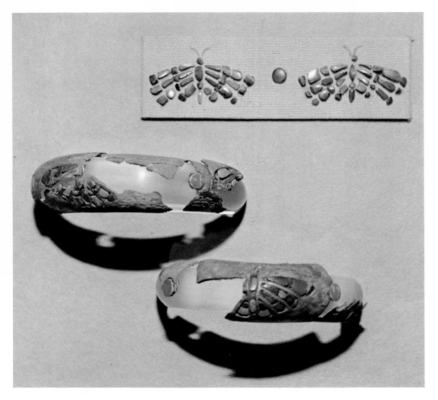

3 Silver inlaid bracelets of
Queen Hetep-her-es, from
Giza

4 Gold fillet of a princess,
from Giza

5 Gold beetle necklace of
a princess, from Giza

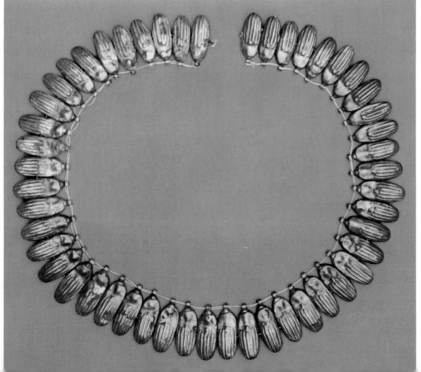

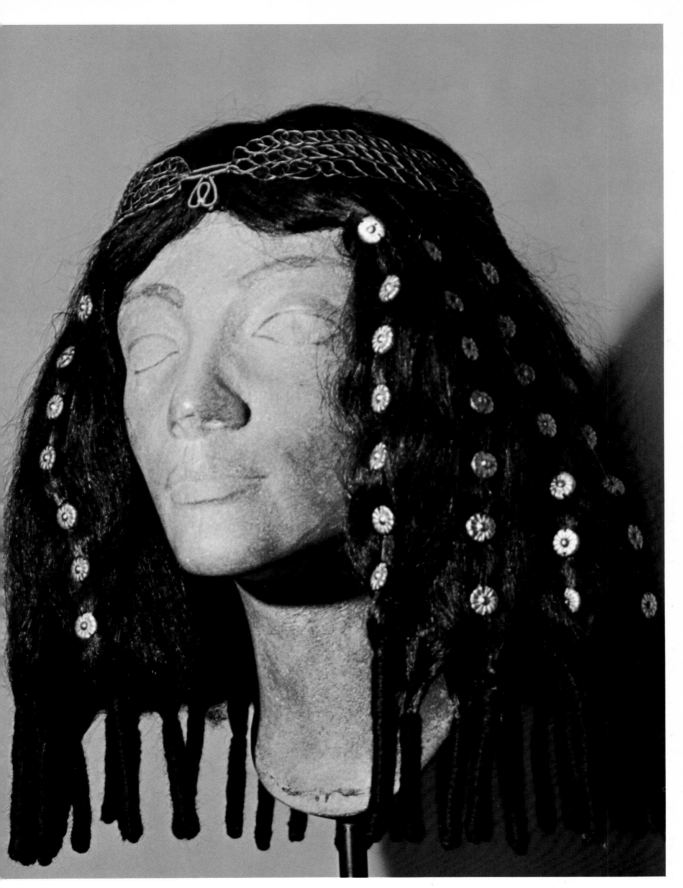

6 Gold wig ornaments and fillet of Seneb-tisi, from Lisht

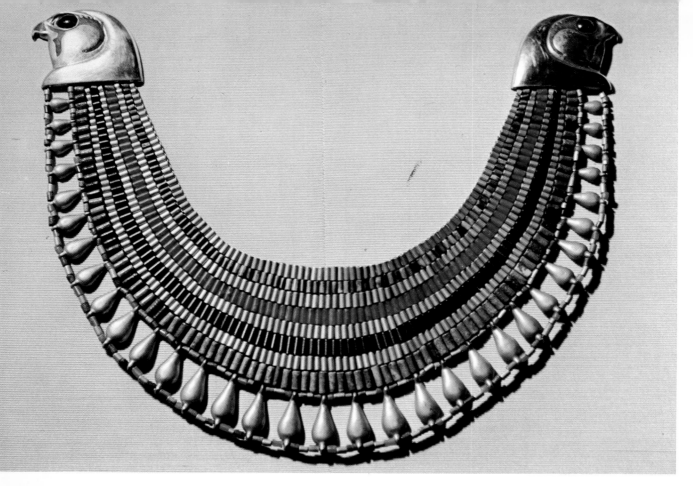

7 Gold, stone and faience Falcon Collar of Seneb-tisi, from Lisht

8 Gold, stone and faience Broad Collar of Seneb-tisi, from Lisht

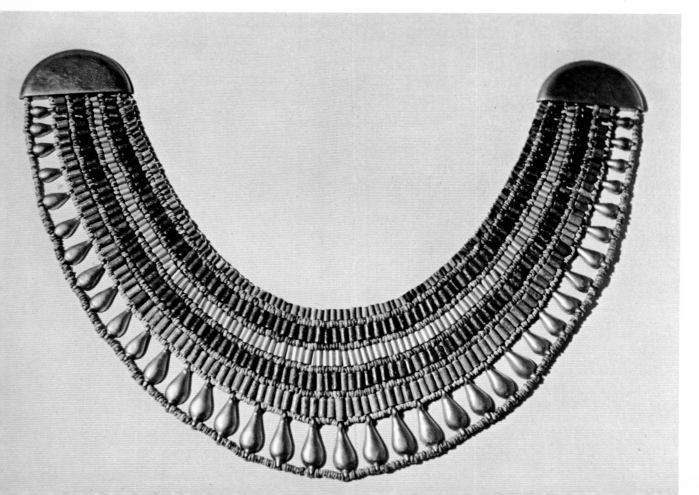

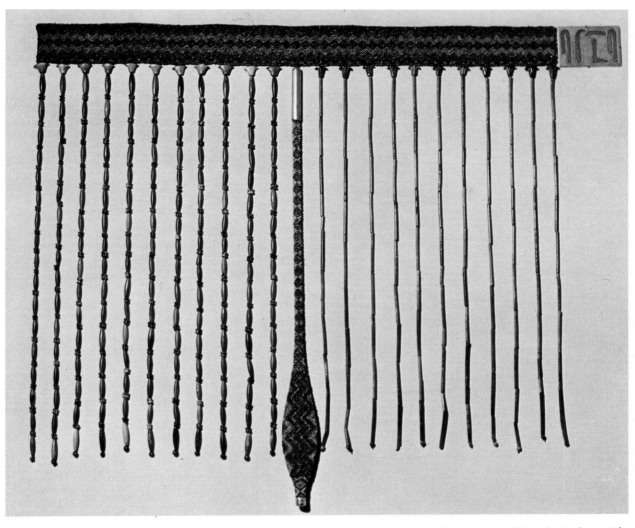

9 Bead belt and apron of Seneb-tisi, from Lisht

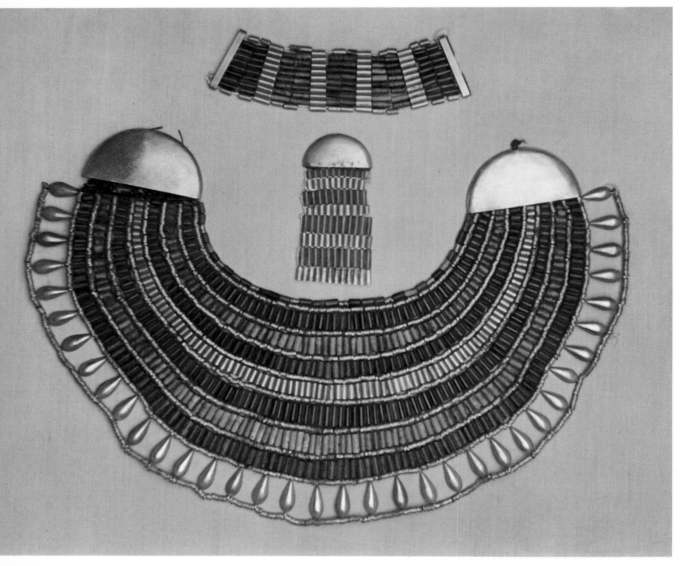

10 Broad Collar, counterpoise and bracelet of Princess Ita-weret, from Dahshur

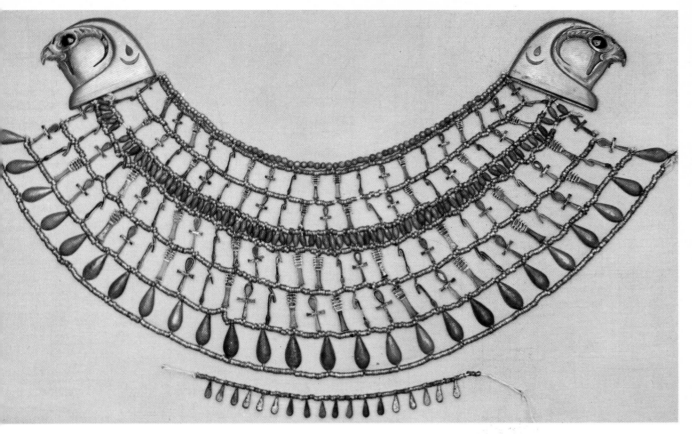

11 Falcon Collar of Princess Khnumet, from Dahshur

12 Funerary jewels of Princess Khnumet, from Dahshur

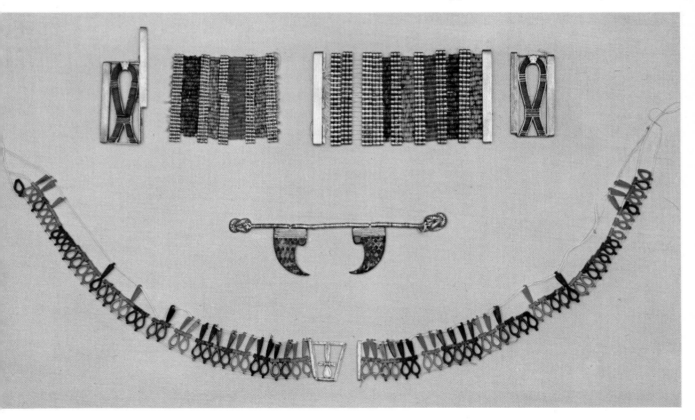

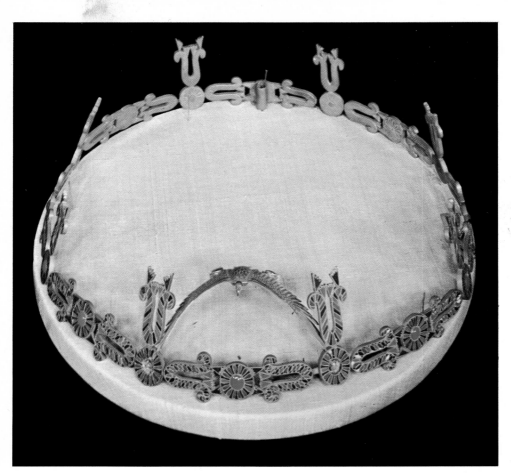

13 Crown of Princess Khnumet, from Dahshur

14 Floral circlet of Princess Khnumet, from Dahshur

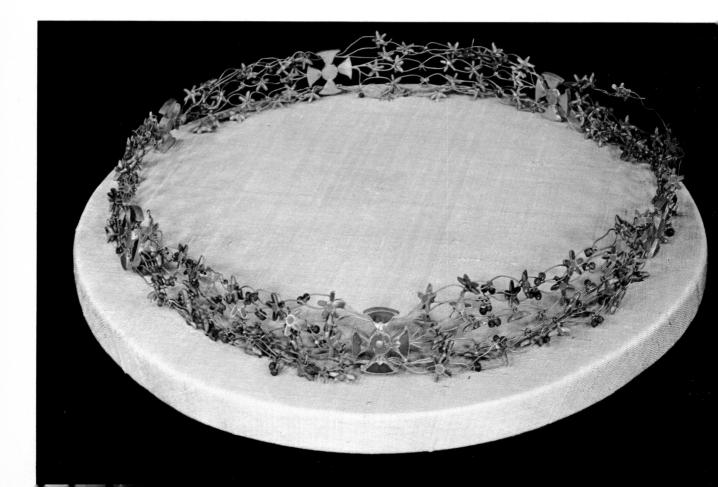

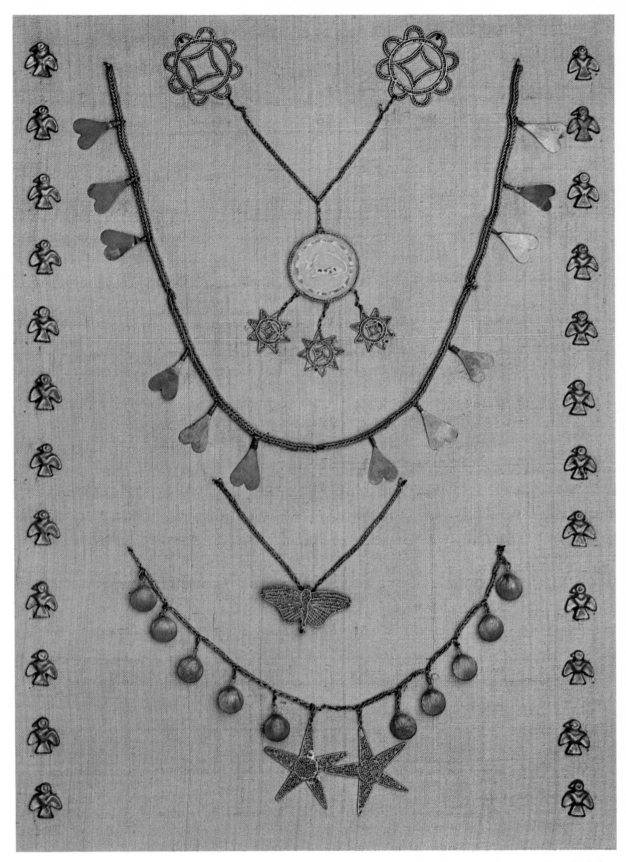

15 Granular jewelry of Princess Khnumet, from Dahshur

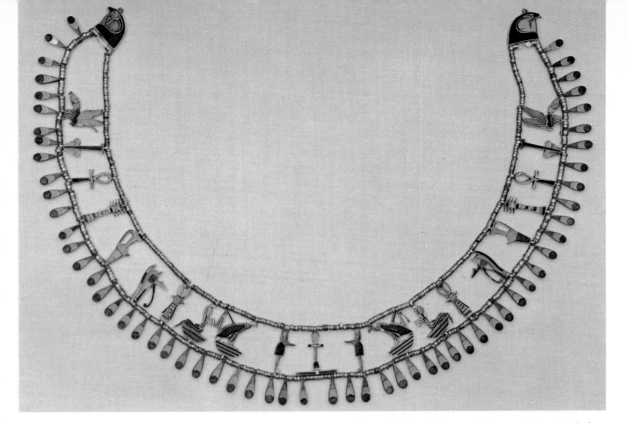

16 Falcon Collar of Princess Khnumet, from Dahshur

17 Motto clasps of Princess Khnumet, from Dahshur

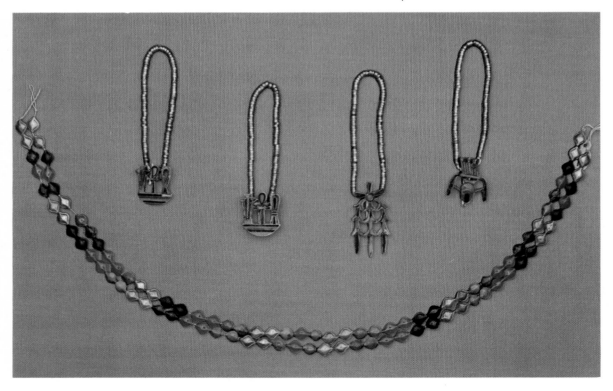

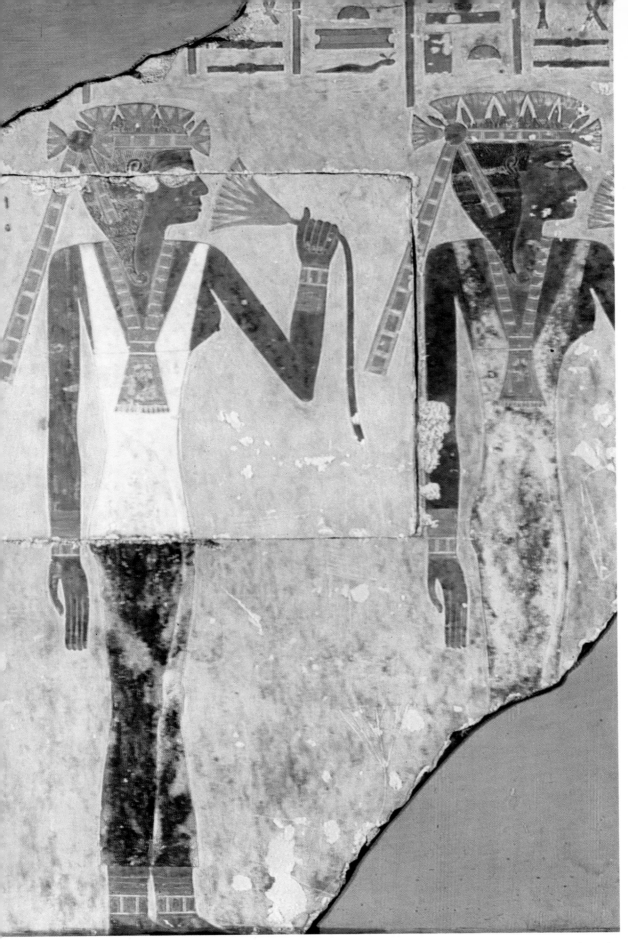

18 Wall-painting of the daughters of Djehuti-hotpe, from his tomb at Deir el-Bersha

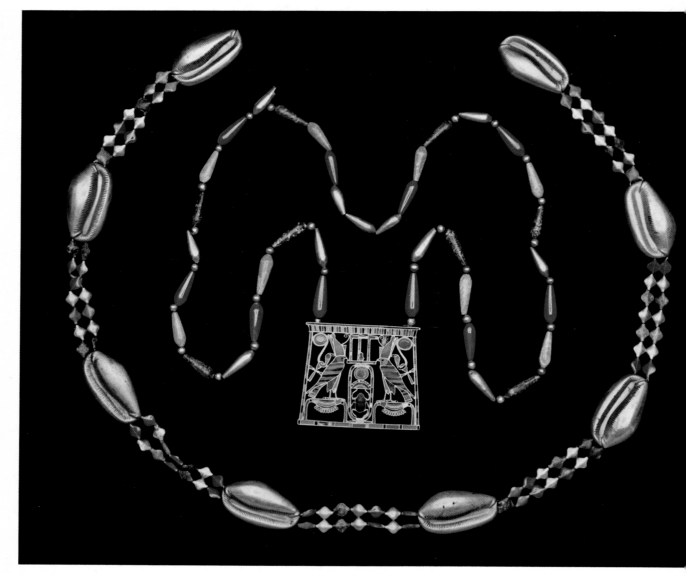

19 Necklace and pectoral of Princess Sit-Hathor, from Dahshur

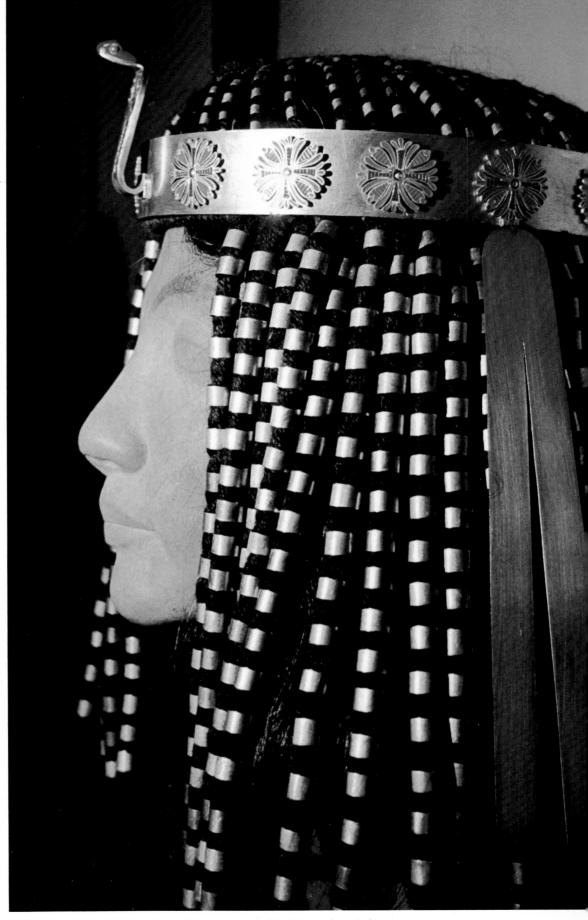

20 Wig ornaments and crown of Princess Sit-Hathor-Yunet, from Lahun

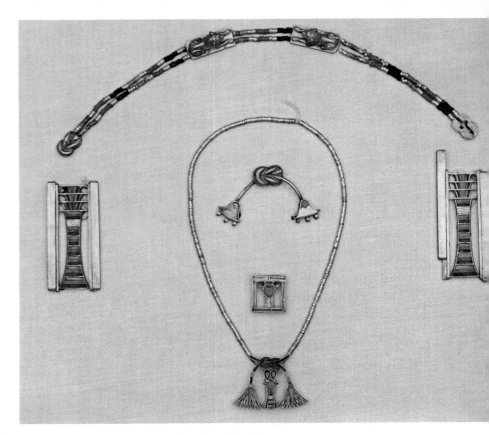

21 Jewelry of Princess Sit-Hathor, from Dahshur

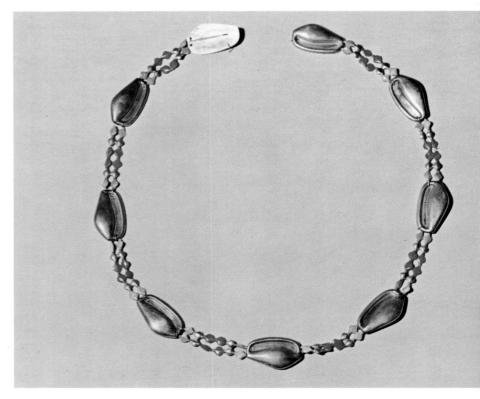

22 Gold cowrie-shell girdle of Princess Sit-Hathor-Yunet, from Lahun

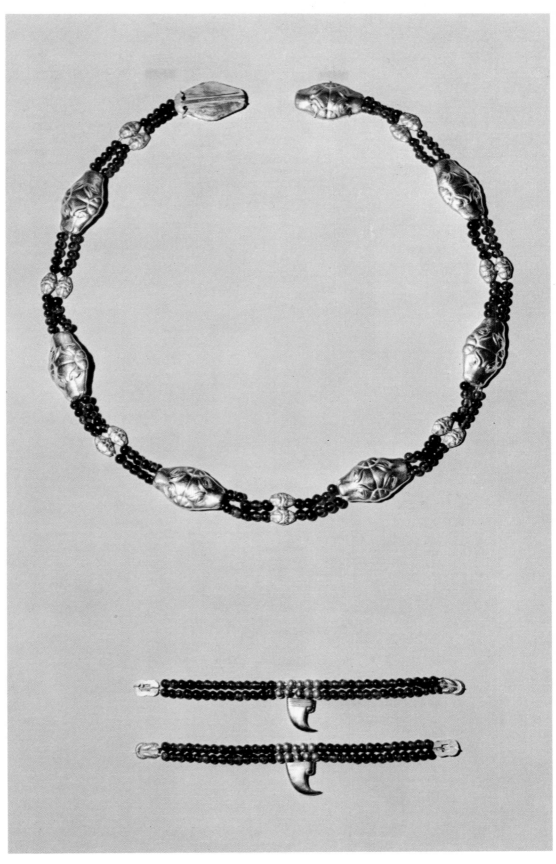

23 Gold leopard-head girdle and claw anklets of Princess Sit-Hathor-Yunet, from Lahun

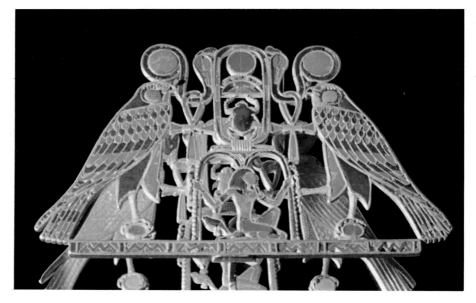

24 First pectoral of Princess Sit-Hathor-Yunet, from Lahun

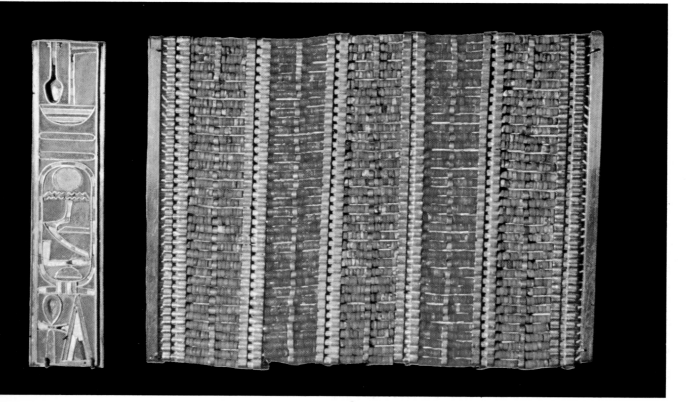

25 Bead bracelet of Princess Sit-Hathor-Yunet, from Lahun

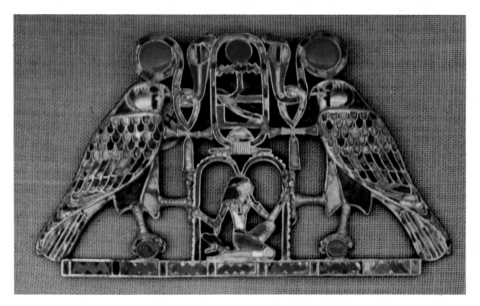

26 Second pectoral of Princess Sit-Hathor-Yunet, from Lahun

27 Uraeus of Sesostris II, from Lahun

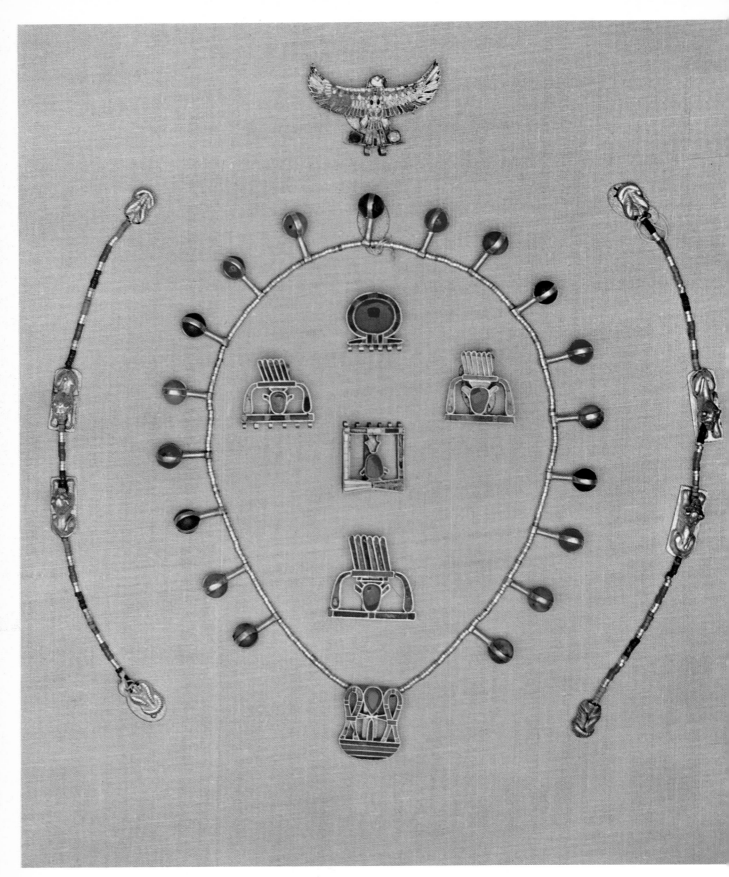

28 Jewelry of Queen Mereret, from Dahshur

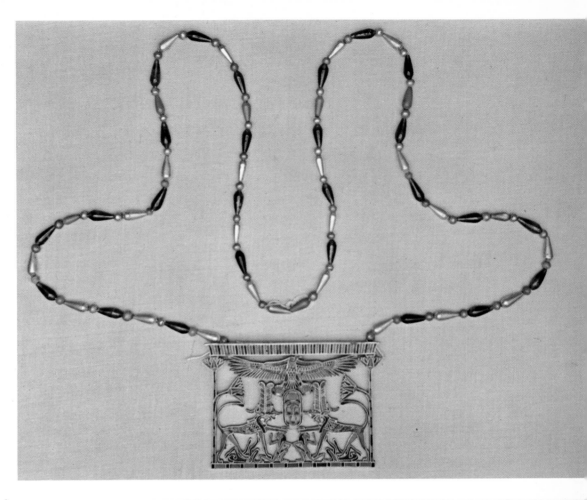

29 First pectoral of
Queen Mereret,
from Dahshur

30 Second pectoral of
Queen Mereret,
from Dahshur

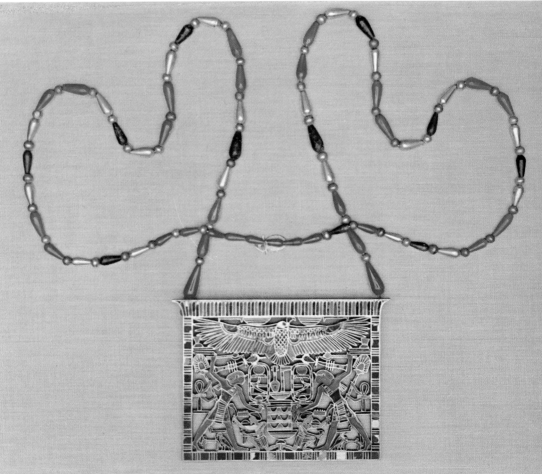

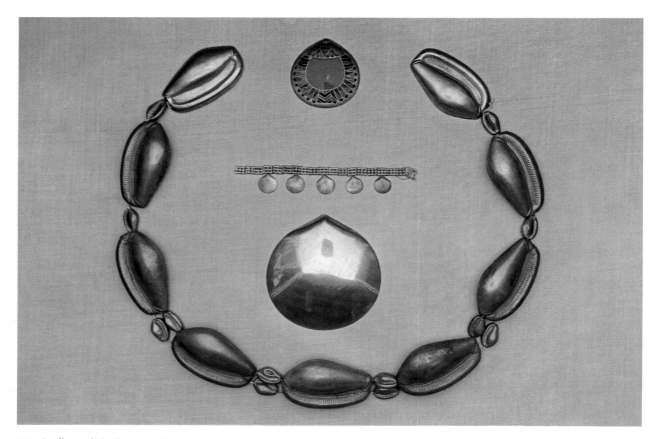

31 Girdle and shell pectorals of Queen Mereret, from Dahshur

32, 33 Jewelry of Queen Mereret,
from Dahshur

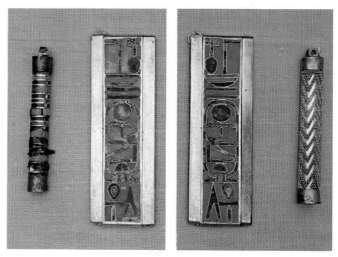

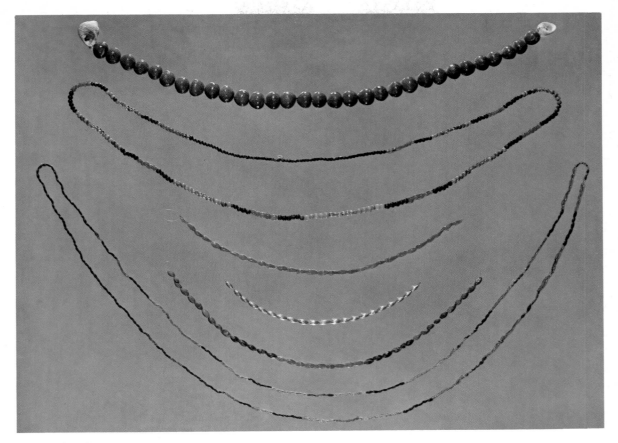

34 Bead necklaces of
the Middle Kingdom

35, 36 Electrum bead
girdle and gold parure,
Qurna

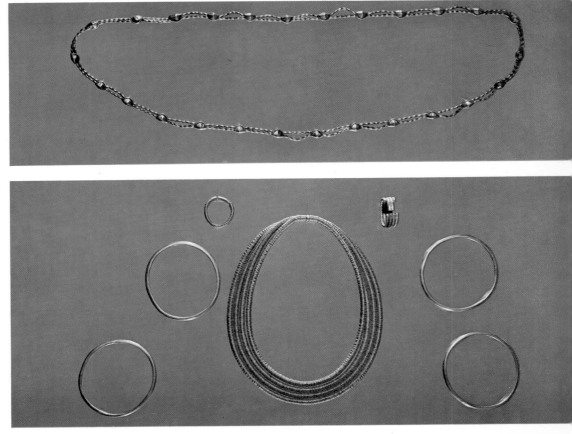

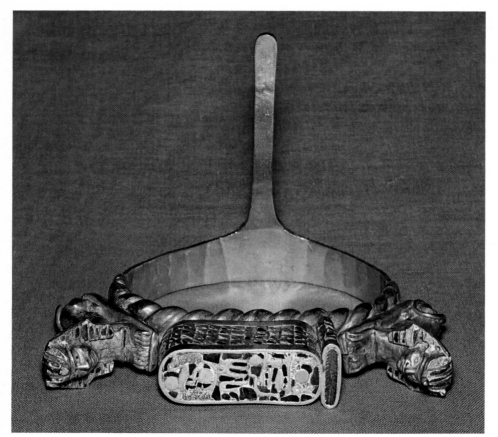

37 Armlet of Queen Ah-
hotpe with sphinxes, from
Western Thebes

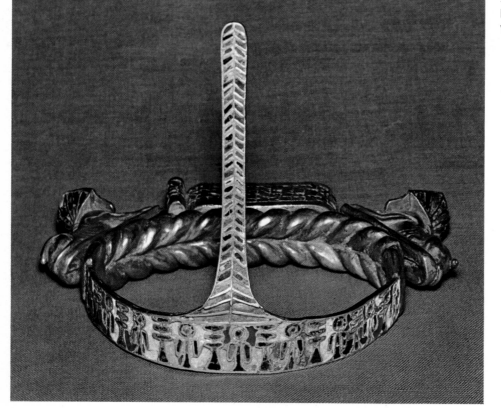

38 Armlet of Queen Ah-
hotpe with sphinxes, from
Western Thebes

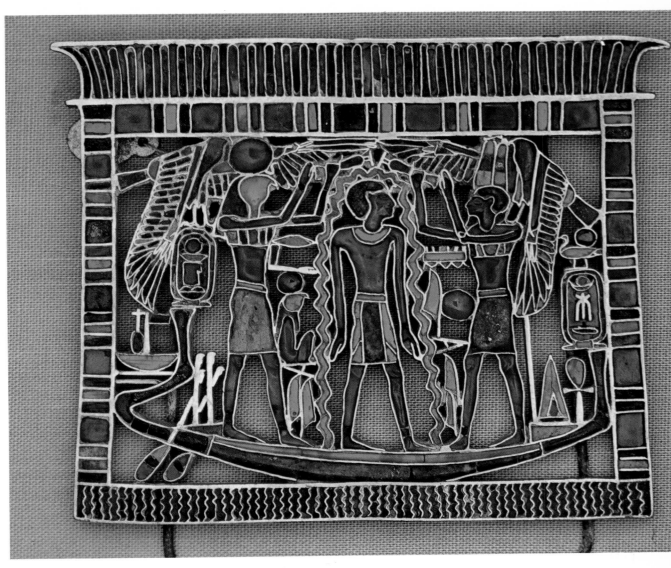

39 Pectoral of Queen Ah-hotpe, from Western Thebes

40 Bead bracelets of Queen Ah-hotpe, from Western Thebes

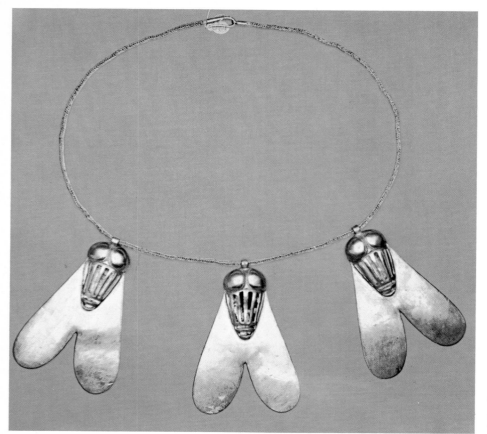

41 Gold flies of Queen
Ah-hotpe, from Western
Thebes

42 Gold bracelet of
Queen Ah-hotpe, from
Western Thebes

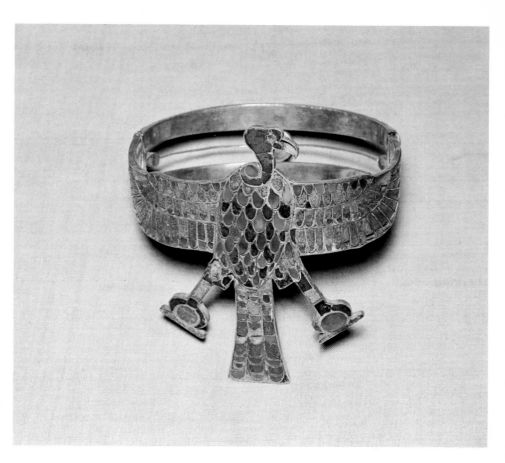

43 Armlet of Queen
Ah-hotpe in the form of
a vulture, from Western
Thebes

44 Rigid bracelet of
Queen Ah-hotpe, from
Western Thebes

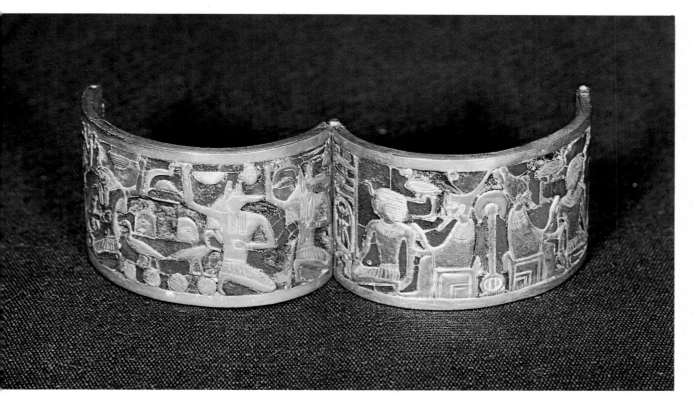

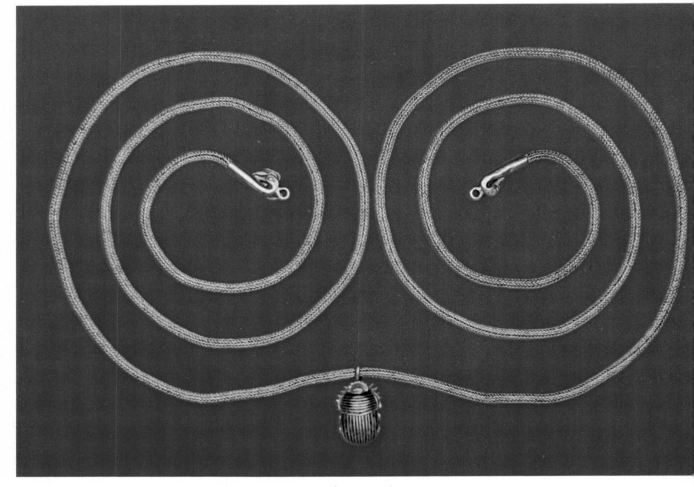

45 Scarab and chain of Queen Ah-hotpe, from Western Thebes

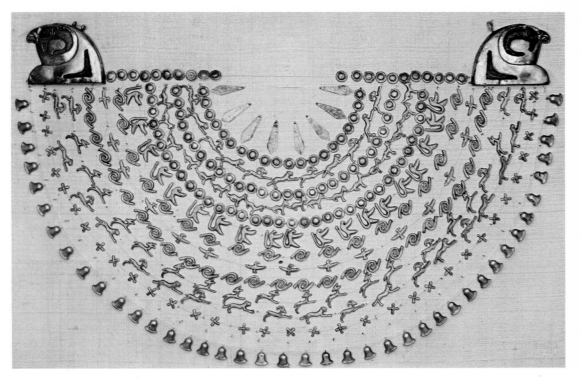

46 Falcon Collar of Queen Ah-hotpe, from Western Thebes

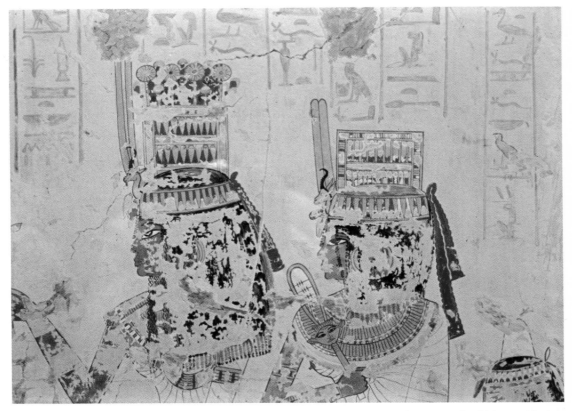

47 Wall-painting of royal concubines, tomb of Menna, Thebes

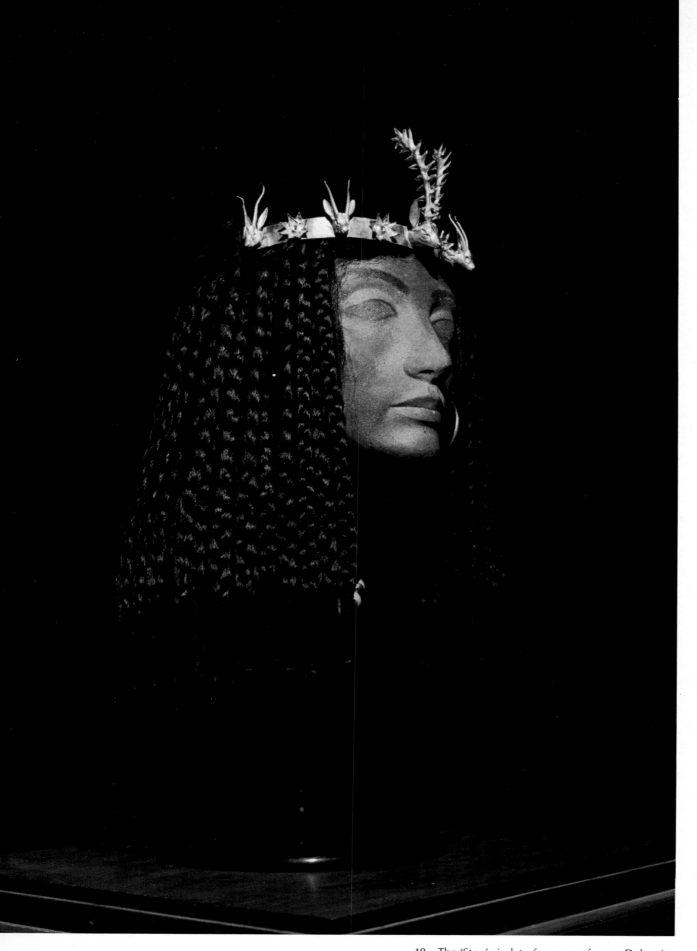

48 The 'Stag' circlet of a queen, from a Delta site

49 Gazelle circlet of a queen of
Tuthmosis III, from Thebes

50 Fish girdle of a queen of
Tuthmosis III, from Thebes

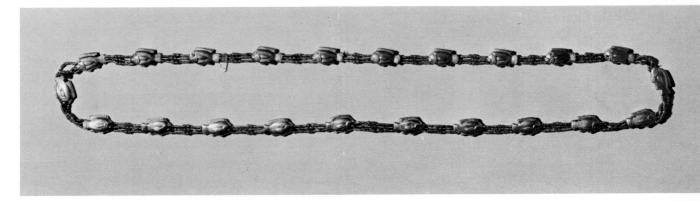

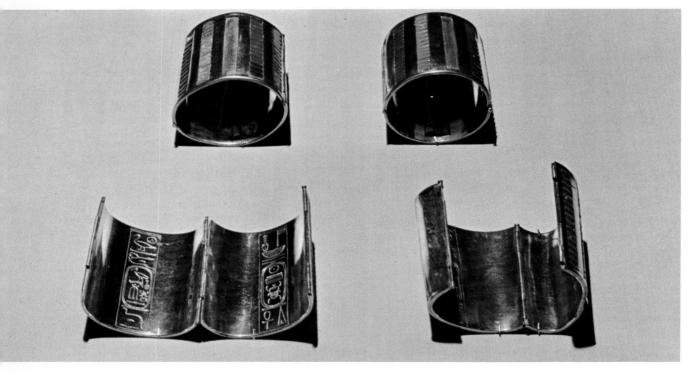

51 Gold rigid bracelets of queens of Tuthmosis III, from Thebes

52 Belt of a queen of Tuthmosis III, from Thebes

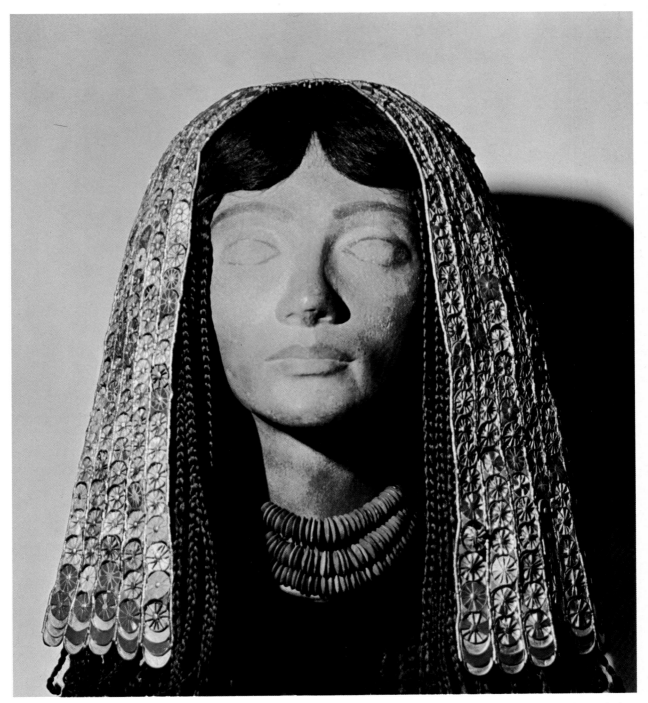

53 Long headdress of a queen of Tuthmosis III, from Thebes

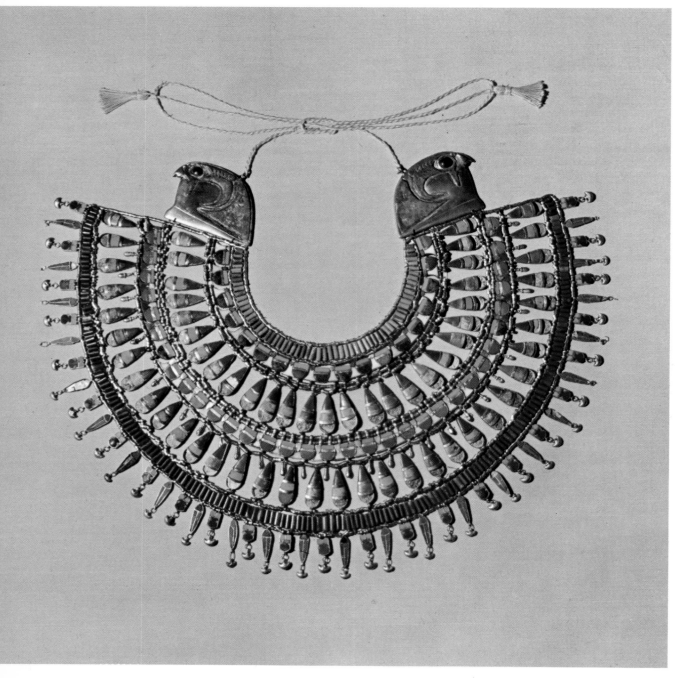

54 Falcon Collar of a queen of Tuthmosis III, from Thebes

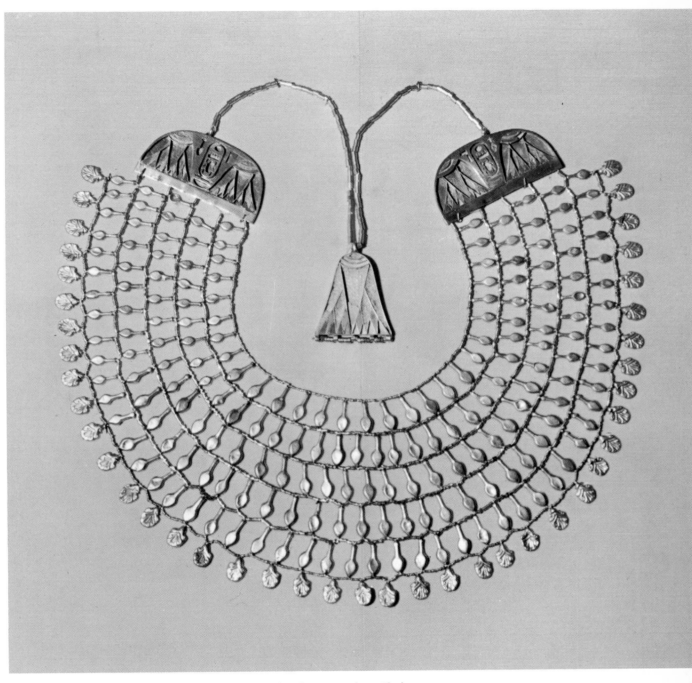

55 Broad Collar with flower terminals of a queen of Tuthmosis III, from Thebes

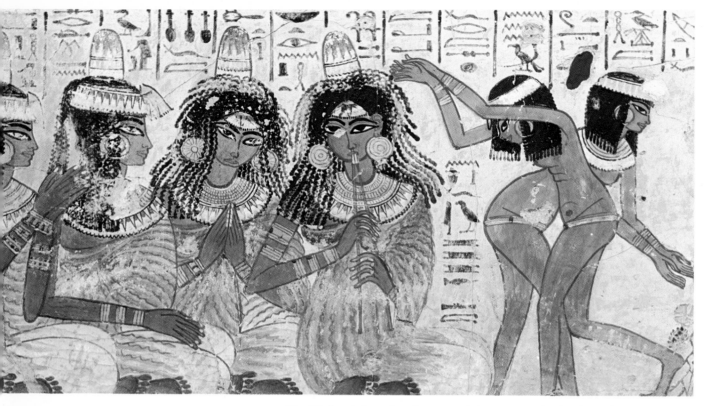

56 Wall-painting of orchestra and dancers, tomb of Neb-Amun, from Thebes

57 Broad Collar of King Smenkh-ka-re, from Thebes

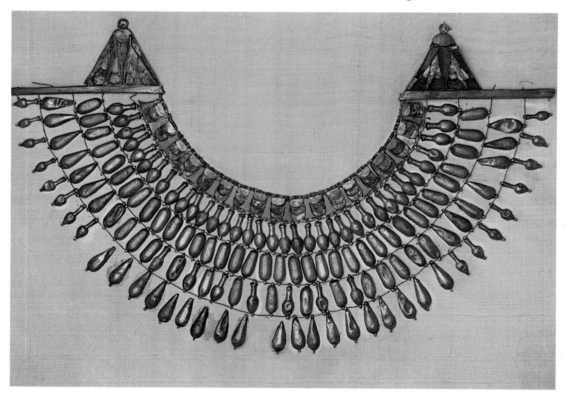

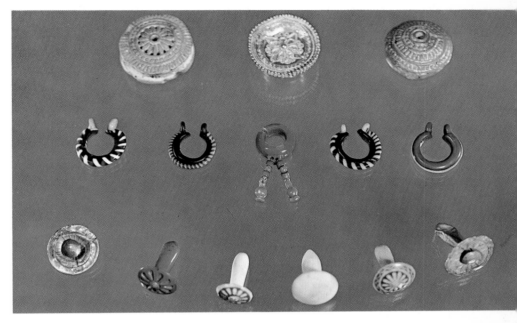

58 Ear-plugs and earrings of the New Kingdom

59 Rings of Amenophis III, the Aten and Akhenaten

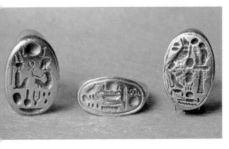

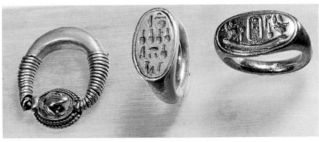

60 Rings of the Amarna Period

61 Gold Vulture Collar of King Smenkh-ka-re, from Thebes

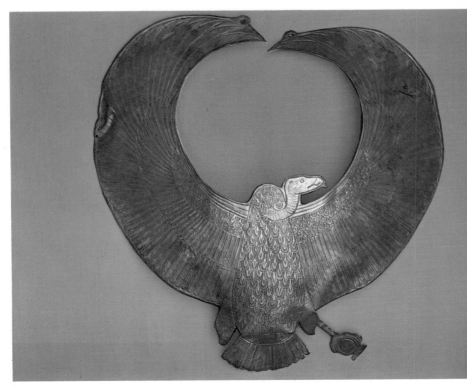

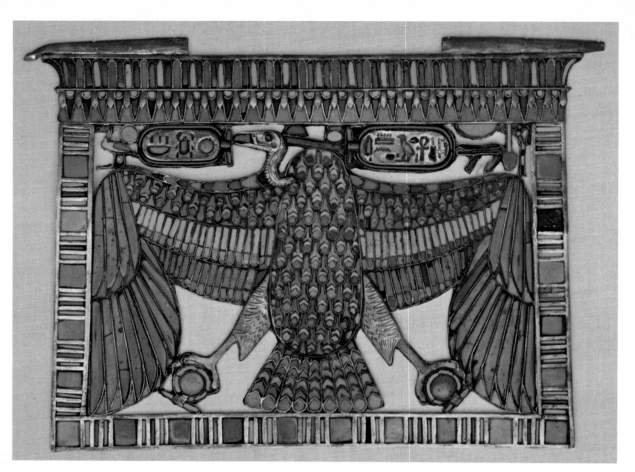

62 Vulture pectoral of Tut-ankh-amun, from Thebes

63 Winged scarab pectoral of Tut-ankh-amun, from Thebes

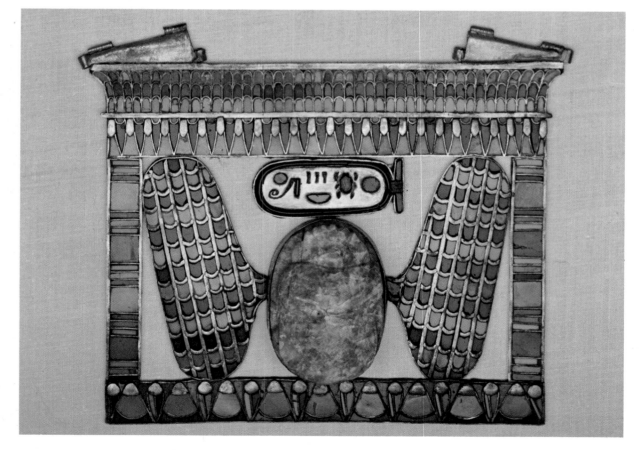

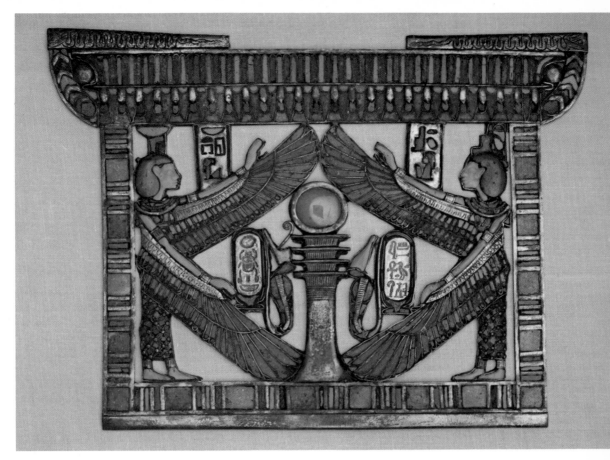

64 *Djed*-column pectoral of Tut-ankh-amun, with Isis and Nephthys, from Thebes

65 Osiris pectoral of Tut-ankh-amun, with Edjo and Nekhebet, from Thebes

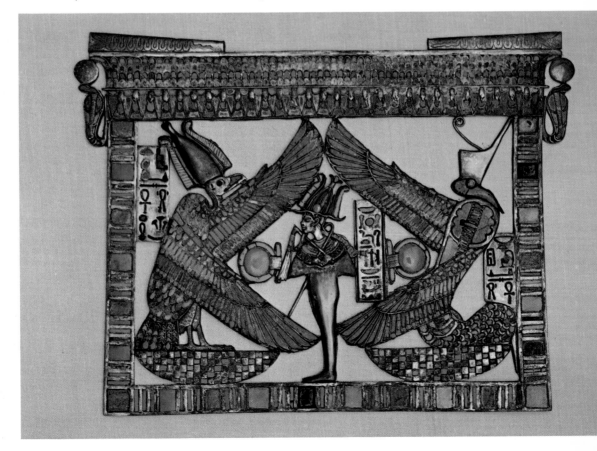

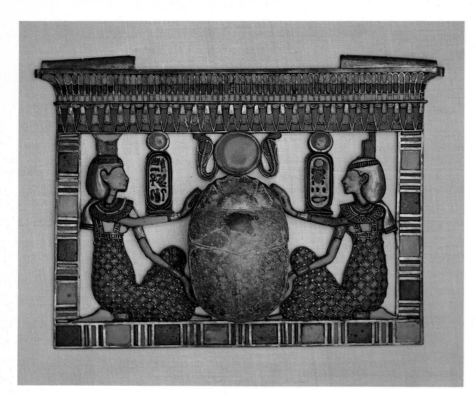

66 Scarab pectoral of Tut-ankh-amun, with Isis and Nephthys, from Thebes

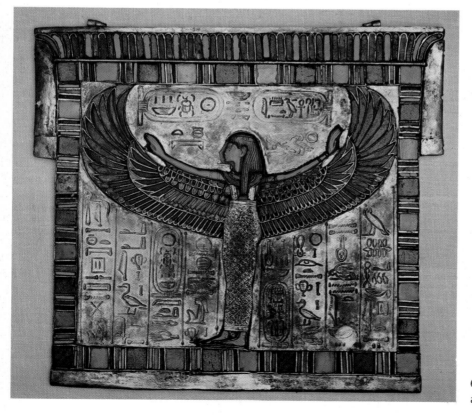

67 Nut pectoral of Tut-ankh-amun, from Thebes

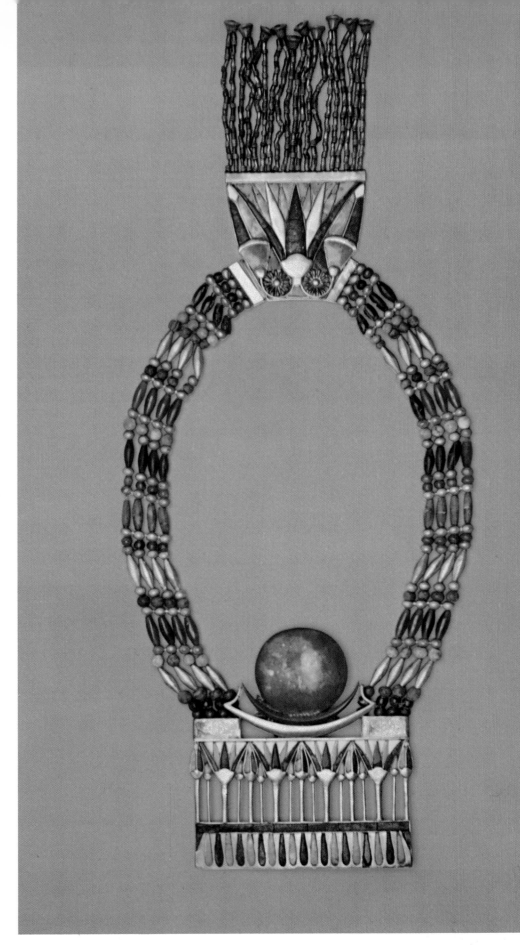

68 Pectoral of Tut-ankh-amun with moon bark, necklace and counterpoise, from Thebes

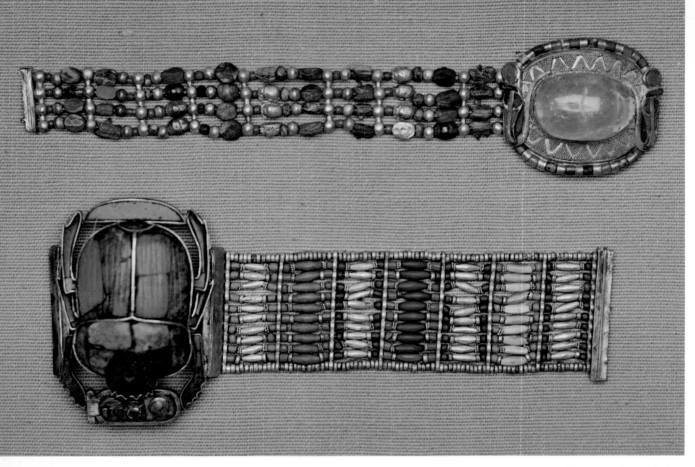

69 Two scarab bracelets of Tut-ankh-amun, from Thebes

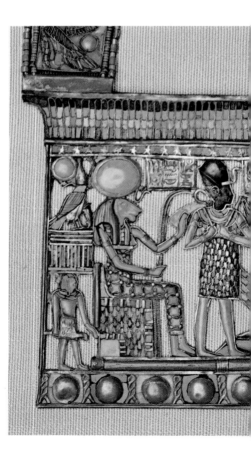

70, 71 Coronation pectoral
and counterpoise of Tut-
ankh-amun, from Thebes

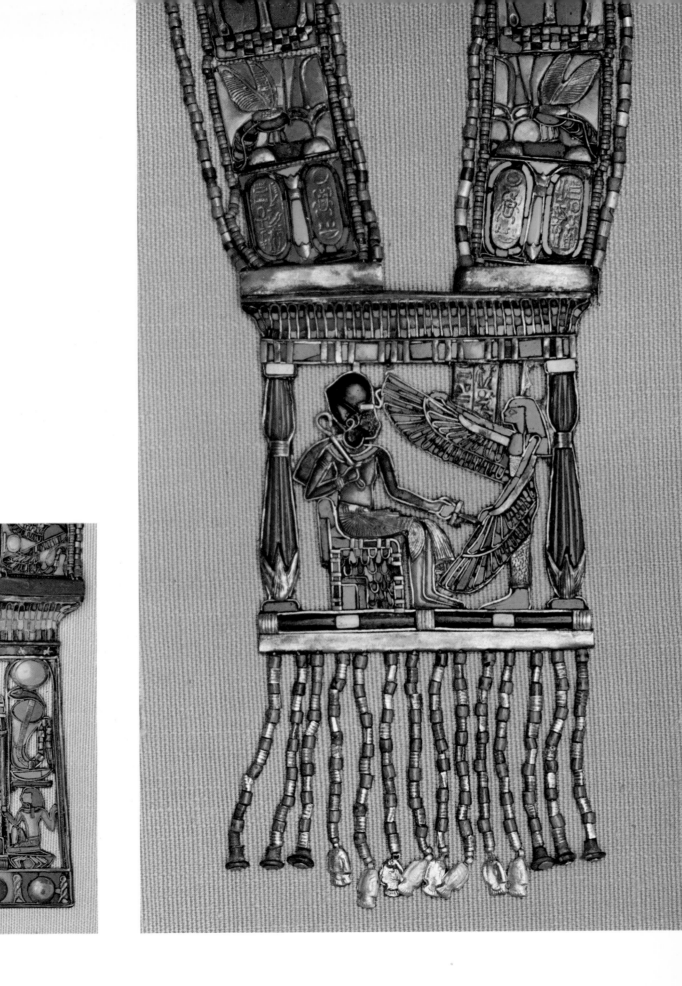

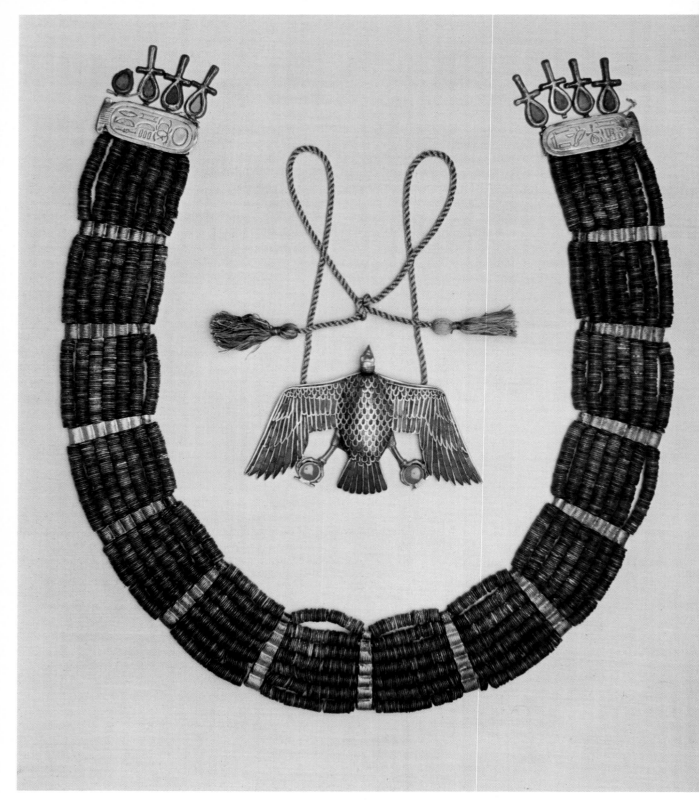

72 Bead stole and vulture pendant of Tut-ankh-amun, from Thebes

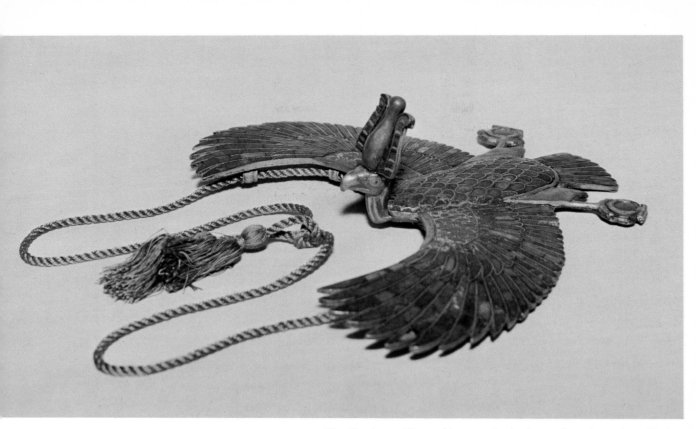

73 Pendant of Tut-ankh-amun in the form of a vulture, from Thebes

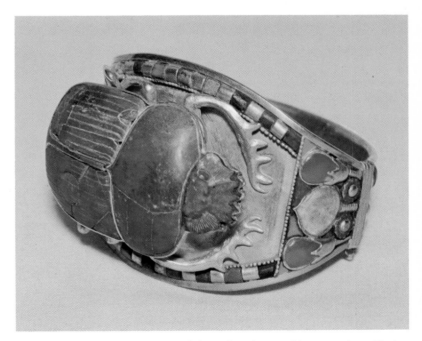

74 Massive scarab bracelet of Tut-ankh-amun, from Thebes

75–77 Scarab pendant (*below*) and two clasps
(*left*) of Tut-ankh-amun, from Thebes

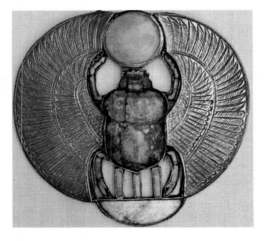

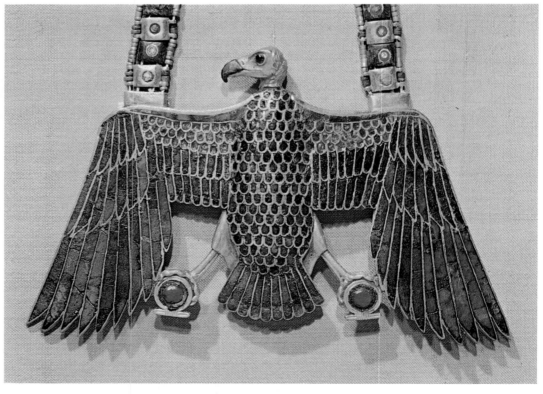

78 Vulture pectoral of Tut-ankh-amun representing Nekhebet, from Thebes

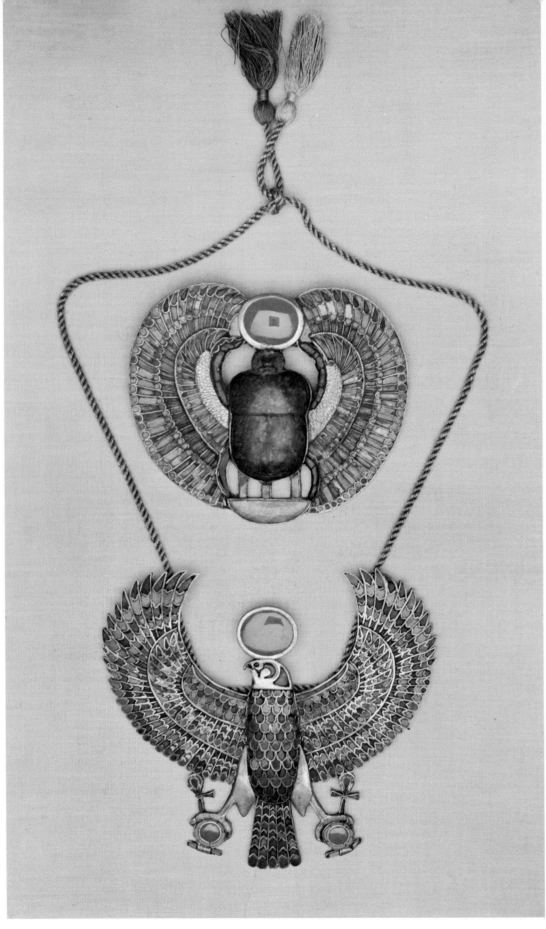

79 Scarab and falcon pendants of Tut-ankh-amun, from Thebes

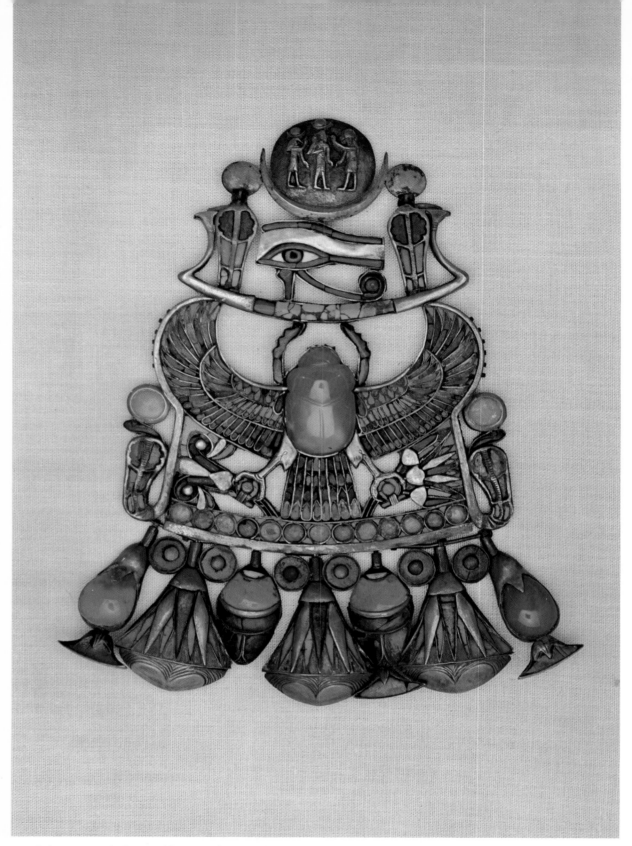

80 Rebus pectoral of Tut-ankh-amun, from Thebes

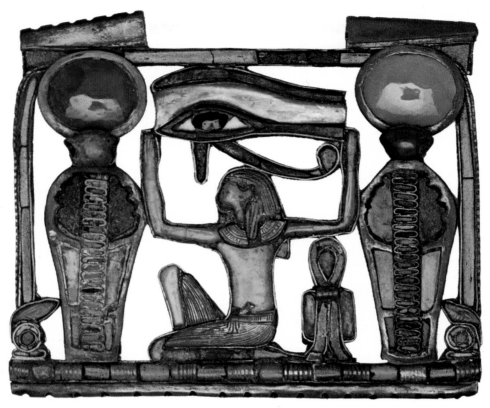

81 Counterpoise of Tut-ankh-amun, with figure of Eternity, from Thebes

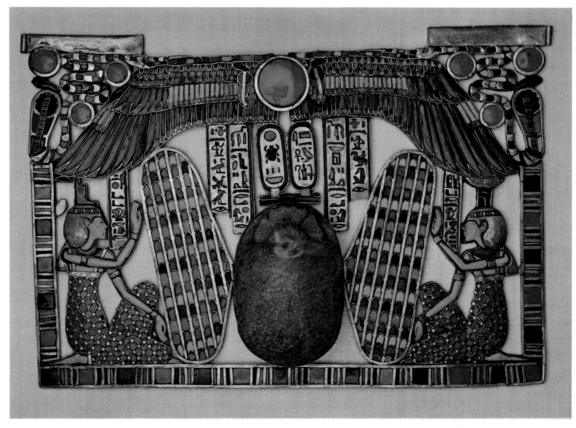

82 Winged scarab pectoral of Tut-ankh-amun, with Isis and Nephthys, from Thebes

83, 84 Earrings and ear-studs of Tut-ankh-amun, from Thebes

85 Detail of the diadem of Tut-ankh-amun, from Thebes

86 Gold statuette of a king from the tomb of Tut-ankh-amun, from Thebes

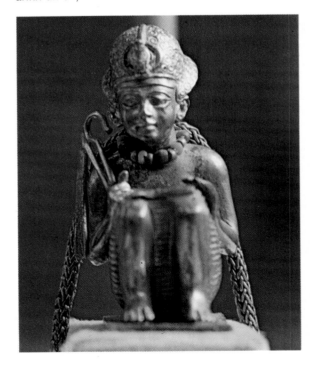

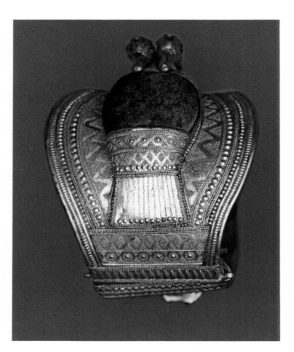

87, 88 Bracelets of Ramesses II

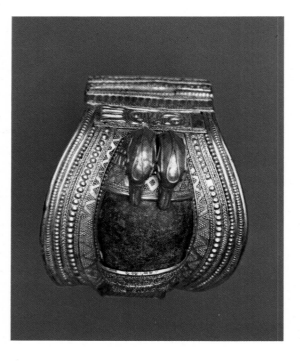

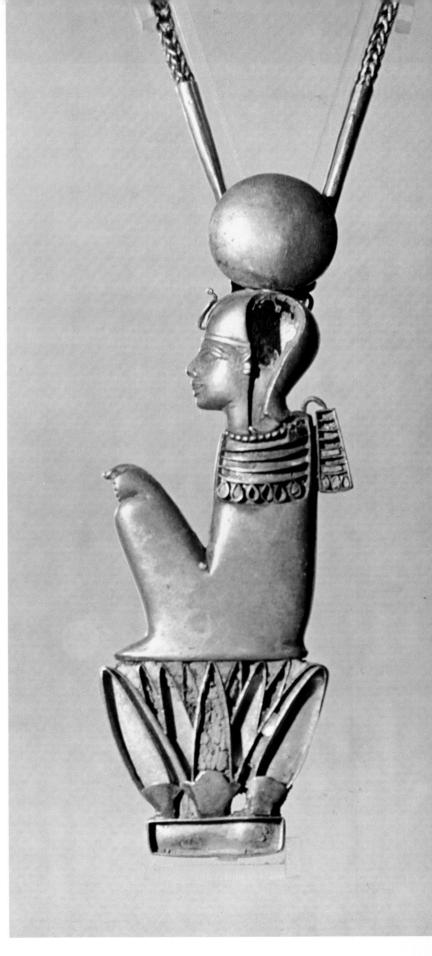

89 Pendant and chain,
perhaps of Ramesses II

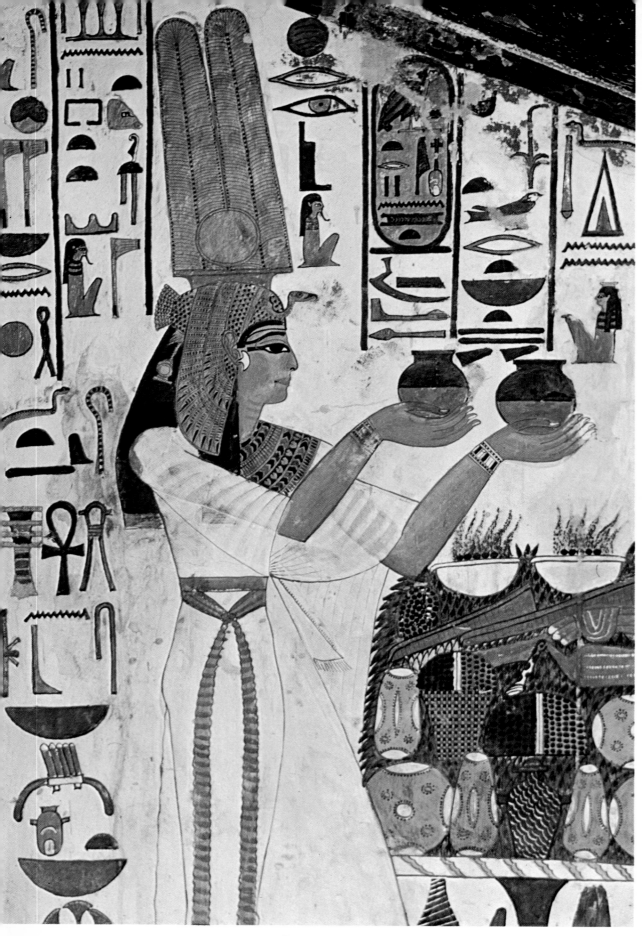

90 Wall-painting of Queen Nefert-ari offering water in her tomb at Thebes

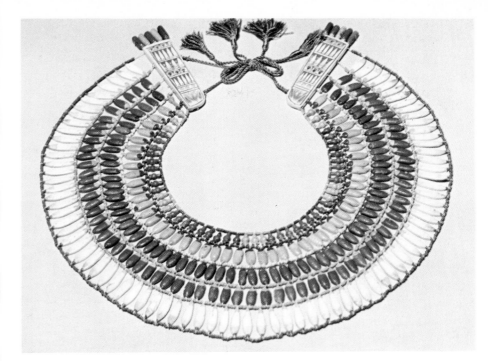

91 Faience floral collar

92 Coffin-board of a Singer of Amun
with a painted floral collar, from Thebes

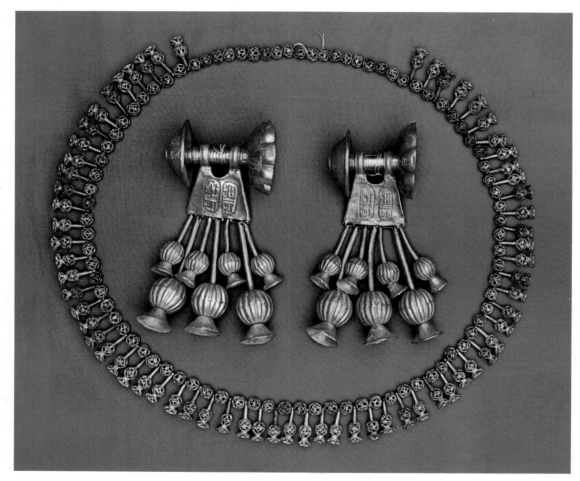

93 Earrings and necklaces of Queen Twosre

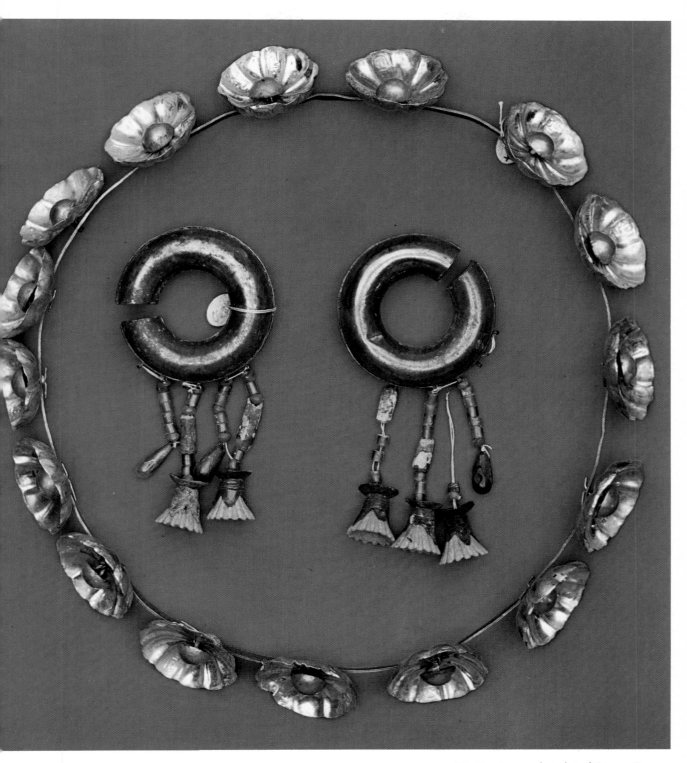

94 Earrings and circlet of Queen Twosre

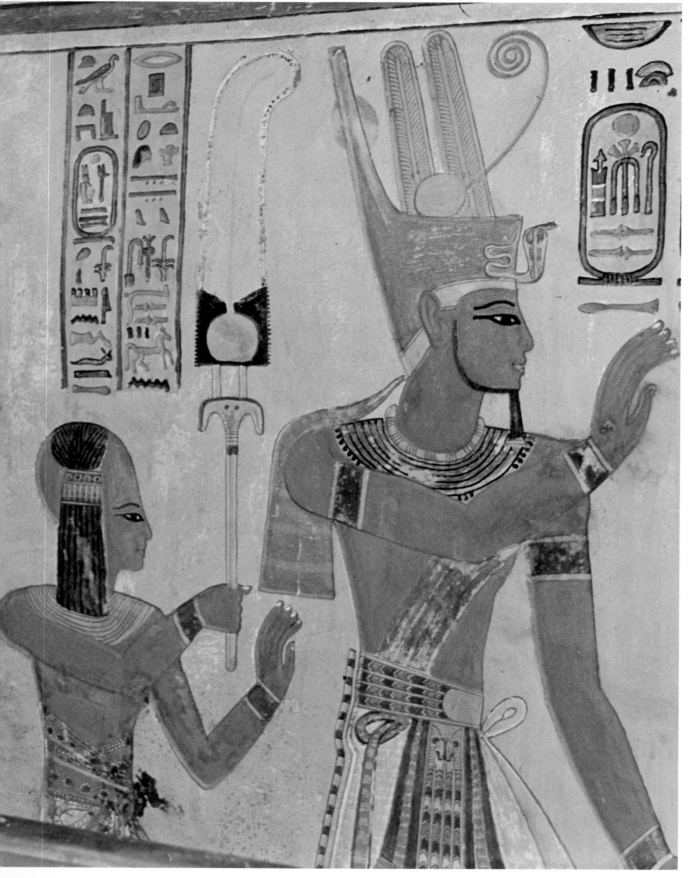

95 Wall-painting of Ramesses III and his son, Amen-(hir)-khopeshef, from the latter's tomb at Thebes

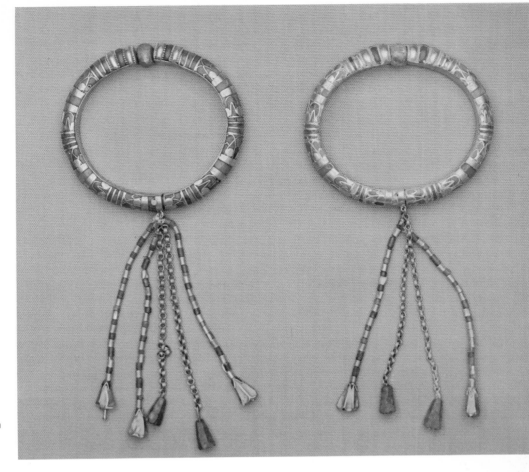

96 Bracelets of the High
Priest Pi-nudjem II, from
Thebes

97 Ear-plugs of Ramesses
XI, from Abydos

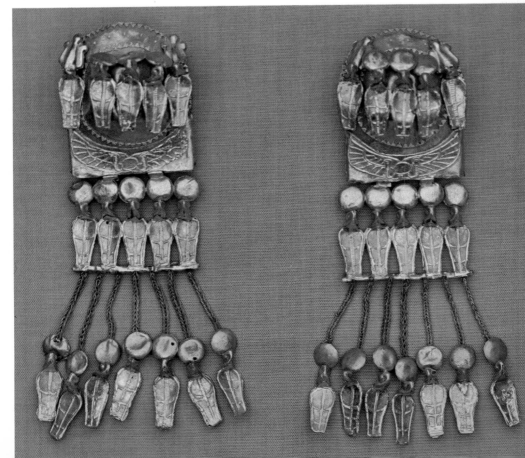

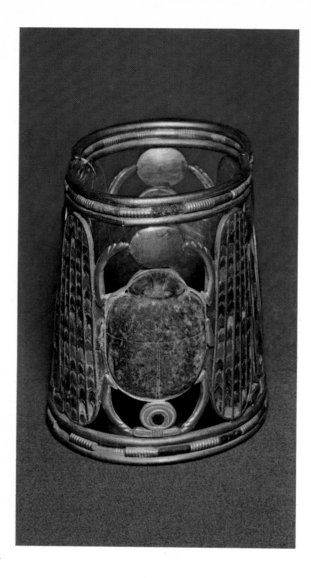

98, 99 Bracelets of Psusennes I, from Tanis

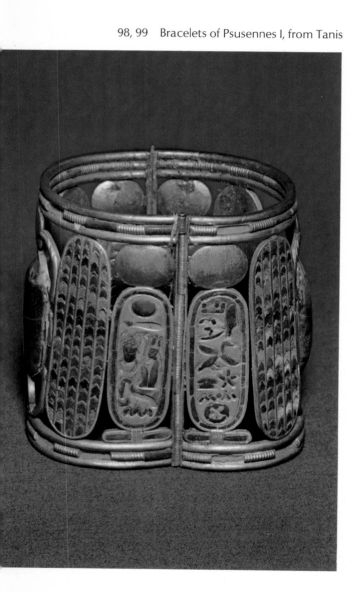

100, 101 Anklet and bracelet of
Psusennes I, from Tanis

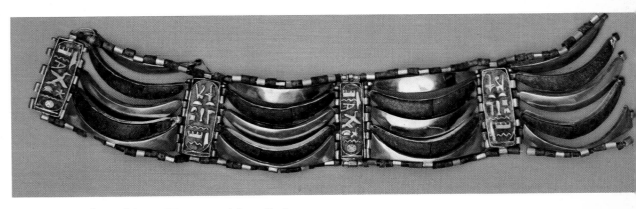

102, 103 Bracelet and rings of Psusennes I, from Tanis

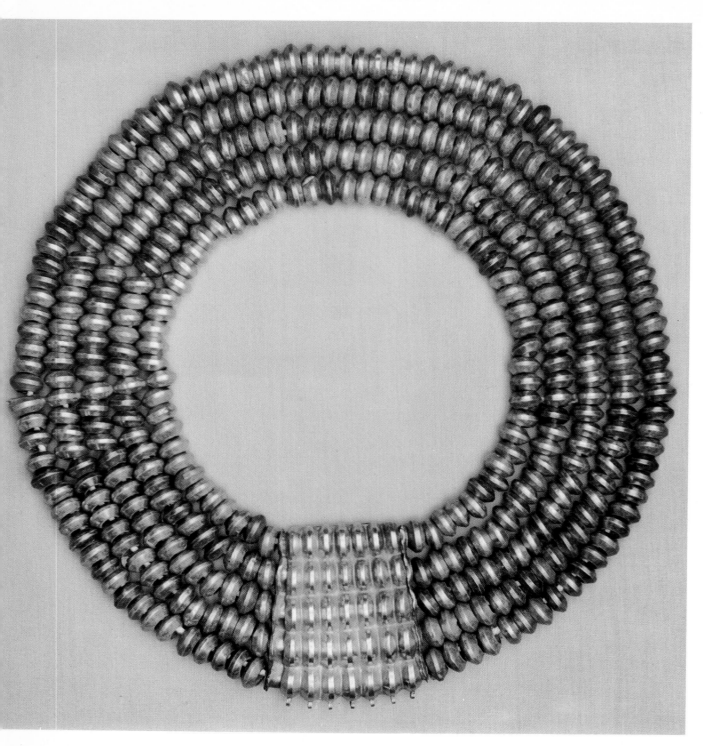

104 Collar of Psusennes I, from Tanis

105 Collar of Amenophthis, from Tanis

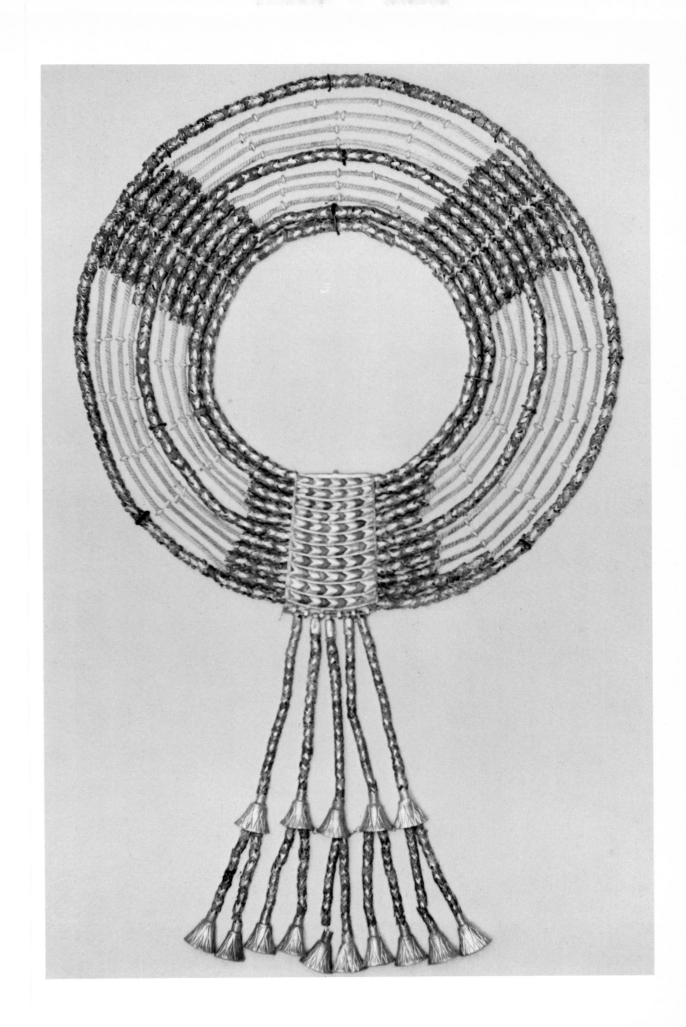

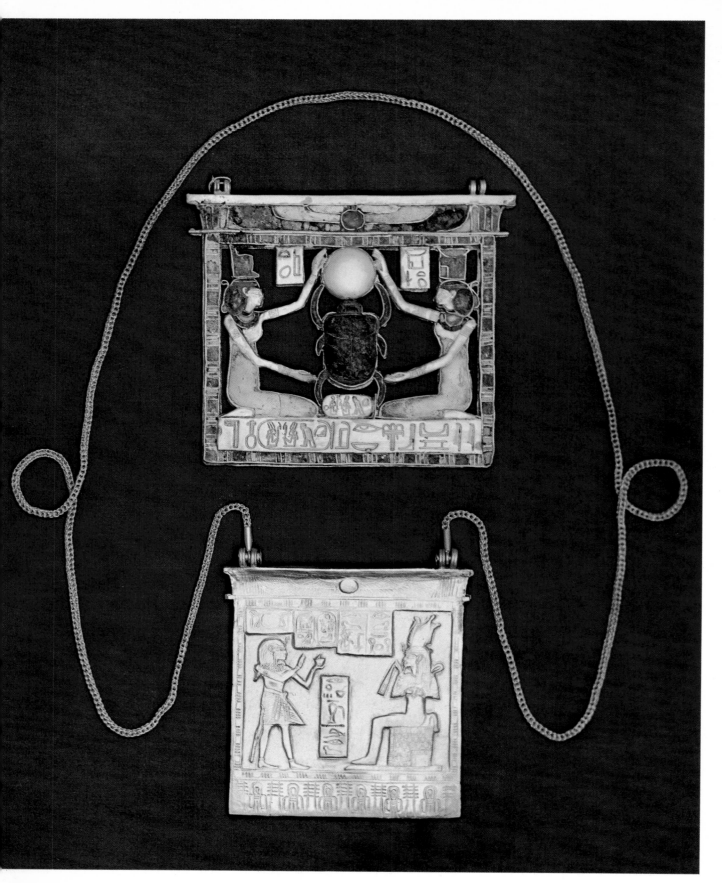

106 Pectorals of Amenophthis, from Tanis

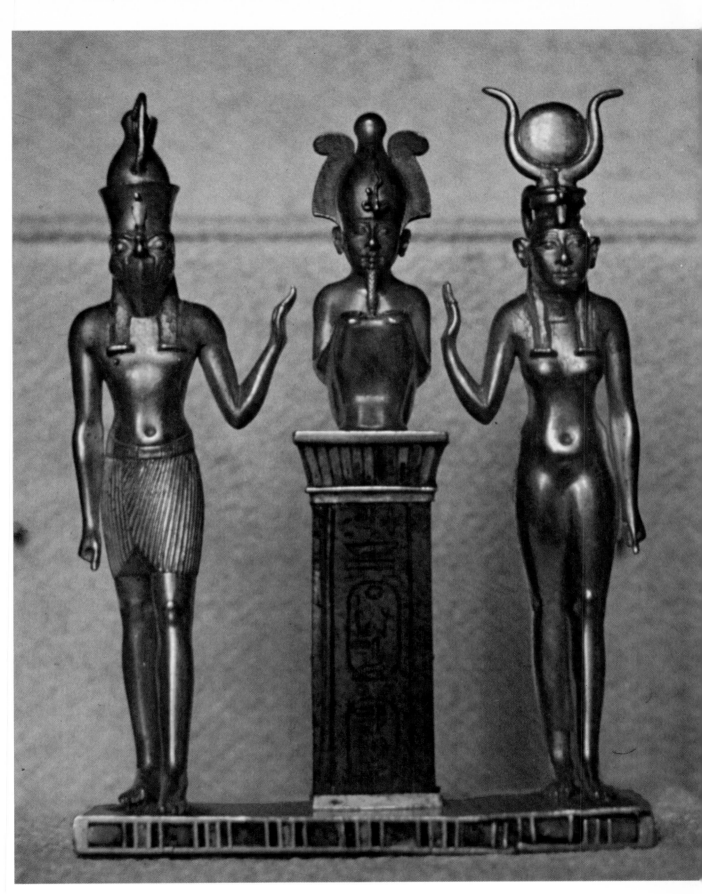

107 Pendant of Osorkon II

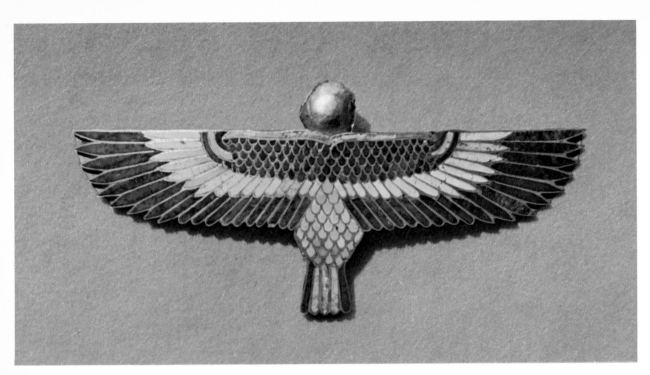

108 *Ba*-bird pendant, upper side, from Saqqara

109 *Ba*-bird pendant, under side, from Saqqara

Notes on the Colour Plates

1 Bracelets, from the cenotaph (?) of King Djer at Abydos. First Dynasty, c. 3020 BC. In the Cairo Museum. In 1901 Flinders Petrie continued his re-excavation of the ravaged archaic sites at Abydos, where the tombs or cenotaphs of the first Pharaohs had been made. He found in a crevice in the brickwork of the complex of Djer the wrapped forearm of a woman of the royal household, her bracelets held in position by the bandages, and was thus able to recover their original order of stringing. They are shown in the plate in the sequence in which they were found, the top specimen being nearest the wrist.

Top row: Bracelet (now in two halves) gold, lapis lazuli and turquoise. L. (of each part) 3·7 and 2·2 cm. Cat. No. 52011. The two parts when found were joined by strings of hair and gold wires of equal thickness plaited together. The front half has a central hollow gold rosette, made in imitation of a half-opened flower. It is pierced with holes through which run three threads carrying turquoise beads, alternating with gold ball beads and ring beads soldered in threes to form spacers. Both strings are caught at each extremity by a single lapis lazuli ball bead and a hollow gold ball bead.

Second row: Bracelet, gold and turquoise. L. 15·6 cm. Cat. No. 52008. This, the most celebrated of the quartet, consists of thirteen gold and fourteen turquoise graduated plaques in the form of the king's *serekh* surmounted by a falcon. The king's name, as the incarnation of the distant sky-god Horus, is usually inscribed within the *serekh*. Here it is rendered as Djer. The gold *serekhs* appear to have been formed by casting.

Third row: Bracelet, gold, amethyst and turquoise. L. 15 cm. Cat. No. 52010. This is the most original bracelet in the group, its design being based upon beads of hourglass shape, strung in four vertical groups of three, alternating with larger turquoise beads.

Bottom row: Bracelet, gold, lapis lazuli and turquoise. L. 13 cm. Cat. No. 52009. This bracelet is similar in design to the one in the top row, consisting of three rows of beads caught at four points by single large ball beads.

Petrie's words, which he penned on first discovering these bracelets, are still worth quoting: 'Here, at the crystallizing point of Egyptian art, we see the unlimited variety and fertility of design. Excepting the plain gold balls, there is not a single bead in any one bracelet which would be interchangeable with those in another bracelet. Each is of independent design, fresh and free from all convention or copying. And yet not one of these would be in place among the jewellery of the XIIth Dynasty.'

2 Parure, gold, from a burial of First Dynasty date. In the Cairo Museum. In 1903 G. A. Reisner excavated an archaic tomb at Nag-ed-Der in which the mass of the superstructure had collapsed, crushing the body beneath it and preserving it from the attention of robbers who had been active in other parts of the necropolis. The deceased had originally worn a plain gold circlet around the brow and bracelets in flint, slate and copper, in addition to plain gold rings which may be among the earliest finger-rings known. Ten package-shaped gold amulets, beads in garnet and carnelian and black-and-white stone pendants, were also retrieved.

Centre: Two pendants, gold. L. 4 cm. and 3·8 cm. Cat. Nos. 53824–5. The animal on the right is a steer (Apis bull?), the horns of which are missing. From its neck hangs a pendant in the form of the 'aegis' of the goddess Bat. The animal on the left is an oryx with a *tyet* (girdle-tie) around its neck.

Outer: A necklace of twenty-four gold shells. L. (of each) 1·5 cm. Cat. No. 53802. Each shell has been formed by hammering gold foil into a suitable mould and enhancing the coils by repoussé. A ring has been soldered on the outside at each extremity. Originally the beads were threaded on two strings and perhaps held in position by knotting, but of this no traces remain.

3 Bracelets of Queen Hetep-her-es, silver, inlaid with carnelian, lapis lazuli and turquoise. Outer diam. 9 to 11 cm. Excavated by G. A. Reisner at Giza. IVth Dynasty. In the Museum of Fine Arts, Boston (Mass). Reg. Nos. 47.1699–1701. The greatly decayed secondary burial of the mother of Kheops was found in the vicinity of that king's Great Pyramid on the Giza plateau in 1925. The deposit contained, among other spectacular items, the remains of a gold encased wooden box carrying two removable tapered rollers for the storage of twenty silver bracelets worn on the forearms in the manner shown in contemporary reliefs. The bracelets follow the pattern of such ornaments of the Archaic Period, being formed as hollow shells of thin metal but with depressions worked in them for the reception of the stone inlays cemented in position.

4, 5 Parure of a woman of the royal house, excavated at Giza in the Re-wer tomb complex (shaft No. 294) by Selim Hassan in 1931. IVth Dynasty. In the Cairo Museum.

4 A circlet, gold, copper and carnelian. L. 56 cm. D. (of central rosette) 7·8 cm. The simple gold fillet found on a burial of the Archaic Period and referred to above, has here assumed the sophisticated form common in the Old Kingdom.

5 A collar, gold. L. (of each bead) 2·7 cm. D. c. 16 cm. In addition to the circlet, the body of the woman found at Giza was adorned with bracelets of gold and copper at the wrists and ankles and a necklace of gold and faience beads strung on gold wire with gold clasps at the ends. Its unique adornment, however, was the collar illustrated here which consists of fifty hollow gold beads in the form of the beetle *Agrypnus notodonta Latr.*, which was sacred to Neith, a goddess of great influence in the earlier dynasties. The collar was thus not only an adornment but also an amulet placing the wearer under the protection of the chief goddess of the age.

6–9 The Egyptian Expedition of the Metropolitan Museum of Art, New York, working at Lisht in 1907 in the vicinity of the ruined pyramid of King Ammenemes I (c. 1991–1962 BC), found the tomb of Seneb-tisi, a woman of the family of the Vizier Sen-wosret, which had been partly rifled and was in a greatly decayed state. The excavators, Mace and Winlock, were able to recover almost completely the original form and features of the deposit, and their reconstructions of some of the funerary jewelry, now in the Metropolitan Museum, are illustrated in the following four plates.

The personal jewels of Seneb-tisi had been stolen in antiquity and only traces of her wig in its crushed container were found. The jewelry illustrated here was found mostly embedded between layers of linen wrappings soaked in resin that covered the body and allowed the original order of stringing to be determined.

6 Wig ornaments of the House Mistress Seneb-tisi, gold, early XIIth Dynasty. Metropolitan Museum of Art, New York. Reg. No. 07.227.6–7. The rosettes, of marguerite form, each 1·1 cm. in diameter, were made by beating heavy gold sheet into two moulds, one with sixteen radiating divisions, the other with twelve. Eighty-five rosettes of the latter type had been pierced with two holes to take threads binding them to the tresses of the wig: the remainder have a bar of gold soldered across the back for the same purpose. These rosettes are shown on a reconstruction of the wig. The circlet is of gold wire in three zones, each coiled into a series of continuous loops to form a kind of expansible chain.

7 Collar, turquoise, carnelian, green faience, and gold foil filled with plaster. W. 25·5 cm., early XIIth Dynasty. Tomb of Seneb-tisi. Metropolitan Museum of Art, New York. Reg. No. 08.200.30. One of the three funerary collars of Seneb-tisi of a type known as 'The Falcon', from the design of its terminals, each made in the shape of the head of the bird with an eye of carnelian and markings inlaid in blue pigment.

8 Collar, turquoise, green faience and gold foil filled with plaster. W. 25 cm., early XIIth Dynasty. Tomb of Seneb-tisi. Metropolitan Museum of Art, New York. Reg. No. 08.200.31. A similar neck ornament to the one above, but with semicircular end-pieces, known as a 'Broad Collar', is made of tubular beads graduated in size so that the longest are in the middle of each row. The vertical tubular beads are separated and bordered by strings of small beads. Both collars have the characteristic shape of such adjuncts during the XIIth Dynasty, being U-shaped rather than quasi-circular, with the shoulder-pieces lying further apart, and rather shallower than earlier examples. Such funerary collars were merely laid on the breast of the deceased.

9 Apron, green, white, yellow, and black faience beads with some gold foil. W. 58·5 cm., early XIIth Dynasty. Tomb of Seneb-tisi. Metropolitan Museum of Art, New York. Reg. No. 08.200.29. This is the most complete example to have survived of a *besau* or protective bead apron, otherwise known from the coffin pictures and representations on the monuments. Originally it was a primitive garment worn only by the Pharaoh as part of his insignia, but by the Middle Kingdom it had been appropriated for funerary use by commoners. The apron consists of a bead-work belt with a buckle of wood covered with gold foil bearing the owner's name in blue pigment. At the rear hangs an imitation animal's tail in bead-work over a wooden core. From the lower edge of the belt also depend twenty-two strings of bead-work representing the heraldic plants of Upper and Lower Egypt, the flowering rush on the right and the papyrus on the left.

10–33 Jewels from the Dahshur and Lahun Treasures. XIIth Dynasty, now in Cairo and New York. In 1895 the French Egyptologist J. de Morgan uncovered jewelry belonging to the princesses of the family of Sesostris III (c. 1878–1843 BC) in their tombs within the precincts of that king's pyramid, the northern brick pyramid, at Dahshur. Some months later he found another treasure belonging to an earlier generation of royal women in tombs in the enclosure of the ruined stone pyramid of Ammenemes II (c. 1929–1895 BC) at the same site. In 1914 G. Brunton, working for Flinders Petrie, excavated a similar treasure which had been buried with the Princess Sit-Hathor-Yunet in a tomb within the precincts of the brick pyramid of her father Sesostris II (1897–1878 BC) at Lahun. Nearly all these parures had been used by the princesses during their lifetimes and show signs of wear. They were buried with their owners in wooden caskets

which, however, had decayed almost entirely by the time of their discovery. These jewels are substantial pieces, made of precious and hard-wearing materials and should be compared with those of Seneb-tisi made solely for funerary use.

10 Funerary parure of the Princess Ita-weret who was buried at Dahshur near the pyramid of her father (?) Ammenemes II. Gold, carnelian, turquoise, green faience and lapis lazuli. W. (of collar) c. 28 cm. In the Cairo Museum (no reg. no.).

The Broad Collar of Ita-weret was unusual in being furnished with a *menkhet* counterpoise and appears to have been one worn in life and adapted for funerary use. The semicircular end-pieces are perforated to take the tie-strings that connect it to the counterpoise. A bracelet shown in the illustration appears to have been composed out of one of the 'various' examples found by de Morgan on Ita-weret's ankles or wrists, but the beads have been improperly matched so that the band assumes a curved shape. It was presumably clasped with tie-strings.

11–17 Jewelry from the parure of the Princess Khnumet who probably became a queen in later life and was buried in the vicinity of the pyramid of Ammenemes II at Dahshur. Her jewels represent the products of the royal workshops during the earlier part of the XIIth Dynasty.

11 Collar, gold, inlaid with lapis lazuli, turquoise, carnelian, garnets, green felspar: size of terminals, H. 3·8 cm., W. 4·3 cm. In the Cairo Museum, Cat. Nos. 52861–2 *et al*. A 'Falcon Collar' reconstructed from elements recovered. It comprises seven rows of pendant beads connected by strings of gold ring-beads. Four of the rows consist of three different graduated hieroglyphs symbolizing 'Life', 'Stability' and 'Power' made of gold inlaid with coloured stones.

Below, part of a string of drop beads and gold ring-beads from the same hoard, arbitrarily assembled.

12 *Top Row*: Parts of a pair of bracelets, gold, turquoise, lapis lazuli and carnelian. H. 3·9 cm. In the Cairo Museum, Cat. Nos. 52044–5, 52048–9. At each extremity is a clasp consisting of a completely detachable member made of gold sliding on tongues within channels formed in two end-pieces. Each of the latter is perforated with sixteen holes to take rows of carnelian, turquoise, lapis lazuli and gold cylindrical beads strung on linen threads. When the bracelet was put on the wearer, the handmaid wrapped it around the wrist of her mistress with the two grooved end-pieces opposite each other and connected them by slipping the tongued slide in between them. The design of the slide is based upon a protective *sa*-amulet inlaid in lapis lazuli, the ties being of turquoise and carnelian.

Middle Row: An anklet, gold inlaid with turquoise, carnelian, lapis lazuli, H. of claw pendants 2·25 cm. Cairo Museum, Cat. Nos. 52911–12 *et al*. This jewel, as restrung, shows a pair of imitation bird claws, having a right and left profile, strung on a thread of gold beads with a gold clasp in the form of a knot, one half of which fastens to the other by means of a T-shaped tongue sliding in a groove.

Bottom Row: Necklace of carnelian, turquoise and lapis lazuli *ankh*-signs, with a gold *ankh*-'clasp'. H. of clasp 1·9 cm. Cairo Museum, Cat. Nos. 53012–3, 52916. This necklace, exhibited upside down and curving in the opposite direction to which it should take, is also reconstructed and is incomplete. The 'clasp' is made of gold with two bars, each perforated with three holes, sliding on tongues forming the sides of a trapezoid framing the *ankh*. Each stone *ankh* is made in two parts, the upper loop and cross-bar, and the lower tongue. In its original form, the *ankhs*

were kept in position by matching ring-beads packed on the threads that passed through the upper and lower perforated lugs on each complete sign. A medial thread passed up a hole drilled the length of each tongue into a transverse hole in the cross-bar of the upper half of the *ankh*. It is probable that the so-called clasp is really a pendant or pectoral, and the necklace was a continuous string of beads passed round the neck of the wearer and clasped on the breast by the pendant.

13 Circlet, gold inlaid with carnelian, lapis lazuli and turquoise. D. 20·5 cm., Max. H. 4·2 cm. In the Cairo Museum, Cat. No. 52860. This crown is a translation into cloisonné-work of the type of fillet represented on the statue of Nofret. The circlet is composed of eight identical elements, each consisting of a central rosette flanked by two stylized flowering rush calices and surmounted by such a device. Each of these components is separated from the next by another rosette. Between the centre of two of the elements is soldered an arch in the form of a flying vulture with its talons holding *shen*-signs, suggesting that the owner had reached the status of a queen. Opposite is a socket to take a gold foil ornament, now much damaged, in the shape of a palm tree.

14 Circlet, gold, carnelian, lapis lazuli and turquoise. D. 18 cm. In the Cairo Museum, Cat. No. 52859. This is a gold cloisonné version of a circlet made by twisting a handful of water-weed into a chaplet. The wreath is caught at six points by a Maltese cross formed of four papyrus umbels around a central boss. Each of these anchorages is connected to the next by ten wires, interlaced in pairs through minute gold rings to which are soldered flowerettes, each with five turquoise-filled petals radiating from a carnelian centre, or pairs of lapis lazuli buds on gold wires. From the moment of its discovery, this chaplet has been admired as one of the triumphs of the Egyptian goldsmith, a happy combination of fragility and strength, of formalized flower shapes scattered in the random profusion of nature.

15 Pendant, necklaces, clasp and wig (?) ornaments, gold decorated with applied wires and grains. In the Cairo Museum, Cat. Nos. 52975–9. Khnumet had among her possessions a suite of gold jewelry which has a distinctly un-Egyptian appearance in its designs and techniques. The art of attaching gold wires and granules to ornaments of gold by means of colloidal gold soldering appears to have been developed elsewhere, probably in Syria or the Aegean. This group of granular goldwork may have been presented to Khnumet by an Asiatic ruler, or may have been made by Egyptian jewellers under the inspiration of foreign models.

Top: The pendant consists of a central element, the so-called 'Medallion of Dahshur' (D. 2·85 cm.), a circular plaque of blue frit on which is painted a recumbent cow with a garland hanging from its neck. This miniature is covered by a thin plate of rock crystal retained by a circular gold frame. From the lower edge depend three open-work, eight-pointed, stars. The medallion in turn hangs from two larger open-work rosettes, each with eight semicircular projections. The rayed medallion or star-shaped pendant is a distinctly Syrian motif.

Second Row: A necklace consisting of a length of double loop-in-loop chain, 28 cm. long, from which hang twelve gold pendants in the shape of stylized flies or bees. Similar ornaments have been found at Palaikastro, Crete, and on other Middle Minoan sites.

Third Row: The clasp is in the form of a butterfly (W. 2·7 cm.) made fom thin sheet gold on which the details of the insect's body and wing-membranes have been outlined in gold wire and

soldered in position with granules filling the spaces. To the back is soldered a channel to take the fastening bar. To each part is connected a length of double loop-in-loop chain. While the butterfly is a Minoan motif, it had also existed in Egypt as a design of a jewel at least as early as the IVth Dynasty.

Bottom Row: The necklace consists of a portion of double loop-in-loop chain from which are suspended ten bivalve cockle-shells and two star-shaped pendants (W. of latter, 2·5 cm.) by means of short links. The five-pointed star is an Egyptian celestial motif, but here it may represent a starfish.

Sides: Ornaments in the form of small birds, each 1·1 cm. high, made by working gold foil into an appropriate mould and soldering a flat plate to the back, the edges being trimmed. Two holes in the lower part allowed for the passage of air during heating and cooling and were the means of attaching them, doubtless to a wig.

16 Collar, gold, inlaid with carnelian, lapis lazuli and turquoise. H. (of terminals) 1·3 cm., W. 1·1 cm. In the Cairo Museum, Cat. Nos. 52920–21 *et al.* This Falcon Collar has been reconstructed from elements nearly all of which have a right and left aspect, thus indicating that they formed pairs in some balanced arrangement. They also have a generic resemblance, being made of gold, chased on their backs, and inlaid with coloured stones on their faces. The central element (H. 1·6 cm.) is an *ankh* upon an offering-mat and this is flanked in turn by hieroglyphs symbolizing deities, such as the vulture of Upper Egypt and the cobra of Lower Egypt on *neb*-baskets, the goddess Bat, the King of Lower Egypt, and such abstractions as 'Life', 'Union', 'Strength', 'Stability', 'Protection'.

17 *Upper Row:* Four 'motto-clasps', gold inlaid with carnelian, turquoise and lapis lazuli. H. (left to right) 1·7 cm., 1·9 cm., 3·3 cm., 20 cm. In the Cairo Museum, Cat. Nos. 52914, 52955–6, 52958. It was the fashion for the princesses of the XIIth Dynasty to wear an amuletic cloisonné jewel attached to a cord on the upper arm. Here the cords have been restored by strings of gold beads. Each jewel is composed of a single sign or group of hieroglyphs spelling out a good wish. The cords were knotted into tubes on the back of each jewel, one sliding on a tongue within grooves. The first two clasps read, 'all protection and life is at her back'. The next perhaps signifies a protective *meset*-apron; the last reads, 'joy'.

Lower Row: Girdle (?), gold carnelian, lapis lazuli and turquoise. L. (doubled) 30 cm. In the Cairo Museum, no Cat. No. Part of what was probably a girdle of 'acacia seed' beads placed around the body of Khnumet.

18 Painted limestone relief of Sit-hedj-hotpe and Sit-kheper-ka, two of the daughters of Djehuti-hotpe, the powerful feudal lord of the 'Hare' district of Middle Egypt who died in the reign of Sesostris III, c. 1850 BC. In the Cairo Museum. H. 27·5 cm. This fragment of wall gives a good idea of the full parure of women of high rank in the middle years of the XIIth Dynasty. Each daughter wears her hair plumped out in a bouffant mass kept in place by gold bands, a lower carnelian terminal and a circlet probably of bead-work, but possibly of cloisonné-work. From the neck hangs a trapezoidal pectoral on bead-work straps to fall low on the breast. The girls' arms and legs are decorated with bracelets and anklets also in bead-work.

19, 21 Jewelry of the Princess Sit-Hathor, excavated by J. de Morgan near the brick pyramid of Sesostris III at Dahshur.

19 *Centre:* Pectoral of cloisonné-work and necklace, gold inlaid with carnelian, lapis lazuli and turquoise. H. (of pectoral) 5·2 cm. In the Cairo Museum, Cat. No. 52001 *et al.* The Princess Sit-

Hathor was a daughter of Sesostris II who gave her some of her jewelry early in her adult life: other ornaments were bestowed upon her by her brother or husband, Sesostris III. This pectoral belongs to her earlier years and its design is based upon the titles and names of Sesostris II contained within the primeval shrine or kiosk in which the Creator (the ancestor of the Pharaoh) manifested himself.

The design shows the sky-god Horus as a falcon wearing the Upper and Lower Egyptian crowns, standing upon a collar symbolizing his victory over Set, the god of violence, and supporting two of the names of the King. The sun-disk, encircled by a uraeus which embraces an *ankh*-sign of life further supplements Horus, fills an empty space and strengthens the design. The workmanship of this jewel is impeccable.

Outer: Girdle of Sit-Hathor, gold, lapis lazuli, green felspar. L. *c.* 70 cm. In the Cairo Museum. Cat. No. 53136, 53123 *et al.* The girdle has been restored as a result of the study of the El-Lahun specimen. Some of its parts, however, were stolen at the time of discovery by de Morgan's workmen, and it is thus shorter than it should be.

20, 22–26 Jewelry of the Princess Sit-Hathor-Yunet excavated by G. Brunton and Flinders Petrie in a tomb within the precincts of the pyramid complex of Sesostris II at Lahun, and now mostly in the Metropolitan Museum of Art, New York.

20 Wig ornaments, gold, and gold inlaid with carnelian, lapis lazuli and green faience. Originals in the Cairo Museum, Cat. No. 52641, and Metropolitan Museum of Art, New York, Reg. No. 31.10.8. The ornaments, here seen mounted on a modern version of a wig of the period, are a reproduction of the 'boatman's circlet' worn by Sit-Hathor-Yunet, now in Cairo, and the original gold tubes that were threaded on her tresses in a chequer-pattern.

21 Jewelry of Sit-Hathor, gold, carnelian, lapis lazuli, green felspar, turquoise. In the Cairo Museum, Cat. Nos. 53137, 52041–2, 53141, 53150, 53142.

Top: Bracelet, L. 20 cm. Three of the XIIth Dynasty princesses had bracelets containing a pair of couchant lions, some threaded on double strings, and some on single strings of beads. One of Sit-Hathor's examples shown here is reconstructed after the Lahun specimens.

Left and Right: Bracelet clasps, gold inlaid with carnelian, lapis lazuli and turquoise. H. 3·9 cm. Each slide is decorated with a *djed*-pillar worked *à jour*, chased on its back and inlaid on its face, and connected to a perforated end-piece by a tongue at each long side.

Centre, top and bottom: Clasp, gold inlaid with carnelian, other inlays now missing. L. 3·7 cm. The centre of the clasp is formed by a knot in gold consisting of two halves which slide together on a tongue and groove. 'Motto clasp', gold inlaid with carnelian and lapis lazuli. H. 1·8 cm., consisting of a rebus of hieroglyphs reading, 'the two gods [Horus and Set] are at peace'. Clasps designed to express the same idea are found in other royal deposits of the period. Clasp, gold inlaid with carnelian, lapis lazuli and turquoise. H. 2·7 cm. Two lotus flowers in cloisonné-work with their stalks tied in a knot above the 'aegis' of the goddess Bat form the main design. Anchorages for chords are on the reverse, one of them being detachable. The clasp has been restrung on a necklace of gold ring beads.

22 Girdle of Sit-Hathor-Yunet, gold, carnelian, lapis lazuli, green felspar. L. 84 cm. In the Metropolitan Museum of Art, New York, Reg. No. 16.1.5. The girdle consists of eight hollow gold beads in the form of cowries, one of which is made in two parts and fastens together by a tongue engaging in a slot to form the clasp. These are threaded on two strings of 'acacia-seed' beads in carnelian, lapis lazuli, green felspar and gold, the last being soldered in pairs to form spacers. Each cowrie is double sided showing lips on both faces. A few rattling pellets of a silver alloy are contained in each shell so that the wearer must have tinkled as she walked like the 'daughters of Zion'.

23 Girdle and claw anklets of Sit-Hathor-Yunet, gold and amethyst. L. (girdle) 82 cm., L. (anklets) 17·5 cm. In the Metropolitan Museum of Art, New York, Reg. Nos. 16.1.6, 7. In addition to her cowrie-shell girdle, Sit-Hathor-Yunet had a second girdle, probably made for her in a later reign, in which the eight gold cowrie shells were replaced by seven double-sided, hollow gold beads in the form of opposed leopard heads. These were threaded on a double ring of dark amethyst ball beads and gold spacer-beads.

The claw anklets were evidently made *en suite*, using the same dark purple colour of amethyst for the ball beads.

24 Pectoral of Sit-Hathor-Yunet, gold inlaid with carnelian, lapis lazuli and turquoise. H. 4·5 cm. In the Metropolitan Museum of Art, New York, Reg. No. 16.1.3. This jewel, together with the contemporary pectoral of Sit-Hathor, probably represents the acme of the jeweller's art in Egypt. Its construction is similar to that of Sit-Hathor's example but the primeval kiosk is replaced by a base-bar with a zigzag inlay representing the Waters of Chaos from which Creation arose. Two falcons, each wearing on its vertex the sun-disk encircled by a uraeus with a pendant *ankh*, protect the prenomen of King Sesostris II, which is supported by a kneeling personification of Eternity holding notched palm-ribs to signify a count of years. The whole design symbolizes that the divine power that created the universe is incarnate in the Pharaoh.

25 Bracelet of Sit-Hathor-Yunet, gold, carnelian and turquoise. H. 8·1 cm. In the Metropolitan Museum of Art, New York, Reg. No. 16.1.8. The bracelet unclasped and laid flat gives a good idea of the construction and appearance of such jewels during the Middle Kingdom. Each bracelet, worn at the wrist, consists of a band of thirty-seven rows of carnelian and turquoise beads strung on threads between two gold end-pieces. The strings are held together at intervals by six gold spacer-bars. The slide, which forms a red element in the alternation of red and green vertical stripes, is inscribed with a title and name of Ammenemes III in cloisonné-work.

26 Pectoral, gold inlaid with carnelian, lapis lazuli, green faience and amethyst. W. 8·2 cm. In the Cairo Museum, Cat. No. 52712. Sit-Hathor-Yunet's second pectoral is a copy of the earlier one and was made for her in the reign of Ammenemes III, whose name replaces that of Sesostris II in the cartouche upheld by Eternity. During the forty years or more that separate the date of the two jewels there are signs of a decline in the standards and skill of the Court jewellers. The falcons are clumsy and earth-bound when compared with those of Sesostris II and the chasing of the back-plate is coarser and less detailed. The colour scheme is also different, ball beads of amethyst instead of lapis lazuli being used in the suspensory necklace. An artificial substance, probably frit, has been used in place of the green and blue stones, and has decayed to a white powder.

27 Uraeus of Sesostris II, gold, inlaid with carnelian, lapis lazuli and green felspar. H. 5·5 cm. In the Cairo Museum. Cat. No. 52702. This jewel was found by G. Brunton after sifting the dust

and rubble in the rifled burial-chamber of the king's pyramid at Lahun. There is little doubt that this emblem of the king's personal deity, that was supposed to spit fire in the eyes of his enemy, was actually attached to one of the crowns of Sesostris II. The body is of gold made by hammering heavy sheet and soldering on the details. The head is carved from a piece of lapis lazuli with eyes of garnet set in gold rims. The body, of hollow section, makes an S-turn before tapering to an undulating tail.

28–33 Jewelry of Queen Mereret, excavated by J. de Morgan, near the brick pyramid of Sesostris III at Dahshur, XIIth Dynasty. In the Cairo Museum.

28 *Top:* Pendant, gold inlaid with carnelian and blue and green faience. W. 3·3 cm. Cat. No. 53078. The pendant is in the form of a falcon with outspread wings holding *shen*-signs in its talons. Of the inlays, only the carnelian has retained its colour, the rest have decayed to a white paste; some are missing.

Sides: Bracelets, gold, carnelian and turquoise. L. *c.* 16·5 cm. Cat. No. 53096–9.

Centre (inner): Five 'motto' clasps, gold inlaid with carnelian and discoloured pastes. W. 1 to 3·3 cm. Cat. Nos. 53076, 53079–82. The 'mottos' are (top) the *shen*-sign signifying the entire circuit of the sun over which the Pharaoh ruled, 'joy' and 'the two gods are at peace': this last is arranged upside down on the plate.

Centre (outer): A necklace, gold, carnelian, lapis lazuli and turquoise. L. *c.* 35 cm. Cat. Nos. 53069, 53083. A necklace reconstructed from random elements found in the tomb of Queen Mereret. The pendants are formed of eight turquoise, five carnelian and five lapis lazuli balls, each held in a cage formed of two large circles of gold strip soldered to a striated tube by which the pendant is hung on a string of gold beads. The clasp is in the form of a motto with signs reading 'all protection and life'.

29 Pectoral of Queen Mereret, gold inlaid with carnelian, lapis lazuli and turquoise. W. 8·5 cm. Cat. No. 52002 *et al.* Within the primeval shrine, which has its cornice supported by a lotus flower on a slender stalk, King Sesostris III, in the form of a pair of opposed hieracosphinxes, tramples enemies underfoot. The outstretched paws of the sphinxes are on the heads of the subjugated and support the prenomen of the king. The vulture goddess Nekhebet of Upper Egypt, holding *shen*-signs in her claws, spreads protective wings over the entire scene.

30 Pectoral of Queen Mereret, gold inlaid with carnelian, lapis lazuli and faience or frit. W. 10·4 cm. Cat. No. 52003 *et al.* This is a jewel of similar type, but made for the queen by the successor of Sesostris III. The primeval kiosk is of simple design. Over the scene hovers the vulture Nekhebet with protective wings outspread holding the signs of life and stability in her talons. Below, in opposed halves, Ammenemes III raises his mace to strike down bedouin foes helpless before him, each holding a throw-stick and a dagger. The prenomen of the king in a cartouche is before him, and at his back is a fan-bearer in the form of an animated *ankh*-sign. The various elements in the design are held together with descriptive hieroglyphic labels. Nekhebet is entitled 'Mistress of The Two Lands, Lady of Heaven'; the king is 'The Good God, Lord of the Two Lands'; and the action he is performing is 'subjugating all foreign lands', and 'smiting the bedouin of Asia'.

31 *Outer:* Girdle of Queen Mereret, gold. L. (of each shell) 5·7 cm. Cat. Nos. 53074, 53165. The eight cowrie shells were made in the same manner as those of similar girdles belonging to the women of the royal house. Queen Mereret had two or more imitation cowrie shell girdles in her parure, but as parts were

pilfered at the time of discovery, it is impossible to say how they should be reconstructed. It may well be that the smaller gold cowries belong to an entirely separate girdle composed of beads strung on two threads.

Inner (top): Pendant, gold inlaid with carnelian, lapis lazuli and turquoise. H. 4·6 cm. Cat. No. 53070. The pendant is made in imitation of a trimmed pearl shell and is inlaid at its top with a design based on the lotus flower from which hangs a wreath of stylized flower petals, ending in a pendant of three chevrons, all in cloisonné-work. Technically this is the supreme masterpiece from this period.

Inner (middle): Part of a collar, gold. L. *c.* 10 cm. Cat. No. 53171. The collar consists of a number of reticulated gold elements. To the lower edge of the middle of some of them is soldered a gold bivalve shell, 0·8 cm. high.

Inner (bottom): Gold shell. W. 7·6 cm. Cat. No. 53255. A pendant in the form of a bivalve shell beaten out of a disk of massive gold with a suspension ring soldered to the hollow back, at the apex. The originals of such ornaments made of pearl shells trimmed to shape and inscribed with the king's name were common during the Middle Kingdom.

32 *Above:* Three finger-rings, gold, carnelian, turquoise, amethyst. L. 1·1, 1·0, 1·8 cm. Cat. Nos. 52260, 52240, 52244. The bezel of each ring is in the form of a scarab, one in amethyst, another in cloisonné-work on a plain gold base-plate, and a third in lapis lazuli mounted on a gold base-plate inscribed with the name and titles of Ammenemes III. Each scarab swivels on a gold wire ring, the ends of which are coiled about each other, a metal version of a simple linen thread tie.

Below: Two hollow gold heads of the goddess Bat, from the inlays in one of Mereret's decayed jewel-caskets. W. 2·5 cm. Cat. Nos. 53094–5.

33 *Outer:* Two cylindrical pendants, gold, lapis lazuli and turquoise. L. 4·9 cm. and 5·3 cm. Cat. Nos. 53071–2. These curious pendants consist essentially of gold cylindrical boxes fitted with caps furnished with suspension rings. Their exact purpose is unknown.

Inner: A pair of bracelet slides, gold inlaid with carnelian, and turquoise. H. 6·4 cm. Cat. Nos. 42026–7. Queen Mereret received from Ammenemes III two bracelets, similar to those of Sit-Hathor-Yunet, with slides inlaid with his name.

34 Strings of beads from private burials of the Middle Kingdom excavated at Rifa and Haraga. In the Royal Scottish Museum, Edinburgh, Reg. Nos. 1907.713.7; 1914.1088–91, 1095. The beads are of two kinds – ball and barrels, some of the latter are ribbed. The materials of which they are made are (a) natural stones, such as carnelian, amethyst, lapis lazuli, green felspar and turquoise; and (b) artificial substances such as green faience and gilded plaster. The uppermost necklace has natural shell terminals.

35, 36 Parure of an unknown woman, gold and electrum. Late XVIIth Dynasty. In the Royal Scottish Museum, Edinburgh. Reg. Nos. 1909.527.15–19. In 1909 Flinders Petrie, excavating at Qurna, near the mouth of the Valley of the Kings at Western Thebes, found the intact burial of an unknown woman and infant in a shallow grave cut in the rock. The richness of her parure is unusual for such an impoverished age and suggests that the woman and her child were important members of the ruling house at Thebes towards the end of the XVIIth Dynasty.

35 A girdle of electrum beads, L. 79 cm., consisting of twenty-six cowroid shapes alternating with twelve barrel beads threaded on a double string.

36 *Top row:* A pair of earrings, each 2–3 cm. in diameter, consisting of four penannular hoops soldered together, the two inner hoops having a smaller gap and so forming a tongue for penetrating the hole in the earlobe. These are the earliest examples of earrings in Egypt, the wearing of such ornaments evidently being an Asiatic fashion imported into Egypt in Hyksos times.

At sides: Four plain gold bangles worn as bracelets on both forearms; each 6 cm. in diameter and made up of gold bar of D-section bent into a circle and soldered.

Centre: A collar with an outer circumference of 38 cm., consisting of four rows of gold rings threaded on a thick pad of fibre, the centre strings of which are knotted into the terminals. When the two terminals are brought in juxtaposition a locking pin can be inserted between them. Each ring was made from wire of triangular section. This jewel appears to be an early form of the *shebyu*-collar so often given as an award of honour by the Pharaohs to their subjects in the ensuing dynasty.

37–46 Jewels from the parure of Queen Ah-hotpe deposited with her mummy in a huge coffin excavated near the mouth of the Valley of the Kings at Western Thebes. Ah-hotpe was the mother of Ka-mose and Amosis, the Theban princes who in succession fought a war of liberation against their Hyksos overlords ruling in Lower Egypt. Their eventual triumph ushered in a new period of prosperity and high culture for the Egyptians. The burial regalia of Ah-hotpe comprised jewels given to her by Ka-mose and by Amosis, late in whose reign she evidently died. The workmanship of these jewels is generally much cruder than that of the Middle Kingdom craftsmen but details of style and an improvement in the quality of some of the jewels given to Ah-hotpe by Amosis suggests that he fell heir to the experience and traditions of the Memphite studios when he conquered Lower Egypt.

37, 38 Armlet, gold inlaid wirh carnelian, lapis lazuli and green felspar. W. 11 cm., H. 8·1 cm. In the Cairo Museum, Cat. No. 52642. The design is a development of the lion bracelets of the Middle Kingdom worn on the upper arm. King Ka-mose had an armlet consisting of a box-like cartouche bearing his name and two lions (now in the Louvre) that evidently had been strung on a thick double cord. Here the combination has been translated into an inflexible gold armlet, half the gold circlet being worked into the semblance of a double twisted cord. The other half is planished flat and decorated by alternate *djed* and *tyet* symbols in cloisonné-work. From the centre of the circlet, opposite the cartouche, a tongue projects decorated in inlays with a feather-pattern. In use, it lay along the inner side of the arm to prevent the heavy cartouche and sphinxes from twisting the armlet round on the wearer. The internal diameter of the armlet (8·1 cm.) is greater than that of the other armlets of Queen Ah-hotpe, and suggests therefore that it was worn by Amosis himself, perhaps in his earlier years.

39 Pectoral, gold, inlaid with carnelian, lapis lazuli and turquoise. W. 9·2 cm. In the Cairo Museum, Cat. No. 52004. This pectoral is made by the same technique as the Middle Kingdom examples, but is far less accomplished, though the chasing of the reverse is a little more skilful than the lapidary work on the face. The kiosk has a base decorated with vertical zigzags symbolizing the Waters of Heaven on which a solar bark floats protected by falcons flying above left and right. Within this craft King Amosis (centre) is being lustrated by the falcon-headed Re of Lower Egypt and Amun of Upper Egypt who pour streams of water over him

from the libation vases raised on high. The design is tied together by inscriptions which give the names and titles of Amosis. This jewel was probably made for the coronation of Amosis, one of the ceremonies of which was the purification of the king by priests. Here the rite is regarded as taking place in Heaven.

40 *Left and centre:* A pair of bracelets or anklets, gold, carnelian, lapis lazuli and turquoise. L. (unclasped) 15·0 cm. H. 4·3 cm. In the Cairo Museum, Cat. Nos. 52071–2. This jewel is constructed on entirely different principles from its Middle Kingdom counterparts. Firstly, the beads are strung on thirty gold wires, not threads, and have therefore retained their original order. The band, however, is only partly flexible. Secondly, the end-pieces, made in the form of lidless boxes, are fitted with perforated lugs that engage with each other and are locked by a retractable pin. Thirdly, the spacers are formed of five gold strips with their long edges turned up and perforated to ride on the wires. The cylindrical beads are threaded in square groups each bisected diagonally to form triangles, one of which is of gold. The diagonal motif is very common at this period and appears on other jewels of Queen Ah-hotpe. The end-pieces, when joined with their pins, show the names and titles of Amosis, 'beloved of Amun' and 'of Re', chased on the outer surface.

Right: Bracelet, gold, carnelian, lapis lazuli and turquoise. L. (laid flat) 16·5 cm. In the Cairo Museum. Cat. No. 52070. This bracelet, or anklet, one of a pair, follows a more traditional method of manufacture except that eighteen wires are used as threads and the clasp fastens by means of a retractable pin engaging in catches on the end-pieces. The seven gold spacer-bars resemble Middle Kingdom prototypes but are not backed by a flat plate, and have four instead of three ring beads to each tubular unit. An eighth spacer-bar is of box form and has hieroglyphs in silhouette soldered to its outer face.

41 Necklace of three flies on a chain, gold. H. 9·0 cm. In the Cairo Museum, Cat. No. 52671. The Order of the Golden Fly appears to have been a military decoration, perhaps of Canaanite origin (*cf.* Beelzebub, 'Lord of Flies'), bestowed for valour in the field. These three examples found among Ah-hotpe's jewels are the largest and best versions of such an award which, in view of the amount of gold that went into their making, was of great intrinsic value. The design of the flies is of admirable boldness and simplicity. The stripes on the thorax have been simulated by cutting six longitudinal and two transverse slots into the domed body. As the wearer moves, the flash of light over this lattice of metal gives something of the iridescence of the natural insect. The flies are suspended by large rings soldered between the eyes on a loop-in-loop chain furnished with a simple hook-and-eye fastener.

42 Bracelet, gold. D. (of opening) 6 cm. In the Cairo Museum, Cat. No. 52073. This is one of only two known examples of a type of bracelet commonly shown on the monuments of the XVIIIth Dynasty and which is probably a translation into metal of an ivory archetype. The jewel has been made by bending a strip of gold, 3·3 cm. in width, into a circle and soldering the two ends together. The resulting cylinder has been hammered on stakes so as to raise an expansion on the cylinder wall for most of its height leaving, however, an upper and lower border.

43 Armlet, gold inlaid with carnelian, lapis lazuli and turquoise (?). D. 6·6 cm. H. 7·3 cm. In the Cairo Museum, Cat. No. 52068. This is an early example of a kind of bracelet that, in the New Kingdom, was to supplement the flexible types which had been so characteristic of earlier times. In essence it consists of two rigid half-cylinders hinged together at both ends, one hinge-pin being

fixed and the other furnished with a knob by which it can be withdrawn or inserted to form a fastening. In this example one half is made in the form of Nekhebet, holding *shen*-signs in her talons; and the other, as two curved bars inlaid with blue and green stones between thick gold cloisons and joined together at their centre by a gold disk inlaid with carnelian. The green inlays have discoloured to brown in places and other inlays are missing, notably the beak of the vulture. The design of the bird is poor and the techniques show a considerable decline from the standards of the Middle Kingdom.

44 Bracelet, gold inlaid with lapis lazuli. Greater diam. 5·5 cm., smaller diam. 4·8 cm. In the Cairo Museum, Cat. No. 52069. This is another example of the rigid bracelet. It consists of two half-cylinders to which have been soldered the various elements of the design cut in gold plate with the details added by chasing. The background to this raised scene has been inlaid with a mosaic of pieces of lapis lazuli cemented in position with a resinous adhesive which is visible as a black substance where the inlays are missing. The balanced scene on the right half shows the Earth God Geb wearing a short cloak and the Crowns of Upper and Lower Egypt as he supports his son, King Amosis, who kneels before him to be crowned. The names, titles and epithets of the king are given in two panels flanking the hinges at both ends. The other half-cylinder shows the ancestral spirits of the Kings of Upper and Lower Egypt, as kneeling men wearing jackal or falcon masks and raising their arms in jubilation to promise Amosis 'all joy' and 'all life and sovereignty for ever'. The two halves are fixed together by hinges, one pin of which is retractable to form the clasp.

45 Pendant on a chain, gold and lapis lazuli. L. (of chain) 201 cm., H. (of scarab) 3·0 cm. In the Cairo Museum, Cat. No. 52670. This jewel is technically the finest among Ah-hotpe's treasure and may indicate that it was made in a Memphite workshop late in the reign of Amosis. The long chain is a sextuple loop-in-loop type made with great skill and regularity. It is fitted at its ends with two ferrules each in the form of a goose-head recurved on its elongated neck, which is inscribed with one of the two great names of Amosis. At the back of the head is soldered a ring as a means of fastening the ends with a tie-cord. The scarab is made from two heavy gold plates, fitted with cloisons to form cells which are filled with pieces of lapis lazuli cemented in position. The legs were cast separately and soldered to the base-plate, giving the underside of the scarab a most naturalistic appearance. Through the suspension rings passes a loop of twisted wire of a somewhat improvised nature; this may indicate that the scarab was not originally designed to be worn on this chain, but had been requisitioned for use as a heart scarab.

46 Falcon Collar, gold with green and blue inlays. W. (of each terminal) 5·5 cm. In the Cairo Museum, Cat. No. 52672. This collar has been reconstructed from a number of the elements found loose on the body of Ah-hotpe, but nearly one hundred and forty other pieces (Cat. No. 52733) have not been included. In view of the unique design of this jewel there is now no certainty about how it should be re-strung. As restored at present, the collar has fourteen rows of beads whereas the falcon-headed shoulder pieces are perforated with eight holes. The various elements have been made by hammering gold foil into suitable moulds and trimming the edges. They include lions pursuing ibex, gazelles, scrolls, birds in flight, winged uraei and cats. While many of these designs are characteristically Egyptian, some of them suggest Aegean influence, particularly in such details as the 'flying gallop'

of the coursing animals. At least the profusion and combination of such elements in a collar of traditional form is distinctly un-Egyptian and may represent the more Asiatic taste of the Hyksos rulers of Lower Egypt who were the patrons of the Memphite jewellers before the conquests of Amosis.

47 Royal concubines, detail from a wall-painting in tomb No. 69 of Menna at Western Thebes. After the copy by Nina de G. Davies in the British Museum. Middle XVIIIth Dynasty. This portion of the painted tomb chapel shows two of the daughters of Menna who were subsidiary wives of Amenophis III. The proud Egyptian beauties are shown in all their finery, which not only includes large gold earrings, collars, bracelets and armlets but a fillet tied round the brows with the ends falling behind. Beneath the fillet is a diadem carrying a gazelle head in front. The vertical rear plumes of Sit-Hathor-Yunet's circlet have here been transferred to the front of the head. The elaborate gold ornament on top of the hair is probably a receptacle for holding the cone of scented unguent which, as it melted, perfumed the wearer's hair and person.

48 Circlet of a queen or princess, electrum. H. (of stag's head) 8·5 cm. From Salhiya (?) in the Eastern Delta. In the Metropolitan Museum of Art, New York, Reg. No. 68.136.1. This unique crown, consisting of a band of electrum 1·5 cm. wide perforated to take tie-strings at the rear and mounted with rosettes and animal heads, appears to have been made in Egypt largely under Asiatic inspiration, if it is not an Asiatic import. In the XVIIIth Dynasty it became the fashion to decorate the diadems of princesses and lesser queens with the figure of a gazelle's head in place of the uraeus or vulture of principal queens. This crown with its four gazelle heads may have been part of the trousseau of a foreign princess sent as a bride for one of the Pharaohs according to the diplomacy of the age. The four octafoil rosettes, too, are not specifically Egyptian with their sharply pointed petals, but they recall the eight-pointed star-shapes among the granular jewelry of Khnumet. The most extraordinary feature of the diadem, however, is the large hollow deer-head which decorates the centre of the band. Although the deer, under the name of *henen*, is sometimes represented in Egypt from predynastic times till the XIXth Dynasty, there is no positive evidence that the species was ever indigenous to Egypt or introduced there in ancient times except as stray marvels from Asia. The stylized treatment of deer antlers on this diadem does not suggest the work of a craftsman who was familiar with the appearance of the stag. For this reason the crown may well be the work of an Egyptian goldsmith and not an Asiatic import. It is reputed to have been found with other goldwork of the Middle Kingdom on a remote Delta site not far from the Hyksos stronghold of Avaris.

49–55 If the treasure of Queen Ah-hotpe is a sampling of the craft of the Egyptian jewellers at the very beginning of the XVIIIth Dynasty, the treasure of the three queens of Tuthmosis III, examples of which are shown in the next seven plates, exhibits their skill a century later when Egypt was in full contact with the high culture of the Eastern Mediterranean. The designs are more sophisticated, the techniques less fumbling, though the actual workmanship does not display the standards achieved in the Lahun and Dahshur jewels. This may be because it was made for secondary queens, evidently of Syrian or Canaanite origin to judge by their names. Originally each queen seems to have been provided with a full set of ornaments of considerable value. In recent years the staff of the Metropolitan Museum of Art have

made valiant attempts to restore this jewelry, now in their possession, to its original appearance as shown here.

49 Circlet, gold, inlaid with carnelian, blue and green frit (now decayed). L. (of diadem) 43 cm. In the Metropolitan Museum of Art, New York, Reg. No. 26.8.99. The circlet is a variation on the classical fillet worn from earliest times. A departure from such designs is a sagittal band that prevents the diadem from slipping over the face. The bands are joined in a T-shape which tapers from 2·8 cm. at their junction to 1·6 cm. at their ends. These are furnished with leopard heads worked separately and soldered in place holding rings in their mouths through which tie-cords are passed. The special feature of this headdress is the pair of gazelle heads which are detachable, fitting onto curved thimbles soldered to the front of the diadem. The triple necklaces shown in this illustration have been made up from the great mass of lenticular beads in blue faience that were recovered from this deposit.

50 A girdle, gold and red glass. L. 96 cm. In the Metropolitan Museum of Art, New York, Reg. No. 26.8.41. This jewel was worn under the gown. It follows the design of such girdles in the New Kingdom, but for the semicircular main beads it substitutes twenty-two hollow gold fishes, each made in two half shells and soldered along their seams with perforations to take three strings of gold and red glass beads. Like all such girdles it is a continuous zone without a clasp and was put on by passing it over the head and shoulders and allowing it to rest on the hips.

51 Bracelets, gold inlaid with carnelian, turquoise and blue frit (?). L. 6·0 cm., D. c. 5·6 cm. tapering to 5·3 cm. In the Metropolitan Museum of Art, New York, Reg. No. 26.8.125−8. These are two of the three pairs of bracelets of this type which were owned by the queens. They are of rigid pattern with pin fastenings. The exteriors are fashioned by the cloisonné technique with rims and raised gold bars alternating with cells of equal width for the insertion of plaques of carnelian, turquoise and a blue substance, now decayed, which was probably a blue frit imitating lapis lazuli. These inlays are ribbed to imitate fifteen rows of cylindrical beads strung between gold spacers. The insides of the bracelets are inscribed with the names and titles of Tuthmosis III and show signs of wear.

52 A belt of gold, carnelian, turquoise and blue faience (?) beads. L. c. 78 cm. In the Metropolitan Museum of Art, New York, Reg. No. 26.8.118−9. The classical Egyptian garment worn by women was the simple linen shift held up by shoulder-straps. No belt was required for this, though girdles might be worn beneath it. In the later years of the XVIIIth Dynasty the more flowing robes of the time demanded some kind of sash to confine the gown around the waist, and a long ribbed girdle, usually woven of some red material, makes it appearance. The two examples in the Metropolitan Museum, however, are the only examples known of a woman's belt in ancient Egypt. It consists of a number of coloured stone beads shaped like acacia seeds strung between spacer-bars consisting of seven similarly shaped gold beads soldered together.

53 The 'Long' Headdress, gold inlaid with carnelian, turquoise and coloured frit (now decayed). H. 37 cm. In the Metropolitan Museum of Art, New York, Reg. No. 26.8.117. This wig, or hair-cover, is a development of the rosette decorations sewn or strung to the braided tresses of the wearer in earlier dynasties. In this example, the rosettes are more numerous and elaborate and are strung on a support which is independent of the hair. The reconstruction shows about 850 inlaid pieces strung in such a way as to form a flexible golden cowl descending at the back and front to cover the typical long wig or coiffure of Egyptian women. Originally the rosettes were inlaid with blue and green artificial stones (probably of frit), which have decayed through damp to the condition of a white paste. This headdress, when it first left the hands of the jeweller, must have been a glittering and opulent object, particularly in the Egyptian sunshine; but it was also a heavy one and its present weight of over one kilogram will have to be doubled to arrive at some idea of how much it weighed when all its inlays were in place.

54 Falcon Collar, gold inlaid with carnelian, turquoise and blue and green frit (decayed). Size of terminals. W. 7·4 cm., H. 5·2 cm. In the Metropolitan Museum of Art, New York, Reg. No. 26.8.59 *et al.* The collar has been reconstructed from the two shoulder-pieces in the form of falcon heads, with eyes inlaid with obsidian and markings in carnelian and turquoise (?), the latter somewhat discoloured, and with beads that have been selected in modern times because of the same colour relationships and standard of craftsmanship. The order of stringing is somewhat uncertain and it is possible that elements from two collars have been combined here.

55 Broad Collar, gold inlaid with carnelian, turquoise and blue frit (decayed). Size of terminals, W. 7·2 cm., H. 3·5 cm. In the Metropolitan Museum of Art, New York, Reg. No. 26.8.135, 70 *et al.* This collar is also restored, the basis for the reconstruction being the two shoulder-pieces with a design of the king's prenomen, centre, flanked by two lotus flowers in cloisonné-work inlaid with carnelian, turquoise and blue frit, of which little now remains. The beads were in the form of *nefer*-signs in gold, graduated in size, half inlaid with coloured stones or frit (mostly missing), and half with plain gold fronts, showing that the gold *nefers* alternated with coloured ones. In the re-stringing, the plain gold backs of the *nefers* and the palmette pendants have been shown with the inlaid fronts of the shoulder pieces to give a uniform appearance. With this reconstruction has been included a lotus flower counterpoise still retaining some of its carnelian and turquoise inlays. It would probably have had a lower border of bead tassels.

56 Orchestra and dancers, part of a wall-painting from the tomb of Neb-amun in the British Museum. Reign of Amenophis III, XVIIIth Dynasty. The complete scene shows guests being entertained at a banquet. The squatting girls play on the double pipes, clap their hands and sing of the joys of the Inundation, when 'the whole land is flooded with love', while two of their number perform a posturing dance. Their jewelry is worthy of note. All wear fillets on their heads, probably made of strips of papyrus sewn with leaves and flower petals, or bead versions of such an ornament. A similar decoration surrounds the container holding the unguent cone on top of their hair. A lotus flower tucked in the fillet hangs over the forehead. Around their necks they wear festal collars and over them plain gold collars or complete inlaid gold and silver versions of the floral collar. Their earrings or ear-plugs are large. They wear two or three gold bracelets on each forearm and two gold inlaid armlets. In addition, because the dancers have divested themselves of their gowns, the girdles around their hips are readily visible.

57 Broad Collar of King Smenkh-ka-re, gold and electrum inlaid with coloured glass. Size of terminals, L. 9 cm., H. 4·5 cm. Found on the body of the king in tomb No. 55 in the Valley of the Kings in 1907. In the Cairo Museum, Cat. No. 52, 674. The collar is shown in the condition in which it was re-threaded soon after its

recovery from the tomb but, owing to the lack of any records kept by the excavators, it is impossible to say how authentic the reconstruction is. The collar is obviously incomplete, a considerable number of ring beads are missing from the six strings, and other elements were retrieved which are not included; a few parts were stolen by Davis' men. Since each shoulder-piece is perforated with six holes there were five rows of pendants which are present here; but in a confusion of sizes and sequences.

58 Ear ornaments, gold, faience, glass and stone. In the Royal Scottish Museum, Edinburgh. XVIII–XXth Dynasties.

Top Row: Ear-plugs in faience and gold (Reg. Nos. 1965.354, 1883.49.12, 1965.355). The two outer specimens (diam. 4, and 3·2 cm.) are made of faience and have a groove round the periphery by which they could be retained in a hole stretched in the ear-lobe. The specimen in the middle (diam. 4 cm.) is made of massive gold and was found in the vicinity of the Royal Tomb at Amarna.

Middle Row: Earrings in glass and jasper. From the Acworth Collection. Average diam. 2·5 cm. Reg. Nos. 1961.514, 516–8, 528. Four of the earrings here illustrated are made of canes of glass of two colours bent into a penannular shape and formed with a loop at each end. A stud of metal, wood or ivory was passed through these stirrups and a hole in the lobe of the ear to hold them in position. The centre ring is made of red jasper of D-section and is provided with a perforated lug from which hang two bead tassels. The position of the slit shows how these rings were worn. They were inserted by stretching the lobe to a very thin ribbon of flesh to pass through the gap. It may be assumed that, once in position, the rings were removed very infrequently, if at all.

Bottom Row: Ear-studs in gold, faience and stone. Average diam. 2·5 cm., average length, 3·2 cm. (Reg. Nos. 1883.49, 9, 10; 1965.350–2). These little mushroom-shaped studs appear about the Amarna Period. Three of those illustrated here are made of faience in two or more colours. The white stone specimen is of the same date. The two outer specimens of gold came from the Royal Tomb at Amarna and probably belonged to one of the royal daughters or wives.

59 Three finger-rings, gold and silver. L. (of bezels) 2·5, 2·1, 2·5 cm. Amarna Period, XVIIIth Dynasty. In the former collection of Dr K. J. Stern. These signet rings were made by the same technique as the preceding pair. The first is a massive silver specimen inscribed with a version of the prenomen of Amenophis III who is also described as 'the Son of Amun' and 'Happy in Wealth'. The gold ring is inscribed with the phrase, 'Aten, dwelling on the horizon, is the lord of joy'. The third example is also in silver of high quality and is inscribed with the prenomen of Akhenaten and the epithet, 'Beloved of Re-Herakhty'.

60 Finger-rings, gold and carnelian, reign of Akhenaten. In the Royal Scottish Museum, Edinburgh. Reg. Nos. 1883.49.8,2,1; 190.1. All the rings, with the exception of the specimen on the right, were found in the vicinity of the Royal Tomb at Amarna. The example on the left has a swivelling bezel which is threaded on the ring by drawing out the ends of the loop into very long wires, passing them through its longitudinal hole from opposite ends, and coiling them onto the body. The next (diam. 3 cm.) has a bezel of gold surmounted by the figure of a frog and encircled by a double row of large granules. The other two rings are examples of the massive signet rings of the period made by casting in *cire perdue*, the bezel being *en masse* with the hoop. The inscription,

in intaglio, was also cut in the wax before the ring was cast. The gold ring (diam. 2·5 cm.) is inscribed with the name of Queen Nefert-iti: the other specimen (diam. 2 cm.) is made of an alloy of gold with a high copper content, peculiar to this period. It bears the prenomen of 'The Good God Akhenaten' in a cartouche upon a bark with prow and stern in the form of a royal head wearing horns and plumes.

61 Vulture Collar of King Smenkh-ka-re, gold. H. 24 cm., W. 21 cm. Found on the head of the king in tomb No. 55 in the Valley of the Kings in 1907. In the Cairo Museum, Cat. No. 52, 643. This is a rare example of the 'Collar of the Vulture' known from the coffin pictures of the Middle Kingdom. It had suffered some damage before it was put in the position in which it was found, having lost its right talon holding a *shen*-sign and the *menkhet* counterpoise on a gold wire that connected the two perforated lugs near the tips of the wings. A repair had also been made by soldering a patch onto the right pinion. The vulture is cut in thick sheet gold, the lower edges of the design being turned up for a millimetre to give the figure stability. The outline and feathering of the bird is most expertly indicated by unfaltering lines incised by chasing. This collar, and the somewhat inferior specimen found on the body of Tut-ankh-amun, are the only surviving examples of a funerary jewel with which all the mummies of the great Pharaohs were once provided. A more elaborate version in flexible cloisonné-work was also found upon Tut-ankh-amun.

62–86 Jewelry from the tomb of King Tut-ankh-amun (c. 1362–1353 BC) now in the Cairo Museum.

62–67, 82 A series of pectoral ornaments found within the Anubis Pylon in the 'Treasury' of the tomb. They are funerary jewels based upon the idea of the transfiguration of the dead king within the primeval shrine or kiosk in which the demiurge first manifested himself at the creation of the world.

62 Pectoral, gold, inlaid with carnelian, red, light blue and dark blue glass, the last somewhat decayed. H. 12·1 cm., W. 17·2 cm. Carter Cat. No. 261, P3. The kiosk is of simple form with a 'block border' base and supports, a cavetto cornice and a floral frieze. Within it is displayed the sky-goddess Nut in the form of a vulture with protective wings, tail outspread and talons clutching *shen*-signs. Between the bird and the frieze are the titles and names of the king and the name of the goddess.

63 Pectoral, gold inlaid with carnelian, green, red, light blue and dark blue glass. H. 10·5 cm., W. 14·5 cm. Carter Cat. No. 261, J. The kiosk is of slightly more elaborate form, having in addition to its floral frieze a base of poppy-flowers and lotus buds. In the kiosk appears a scarab carved in the round in green felspar, its wings being of cloisonné-work. The disk of the new-born sun which it supports on its head is here elongated into an oval cartouche containing the prenomen of the king with the additional epithet, 'the Image of the Sun-god'. The design represents the daily resurrection at dawn of the sun-god with whom the king is identified.

64 Pectoral, poor quality gold, inlaid with quartz set in red cement, green, red, light blue and dark blue glass, the last greatly decayed. H. 12 cm., W. 16·3 cm. Carter Cat. No. 261, I. The kiosk is of simple form with a frieze of flower petals below the architrave which carries two anchorages, worked on each face with a winged protective serpent, to take a necklace of four strings. Within the kiosk the sun-god is seen appearing on the primeval *Djed*-column above the waters of Chaos, and is supported by the goddesses Isis (right) and Nephthys (left) with the wings of kites. Uraei wearing the White Crown of Upper Egypt (right) and the

Red Crown of Lower Egypt (left) support the king's two 'great' names. The design symbolizes the original creation of the universe by the sun-god to whom the dead king has become assimilated.

65 Pectoral, poor-quality gold, much tarnished, inlaid with carnelian (?), red, light blue and dark blue glass, the last badly deteriorated. H. 15·5 cm., W. 20 cm. Carter Cat. No. 261, O. Within the primeval shrine, the cornice of which is flanked with a uraeus wearing a sun-disk, appear Edjo the goddess of Lower Egypt (right) as a winged uraeus, wearing the Red Crown, and Nekhebet the goddess of Upper Egypt (left) as a vulture wearing the White Crown with flanking plumes. Both are resting on *neb*-baskets and protect with their wings the king who is shown mummiform wearing the *Atef*-crown of coronation and jubilee, and holding sceptres. The label behind him giving his titles shows that he has now become assimilated to Osiris the god of Resurrection. *Shen*-signs connect him to the two goddesses. Brief labels behind the goddesses show that they are also identified with Isis and Nephthys. The design symbolizes the resurrection of the dead king, ruler of Upper and Lower Egypt and all that the sun encircles, within the primeval shrine, fanned into life by the wings of Isis and Nephthys.

66 Pectoral, gold, inlaid with rock crystal backed with coloured cement, green, red, light blue and dark blue glass. H. 12·8 cm., W. 18·2 cm. Carter Cat. No. 261, N. Within the kiosk is a large, bluish-grey, glazed stone (steatite?) scarab supported by kneeling figures of Isis (right) and Nephthys (left) as representatives of the guardian goddesses of the four quarters. The scarab representing the sun-god Khepri at dawn rolls the disk of the sun across the heavens. Here the disk is encircled by two uraei, symbolizing the king of Upper and Lower Egypt whose two great names appear surmounted by sun-disks between the forearms of the goddesses and the architrave. The design represents the daily rebirth of the king as the sun-god.

67 Pectoral, gold, inlaid with carnelian, red, light blue and dark blue glass. H. 12·6 cm., W. 14·3 cm. Carter Cat. No. 261, P1. The kiosk is of simple form, the architrave below the cavetto cornice being decorated with a block border. Within it stands the sky goddess Nut as a woman with vulture's wings, described as 'the Great Spirit', her arms outspread in a protective gesture. Above her are the names and titles of the king. Below is a text to the effect that Nut stretches her arms over the dead king in order to protect his limbs. The attachments for the strings at the side show that this jewel was meant to be worn as the central element in a belt or girdle consisting of four strands threaded with beads or plaques.

68 Pectoral, with necklace and counterpoise, of gold, electrum, lapis lazuli, green felspar, calcite (some inlays set with coloured cements), white, green, light blue and dark blue glass. Pectoral, H. 11·8 cm., W. 10·8 cm.; counterpoise, H. 6·2 cm. (without tassels), W. 6·8 cm. Carter Cat. No. 269, K, from the same box as Plate 70. The pectoral ornament shows a golden bark carrying the electrum crescent and disk of the moon over the waters of the firmament, symbolized by the lotus buds and flowers springing from the *pet*-sign for heaven, with alternate light and dark blue dew-drops. The counterpoise is in the form of a lotus flower, flanked by buds and two rosettes, furnished with a bar from which hang nineteen beaded tassels. This is another example of a jewel worn by the king during his lifetime.

69 *Above:* Bracelet, gold, amethyst, lapis lazuli, carnelian and red jasper. L. of wrist-band, 13·5 cm., W. 1·9 cm.; H. of centre

piece 4·1 cm., L. 4·5 cm. Carter Cat. No. 269, M. The centre piece is formed of an amethyst scarab bearing the king's prenomen set in an open oval gold plaque decorated with gold granules. It is flanked by inlaid solar uraei, and bordered by ring beads of stone and gold. The underside is inscribed on the border surrounding the base of the scarab with the titles and prenomen of the king 'Living Forever'.

Below: Bracelet, gold, lapis lazuli, carnelian, light blue and dark blue glass, calcite. L. of wrist-band 10·7 cm., W. 3·5 cm. H. of centre piece 6·6 cm., W. 5·1 cm. Carter Cat. No. 269, G.

The design of the centre piece is based upon the king's prenomen, the scarab being greatly enlarged and formed with gold cloisons inlaid with lapis lazuli and one piece of green glass. The sun-disk between its forelegs has been replaced by a cartouche bearing the king's prenomen (here placed upside down). Its rear legs hold the *neb*-basket inlaid with blue glass.

70, 71 Details of a pectoral, complete with its straps and counterpoise, found in a box in the tomb of Tut-ankh-amun. Pectoral and counterpoise, gold of rather poor quality, silver, translucent quartz and calcite set in coloured cements, green, red, black, light blue and dark blue glass: electrum and dark blue glass beads. Pectoral, H. 11·5 cm., W. 14·1 cm.; counterpoise, H. 8·4 cm., W. 7·8 cm.; straps, L. 34·3 cm. Carter Cat. No. 269, I, J, Q.

The pectoral is in the form of a kiosk with the base decorated with eight groups of *heh*-signs signifying 'eternity'; and a starry firmament beneath the architrave. Within this naos the king in the Blue Crown, imbricated cloak and feathered garb of his coronation, and holding his sceptres stands before the deities of Memphis seated on thrones. On the left is the lion-headed Sekhmet who holds out a notched palm-rib symbolizing long years of rule; and on the right, Ptah who gives life and power from the sceptre he holds in both hands. Behind Sekhmet is the king's *Ka*, with another of his names surmounted by a crowned falcon. Behind Ptah is a kneeling figurine of Eternity holding notched palm-ribs and supporting a uraeus wearing the solar disk and coiled upon a *neb*-sign. Inscriptions declare that Sekhmet promises the king 'years of eternity'; and Ptah, 'Life, Power and Well-being'.

The counterpoise is also of kiosk shape but the columns are of clustered papyrus-bud form and the base has a bar from which hang fourteen beaded tassels, eight of which end in little gold fishes. Within the kiosk, the king wears the Blue Crown and, holding a sceptre, sits on a throne before the winged goddess Maet, from whom he receives the sign of life.

Each strap is made of fifteen plaques of four different designs, the names of the king alternating with his titles and with good wishes, and each is bordered with strings of beads.

There is little doubt from the design of this jewel which shows the king as a terrestrial ruler, and its location within the tomb, that it was not part of his funerary equipment but had been made for his coronation.

72 *Outer:* A scarf or stole, probably part of a sacerdotal dress. L. 69·5 cm., W. 4·6 cm. Carter Cat. No. 269, O. The ornament is made of seven strings of blue faience disk beads, caught at intervals by thirteen spacer bars made of graduated tubes of gold soldered together so that it assumes a horse-shoe shape. The terminals are in the form of gold cartouches chased with the names of the king, and with epithets declaring him to be beloved of Sokar and Ptah of Memphis. At the lower edge of each terminal is a row of four *ankh*-signs (one broken). This object, more of a garment than a jewel, was probably worn around the neck of the

king, in the reverse position to that shown on the plate, like a stole when officiating in his capacity of chief priest of the Memphite cults.

Inner: Pendant, gold, inlaid with lapis lazuli (blue glass?), carnelian and obsidian (for eyes). H. 7·4 cm., W. 11·7 cm. Carter Cat. No. 267, O.

73 Pendant, of gold, electrum, lapis lazuli, carnelian, red and blue glass. H. 14·1 cm., W. 16·4 cm. Carter Cat. No. 267, I. Found in a casket. The ornament is in the form of a sated vulture made in gold cloisonné-work inlaid with glass and stones. The body is only slightly curved and the tail outspread; the talons hold *shen*-signs. The head and neck of the bird, however, are worked in the round, apparently by casting. The head is surmounted by an electrum *Atef*-crown with inlaid feathers, probably indicating that it is the goddess Nekhebet of Upper Egypt who is represented here. The back is chased and fitted with rings to take the suspension cord which ends in tassels.

74 Bracelet, gold, lapis lazuli, turquoise, carnelian and quartz set in coloured cement. Internal diameters, max. 5·4 cm., min. 4·2 cm. Carter Cat. No. 269, N. The bracelet consists of a massive, curved oval gold plate carrying the main design, hinged to a curved rectangular gold plate worked with a geometrical pattern and forming the connecting strap. A retractable pin at one of the hinges serves as a fastener. The main design is a scarab, the body of which is formed of gold cells set with pieces of lapis lazuli; its legs are of gold.

All these scarab bracelets appear to be part of the king's personal jewels worn in his lifetime.

75 Clasp, or counterpoise, gold and silver, inlaid with lapis lazuli, calcite set with coloured cements, green, red, and blue glass. H. 6·8 cm., W. 6 cm. Carter Cat. No. 267, B.

The central element is a cartouche containing the king's prenomen surmounted by the crescent moon and disk, the latter of silver heavily tarnished.

76 Clasp, gold, inlaid with lapis lazuli, carnelian and green felspar. H. 5·6 cm., W. 5·6 cm. Carter Cat. No. 261, L.

This fastening is probably an element in a bracelet or belt, the design of which is based upon the king's name. The scarab supports a *neb*-basket with its rear legs, and flanking the sun-disk held between its front legs are two *h*-signs, making the group for 'eternity'.

77 Pendant, gold inlaid with lapis lazuli, green felspar and calcite set in coloured cement. H. 7·5 cm., W. 8·2 cm. Carter Cat. No. 267, P. The design of this jewel is also based upon the elements in the king's prenomen Neb-kheperu-re. The scarab is carved from pieces of lapis lazuli set in gold cloisons. The falcon wings in chased gold are more stylized in order to fit into a circular shape.

78 Pectoral, gold, lapis lazuli, blue, red and green glass. H. 6·5 cm., W. 11 cm. Carter Cat. No. 256, PPP. Found on the mummy of Tut-ankh-amun. The bird is the sociable vulture, representing Nekhebet. The body is worked in the round, the head being cast separately. This jewel is important as being one of the earliest examples of enamelling. The cloisons of the body, tail and the greater coverts of the wings are filled with lapis lazuli-coloured glass, apparently introduced in powdered form and fired *in situ*. The lesser coverts are filled with red glass and a crater formed by an air bubble may be seen in nearly every cell.

79 *Above:* Pendant, gold, inlaid with carnelian, turquoise, green felspar, lapis lazuli and calcite. H. 9 cm., W. 10·5 cm. Carter Cat. No. 267, A.

A scarab of lapis lazuli, with falcon wings in cloisonné-work, supports between his forelegs the red disk of the new-born sun as he stands upon a *neb*-basket with three carnelian inlaid strokes, thus forming the prenomen of the king, Neb-kheperu-re ('Master of Transformations like Re'), besides representing the birth of the sun-god.

Below: Pendant, gold, inlaid with lapis lazuli, carnelian, turquoise, and light blue glass: the eye of obsidian, or black glass. H. 11·7 cm., W. 12·6 cm. Carter Cat. No. 267, M1. The jewel is in the form of a falcon with wings outspread, bearing on its vertex the red disk of the rising sun, and holding *shen*-signs in its talons which are also attached to the wings by *ankh*-signs, one being damaged. This jewel, representing the king as the newly risen Horus, is of traditional form. It is probably part of the king's coronation regalia repacked into the wrong box.

80 Pectoral, gold, silver, chalcedony, carnelian, calcite set in coloured cements, lapis lazuli, turquoise, obsidian, green, red, blue, black and white glass. H. 14·9 cm., W. 14·5 cm. Carter Cat. No. 267, D. The lower part of this complicated jewel consists of a floral garland. The central parts show a solar falcon in cloisonné-work, its wings outspread and its talons holding *shen*-signs and the heraldic flowers of Lower and Upper Egypt – the lotus flower and the flowering rush. The head and body of the bird have been replaced by a chalcedony scarab, worked in the round, representing Khepri the sun-god at dawn. Flanking Khepri are protective solar uraei. Instead of the usual disk of the sun, the forelegs of Khepri support an elaborate symbol representing both the sun and the moon. It takes the form of a celestial bark bearing the left eye of the sky-god Horus which was miraculously restored by Thoth, the ibis-headed god of the moon, after it had been torn to pieces in the contest between Horus and the storm-god Seth. This is flanked by protective solar uraei upholding the crescent and disk of the moon. Within this symbol is a figure of the king supported by the ibis-headed Thoth and the falcon-headed sun-god Re, the two former wearing the crescent and disk of the moon, the last the solar disk.

This jewel is an elaborate rebus on the prenomen of the king. But it also symbolizes the birth of the sun and the moon, and was doubtless part of the king's coronation regalia when a new son of the sun-god was born to rule Egypt at the beginning of the old lunar year.

81 Counterpoise, gold of inferior quality, lapis lazuli, calcite, obsidian, green, light blue and dark blue glass. H. 6·9 cm., W. 8·2 cm. Carter Cat. No. 267, E. The design shows the figure of Eternity, flanked by uraei, kneeling on a mat to uphold the protective eye of Horus, with the *Tyet* girdle of Isis in place of the usual tadpole-and-shen-sign. This, however, is seen at the base of each notched palm-rib, signifying, 'myriads of years of rule', which forms the outer border of the jewel and supports the heavens forming its top.

82 Pectoral, gold, inlaid with carnelian, dark red, light and dark blue glass. H. 16·5 cm., W. 24·4 cm. Carter Cat. No. 261, M. From the Anubis pylon. The base and supports of the kiosk are decorated with a block border, but in place of the usual cornice appears the winged disk of Horus of Edfu flanked by coiled uraei enfolding sun-disks. Within the kiosk are squatting figures of Isis (right) and Nephthys (left), supporting the winged scarab of the sun-god in his aspect of Khepri at dawn. The scarab is carved in the round from a greenish speckled stone, on the flat reverse of which is inscribed a spell from the *Book of the Dead* exhorting the heart of the deceased not to bear false witness at the Last

Judgment. The inlaid inscriptions linking the various parts give the names of the king and the promises of the protecting goddesses. The design symbolizes the transformation of the king into the new-born sun carried on the wings of the sky-god Horus.

83 *Left and right:* A pair of earrings, gold (tarnished in places), carnelian, calcite and quartz set in coloured cements, dark blue and green glass. H. 11·8 cm., W. 5·4 cm. Carter Cat. No. 269, A3. The fasteners consist of two ribbed tubes, one sliding in the other, capped with studs formed with two uraei. To each of these, attached by stirrups hidden behind a spread-falcon, is a large, gold, flanged ring, the interior filled with a carved carnelian figurine of the king holding a sceptre and flanked by a solar uraeus, all upon a *heb*-festival sign.

Centre: A pair of ear-studs, gold inlaid with carnelian, light blue and dark blue glass, calcite set in coloured cement. H. 7·0 cm. Carter Cat. No. 269, A5. These studs penetrate the hole in the lobe of the ear and are closed with a cap, similar to the devices shown in the more elaborate examples.

84 *Left and right:* A pair of ear-studs, gold inlaid with segments of glass. Diam. 2·5 cm. Carter Cat. No. 269, A6. These studs are smaller than the other examples in this group, the tubes being about 0·5 cm. in diameter, suggesting that they were worn by the king in infancy before the holes in his ear-lobes had been distended to 0·75 cm. or more as measured on his mummy. The design incorporates two uraei as protective devices.

Centre: A pair of earrings, 'purple' gold, dark blue glass, black resin. H. 10 cm., W. 5·5 cm. Carter Cat. No. 269, A5. The tubes of the fasteners are capped at the outer ends with gold flowers. The stirrups connect these to hoops formed of dark resin beads, alternating with hollow gold ball-beads, formed into a hoop with blue glass rings between them. All the goldwork is coloured red except for the applied yellow gold granules and wires.

All these earrings are undoubtedly examples of jewels worn by the king in his early years and put away as custom required when he reached the age of manhood. Although commoners are sometimes shown wearing earrings, the Pharaoh never is, to the writer's knowledge.

85 The diadem, gold, inlaid with carnelian, chalcedony, turquoise, obsidian, light blue and dark blue glass. Average diam. 19 cm., W. of band 2 cm. Carter Cat. No. 256, 4O. Found on the mummy of Tut-ankh-amun. This royal fillet is in the form of a 'boatman's-circlet'. To the band are attached the vulture head of Nekhebet in cast gold with obsidian eyes, and the cobra of Edjo, the tail of the latter winding into an arch to prevent the band from slipping over the brow.

86 A statuette of a king, gold cast solid, with glass bead necklace. H. 5·0 cm. Carter Cat. No. 320, C. Found sealed in a nest of miniature coffins in the tomb of Tut-ankh-amun. The ruler, wearing the Blue Crown and carrying sceptres, squats in the pose of the newly born sun-god and the newly arisen king. The statuette was suspended from a loop-in-loop chain and evidently worn as a personal jewel by the owner.

87, 88 A pair of bracelets, gold and lapis lazuli. Greatest diam. 6·6 cm., greatest width 6 cm. From Tell Basta, XIXth Dynasty. In the Cairo Museum, Cat. Nos. 52575–6. These bracelets were part of the Tell Basta Treasure, and are examples of the rigid type that makes its appearance at the beginning of the XVIIIth Dynasty. They were presumably part of the temple vestments, probably decorating a wooden cult statue of Ramesses II. The main half-cylinder carries a dome-shaped piece of lapis lazuli forming the body of a goose with two heads and a common tail. The outline

of this insertion determines the shape of the half-cylinder which is decorated with granules, plain, beaded and twisted wires. The other half is a plain gold band hinged to the major portion and decorated with parallel narrow half-tubes alternately plain and ribbed.

89 Pendant, gold and decayed glass (?) inlays. H. 7·2 cm. Probably XIXth Dynasty. In the Museum of Fine Arts, Boston, Reg. No. 68.836. This pendant is made of gold and represents the king, perhaps Ramesses II, as the young sun-god at his birth from a lotus flower, which rises out of the primeval waters to open and reveal him within. The comma-shaped depression held the side-lock, probably of lapis lazuli and now missing.

90 Queen Nefert-ari makes an offering to Osiris. Part of a wall-painting in the tomb of the queen in the Valley of the Queens, Western Thebes. XIXth Dynasty, c. 1280 BC. The detail shows the chief wife of Ramesses II during the earlier part of his reign offering water to the god of the dead before a piled-up altar. She wears the headdress of a principal queen in the form of a vulture, no actual example of which has survived, but which must have been made of plain or inlaid gold elements threaded together to form a flexible covering. This is surmounted by a squat modius carrying a sun-disk and two tall flickering feathers made of gold. In her ears she wears an ornament of silver, probably representing a papyrus umbel, its stalk passing through the hole in her ear-lobe. Around her neck is a Broad Collar probably made of inlaid plaques imitating flower petals, mandrake fruits and chevron borders. On her wrists are inlaid silver bracelets of traditional form.

91 Floral collar, polychrome faience, late XVIIIth Dynasty. D. 31·5 cm. In the Metropolitan Museum of Art, New York, Reg. No. 40.2.5. This example of costume jewelry is typical of the opulent and florid Amarna Period when the manufacture of faience and glass reached a peak of technical and artistic brilliance. The collar is an imitation in more permanent material of the festal collars made of ephemeral papyrus, flowers and leaves. They were cheaper to produce than the expensive versions in gold and inlays and could be supplied as favours to guests at banquets. Several faience collars of this type were found in the tomb of Tut-ankh-amun.

92 Coffin-board of a Singer of Amun, wood covered with gesso painted and varnished. XXIst-XXIInd Dynasty, from Thebes. In the British Museum, Reg. No. 22542. The painted decoration on the upper part of this coffin-board of a priestess of Amun (c.. 1000–900 BC) is an elaboration of the natural flower garlands which were placed on the persons of the deceased during the burial ceremonies. A lower fringe of lotus flowers is visible and above this are rows of lotus petals, mandrake fruits, cornflowers and poppy petals.

93, 94 Jewelry from the Theban tomb of an infant princess, gold. Late XIXth Dynasty. In the Cairo Museum. In 1908, Edward Ayrton discovered a small pit tomb (No. 56) in the Valley of the Kings at Western Thebes, mostly full of mud and debris which had been washed into it, after it had been opened in antiquity by thieves who partly rifled it. A number of jewels inscribed with the names of Queen Twosre and her first husband King Sethos II (c. 1210 BC) were found near a decayed miniature coffin which probably belonged to their infant daughter.

93 *Centre:* Pair of earrings, gold. H. 13·5 cm. In the Cairo Museum, Cat. Nos. 52397–8. The earrings are of a similar construction to those of Tut-ankh-amun, and since they are inscribed with the cartouches of Sethos II may have belonged to him when he first came to the throne as a minor, though it is

perhaps more likely that they were specially made for this burial. The basis of the design is a concave corolla fluted into eight petals with a hemispherical boss at its centre. Each alternate petal is inscribed with the names of Sethos II worked in repoussé.

Outer: A necklace, gold. H. (of pendants) 2·1 cm. D. (of beads) 0·7 cm. In the Cairo Museum, Cat. No. 52679. A considerable number of loose elements which have been threaded into two necklaces, one in Cairo and the other in New York, were found by Ayrton in his clearance of pit tomb No. 56. This is the earliest example of a filigree technique which has persisted in certain metal jewelry to the present day, particularly in the Mediterranean area. In Egypt it was imitated also in the manufacture of certain open-work beads in faience, a material which often copied metalwork forms.

94 *Centre:* A pair of earrings, electrum, carnelian and blue faience. D. 4·6 cm. In the Cairo Museum, Cat. Nos. 52399. The earrings were found scattered among the other mud-encased jewelry in the pit-tomb and have been reassembled with a fair degree of probability.

Outer: Circlet, gold. D. 17·0 cm. In the Cairo Museum, Cat. No. 52644. The coronet consists of a circle of thick gold sheet, 0·4 cm. in width, perforated at irregular intervals, varying from 2·5 to 4·3 cm. with sixteen holes for attaching the ornaments in the form of flowers. These have been made by burnishing gold foil into stone or wood moulds. Five of the petals are inscribed alternately with the name of King Sethos II and Queen Twosre. A notable feature of this coronet is that some at least of the flowers were made of coloured gold, though the central boss appears to have been of plain metal, and it seems possible that originally the flowers assembled on the band were alternately of red and yellow gold.

The adult jewelry found in this tomb has all the appearance of having been made somewhat carelessly from flimsy materials; but the various pieces are *en suite*, their design being based upon a floral motif, perhaps a poppy or anemone, 'the lilies of the field'. Despite the fact that they are inscribed with the names of Queen Twosre and her husband, Sethos II, it is doubtful whether they were made for her, since they do not bear the insignia of a reigning queen. The assumption is, therefore, that they were made hurriedly for the equipment of the deceased infant.

95 Ramesses III and his son, Amen-(hir)-khopeshef. Part of a wall-painting in the tomb of the prince in the Valley of the Queens, Western Thebes. XXth Dynasty c. 1180 BC. Ramesses III and his son are shown in full regalia, the prince acting as a fan-bearer. The king wears a necklace and Broad Collar, armlets and bracelets, and has a belt made of inlaid gold plaques from which hangs an apron from a leopard head, also made in cloisonné. The prince wears a Broad Collar and bracelets: his sash is woven with a pattern or has the design applied in needlework. The sidelock of infancy into which his hair is plaited is confined by an inlaid gold clasp which takes the form of a miniature bracelet.

96 Bracelets of the High Priest Pi-nudjem II, gold, carnelian and lapis lazuli. Outer diam. 6·8 cm. From Thebes, XXIst Dynasty. In the Cairo Museum, Cat. No. 52089. These were found upon the mummy of the First Prophet (High Priest) of Amun, Pi-nudjem, who was the virtual ruler of Upper Egypt in the latter part of the XXIst Dynasty (c. 960 BC). They are variations upon the design of the rigid bracelet, the two half-cylinders being reduced to half-loops, their interior surfaces flattened to a ribbon. In cross-section each hoop is almost circular.

97 Ear-plugs of Ramesses XI, gold. L. 16 cm., D. 5 cm. From Abydos. XXth Dynasty. In the Cairo Museum, Cat. Nos. 52323–4.

These massive gold ornaments were found by Mariette in 1859 on a decayed mummy, evidently an unknown woman of the royal household. Each consists of a hollow, lenticular disk, grooved on the rim for inserting in the greatly enlarged holes in the ear-lobes. On the outer face of this disk is soldered a plate decorated with a winged sun-disk in repoussé, and from which the pendants are suspended. The rest of the outer face carries five uraei worked in the round; three of them carry solar disks, while the outer pair wear *atef*-crowns. The pendants take the form of solar uraei, each made of two plates soldered together, five in the first row attached to a bar and hinged to the disks. A feature of this jewel is that the disk is made of coloured ('purple') gold, the most recent ornament so far known to exhibit this technique.

98–106 Jewels from the royal tombs at Tanis, XXIst Dynasty. In the Cairo Museum. In 1939 Pierre Montet, excavating in the area of the main temple at Tanis, uncovered the substructures of a group of royal tombs which had been built in the south-west corner of the site. The tombs of Psusennes I and Amenophthis of the XXIst Dynasty, and four kings of the XXIInd Dynasty were found, most of them reasonably intact though it was obvious that their burials had been disturbed and rearranged in antiquity. From these deposits a number of jewels, nearly all destined for funerary use, were retrieved. Some of these later examples of the goldsmith's craft are of excellent workmanship and novel design, showing that the best standards achieved in the New Kingdom could be maintained on occasion in the Late Period, so far as can be judged from the little that has survived.

98, 99 Bracelets of King Psusennes I, a pair, gold inlaid with lapis lazuli, carnelian and green felspar (?). H. 7 cm. Greatest diam. 8·0 cm. Montet Cat. Nos. 653–54. These display a late variation on the design of the rigid bracelet consisting of two half-cylinders hinged at each end, one of the hinge-pins being retractable to form a clasp. The bracelet is worked *à jour* in a cloisonné design. In each half-cylinder is a winged scarab holding a sun-disk in his forelegs and a *shen*-sign between his rear legs. This is flanked by the cartouches of the king bearing his two great names and surmounted by solar disks. Some of the inlays have been lost. These bracelets were found on the mummy of King Amenophthis.

100 Bracelet of King Psusennes I, one of a pair, gold. H. 4·3 cm. Outer diam. 6·1 cm., inner diam. 4·9 cm. Montet Cat. No. 549. This restrained but effective design of bracelet consists of two half-cylinders hinged together, one of the pins being retractable. Each half is composed of seven tubes of D-section, the outer surfaces being alternately smooth and ribbed. An inscription chased in the interior surface gives the titles and names of the king and his chief queen.

101 Anklet, one of a pair, gold and lapis lazuli. H. 5 cm. Greatest diam. 6 cm. Montet Cat. No. 600. These slightly tapering limb ornaments are one of the few incontrovertible examples of male anklets to have survived, having been found in position on the legs of King Psusennes I. The design is *en suite* with the bracelet shown below, the greater half-cylinder being composed of similar lunettes alternately gold, and lapis lazuli set in gold. The lesser half-cylinder is formed with a design of the king's prenomen.

102 Bracelet, one of a pair, gold and lapis lazuli. L. c. 19·5 cm. Montet Cat. No. 598. From the position in which he found them, Montet argued that the pair of bracelets, of which one example is illustrated here, were worn just below the knee. Such knee ornaments, however, do not appear on the monuments at any period. The lengthy ritual of wrapping the royal corpse gave a

number of chances for the embalmers to commit errors. Judging from the design of a rigid anklet belonging to Psusennes made *en suite*, this jewel is really a bracelet. It consists of two pairs of rectangular elements giving the names and titles of Psusennes in cartouches inlaid in cloisonné-work and the lunate elements, alternately in gold, and lapis lazuli set in gold.

103 Finger-rings, from the gold sheathed fingers of King Psusennes I, gold, lapis lazuli, red jasper and glazed steatite. Average D. 2·5 cm. Montet Cat. Nos. 566, 575, 570. Each finger-ring is made of a penannular gold hoop with ends bent sharply to enter the rings on the fundae, and are held in position by a separate thin connecting wire threading the hole in the bezel and wrapped for some distance around the shank. Three of the rings are decorated with a *wedjet*-eye on the obverse and the name of the king on the reverse. The fourth has a simple scarab mounted in a massive gold funda. The rings appear to have been made for funerary use since for everyday wear the more robust rivetted design had long been in existence.

104 Collar, gold, of King Psusennes I. D. *c.* 20 cm. Montet Cat. No. 482. This collar is a late version of five *shebyu* necklaces of honour fashioned into a single unit. The jewel is built up of 382 lenticular beads 1·25 cm. in diameter. Four groups of five such beads have been soldered into spacer bars so as to divide the collar into five sectors. The fastener is a trapezoidal box 6·5 cm. long, the outer face of which has been worked with a design imitating the reticulations of the separate strings of beads. Seven rings are soldered to the lower edge to take the tasselled counterpoise, but this has gone astray.

105 Collar, gold inlaid with 'Egyptian blue' (?), found on the mummy of King Amenophthis. D. 26 cm. L. (of pendant) 15 cm. Montet Cat. No. 644. The collar consists of eleven strings of beads attached to an end piece in two parts. These fasten together by means of a pin traversing perforated lugs to form a trapezoidal element of gold inlaid on the face with chevrons of lapis lazuli (?), repeating the design that is formed in beadwork on the rest of the collar. These beads consist of perforated gold cylinders with dentated edges meshing into similar beads in imitation of lapis lazuli, many of which are missing.

106 *Upper:* Pectoral of King Amenophthis, gold inlaid with lapis lazuli, much decayed. H. 9·8 cm., W. 10·6 cm. Montet Cat. No. 645. The primeval shrine has a base, two pillars and an architrave all decorated with a block-border pattern and surmounted by a cavetto cornice carrying the winged disk of Horus of Edfu. Within this, on a podium inscribed with the title and cartouche of Amenophthis, 'beloved of Osiris the Lord of Abydos', squats Isis, left, and Nephthys, right, supporting the scarab of Khepri who holds the new-born disk of the sun between his forelegs and the name of the king between his rear legs. Two pairs of rings on the upper edge of the cornice are the means of taking a suspensory

chain similar to the example shown below. The design is feeble, the proportions and drawing of the two goddesses being particularly poor, and the execution careless. As this was essentially a funerary jewel few pains appear to have been taken to produce a masterpiece.

Lower: Pectoral of King Amenophthis, gold. H. 8·8 cm. W. 8·5 cm. Montet Cat. No. 646. The pectoral is made of two sheets of gold, comprising the front and the back, soldered to an edging so as to form a thin hollow box, 2 mm. thick. The face is worked in repoussé and chasing with a scene showing, within the kiosk, left, the deceased King Amenophthis wearing the *nemes* headcloth, broad collar, kilt and bull's tail, and offering incense to Osiris 'the Lord of Eternity', seated right. The inscription between them speaks of offering incense and libations 'three times' to 'his father Osiris'. At the base of the shrine is a dado of *djed* and *tyet* amulets. Above, the cavetto cornice is decorated with the winged disk of Horus of Edfu. A simple loop-in-loop chain, the ends soldered to ferrules, forms the means of suspension.

107 Pendant, gold, lapis lazuli, carnelian and frit. H. 9 cm. XXIInd Dynasty. In the Louvre, Paris. Reg. No. E.6204. This technically superb jewel, here shown enlarged to over twice its size, is an elaborate example of a pendant representing a divinity. A large ring soldered to the rear part of each figure provides the means of suspension. The three statuettes, cast in solid gold and affixed to a base-plate decorated with an inlaid border, represent the Osirian trinity. In the centre is Osiris, with whom King Osorkon II is identified, squatting on a shrine, the body of which is carved from a block of lapis lazuli inscribed with the names of the king. He is protected on one side by his wife Isis, and on the other by his son, the falcon-headed Horus wearing the Double Crown. Isis is represented as an elegant woman wearing a tight-fitting dress and wearing a disk and cow-horns. Her long wig with lappets would have been fashioned of 'Egyptian blue' but this has decayed and entirely disappeared.

108, 109 Pectoral, gold, inlaid with lapis lazuli, turquoise and steatite. W. 7 cm., H. 3 cm. Ptolemaic Period or later. From Saqqara. In the Brooklyn Museum, Reg. No. 37.804E. Though this jewel was made in Hellenistic times, it is one of the best surviving examples of an amulet that is characteristically Egyptian in its design and technique. Such *ba*-bird pectorals are not uncommon in burials of the late period. They represent the *ba* or soul of the deceased as a human-headed falcon with wings outspread, a concept which first makes its appearance in this form during the New Kingdom. An early example in cloisonné-work was found on the breast of the mummy of Tut-ankh-amun. The specimen illustrated here is much smaller and the cloisonné-work less elaborate but the body is made in the round, the human face bearing a particularly spiritualized expression. The jewel was attached to the mummy wrappings by two ribbed loops.

Index

Numbers in italics refer to the colour plates